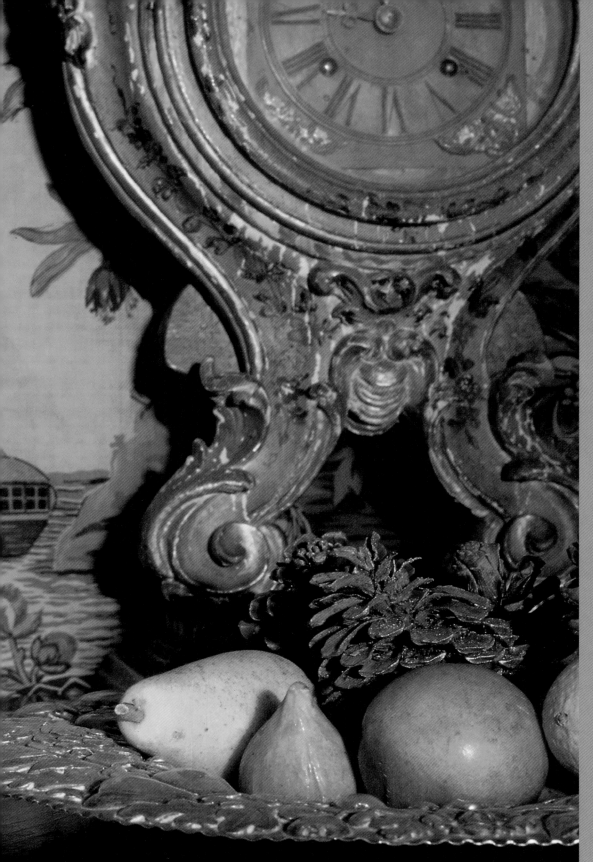

Enchanted Liguria

DAVID DOWNIE PHOTOGRAPHS BY ALISON HARRIS

RIZZOLI

Half Title: A centuries-old doorknocker at the
Palazzo Ducale in Genoa.

Title Page: An 18th-century *mezzaro* wall-hanging
in a Genoa apartment.

Contents Page: A village street in Dolceacqua
(*right*), a basket of summer vegetables from a
kitchen garden (*top*), fishermen unloading the
day's catch (*center*), olive tree (*bottom*).

First published in the United States of America in 1997 by
Rizzoli International Publications, Inc.
300 Park Avenue South
New York, New York 10010
Library of Congress Cataloging-in-Publication Data
Downie, David.
 Enchanted Liguria: a celebration of the culture, lifestyle and food of the Italian Riviera /
 by David Downie; photographs by Alison Harris.
 p. cm.
 Includes bibliographical references and index.
 ISBN 0-8478-2007-6 (hc)
 1. Cookery, Italian. 2. Liguria (Italy)—Social life and customs.
 3. Riviera (Italy)—Social life and customs. 4. Riviera (Italy)—Description and travel. I. Title.
TX723.D688 1997
641.3'0945' 18—dc21 96-47013
 CIP

DESIGNED BY JOEL AVIROM
DESIGN ASSISTANTS: MEGHAN DAY HEALEY & JASON SNYDER

Printed in Singapore

To our parents

We would like to express our sincere thanks to the following individuals for their help and encouragement:

Teresa d'Albertis; Marcella Colombo Andreani; Don Franco Anfossi;
Maria-Clotilde Giuliani-Balestrino; Mauro Balma and "I Giovani Canterini di Sant'Olcese";
Antonio Beuf; Bruno Bini; David M. Bixio; Kaisa and Anssi Blomstedt; Anna and Francesco Bo; Davide Bolzonella; Emanuela and Vittorio Bozzo; Oreste Bozzo and Maria Antonetta Bernardelli; Marisa Capurro; Alice Brinton; Anna Conti; Rosalia and Paolo Delpian; Gesine Doria-Pamphilj and Massimiliano Floridi; Jonathan Doria-Pamphilj; Don Adriano Fasce; Andreina, Stefano and Francesco-Saverio Fera; Carla Gallo; Maria Adele Gagliardi; Giovanni and Angioletta Gramatica; Chito Guala; Anne Harris; Catherine Healey; Andrea Jelenkovich; Anna Trucco Lanza;
Luca Alfredo Lanzalone and Alessandra Brunetti; Anna, Italo and Valeria Maccarini;
Paolo Mangiante; Ida Mortola; Arturo and Antonetta Paolucci; Paola Pennecchi; Enrica Piccardi-Parodi; Franca Pertusati; Renzo Piano; Francesco Enrico Rappini; Emanuele Revello and Caterina Carbone; Luca Rocco and Anna Pellegrino; Farida Simonetti and Graziano Ruffini;
Maria Grazia Spinola; Piero and Daniela Telefono; Teresa Toneguzzi; Luca and Maria Vacchelli.

We would also like to thank: Accademia della Cucina Italiana;
Associazione Dimore Storiche Italiane, Sezione Liguria; Assolapide; Floratigula.

With special thanks to our editor Carole Lalli, her assistant Liana Fredley
and our designer Joel Avirom.

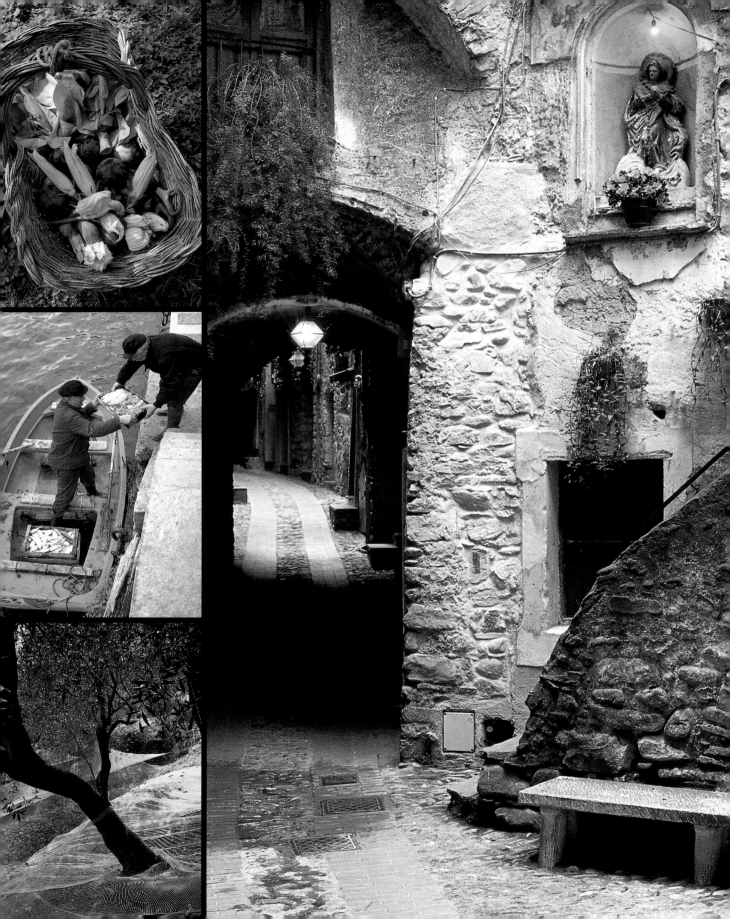

CONTENTS

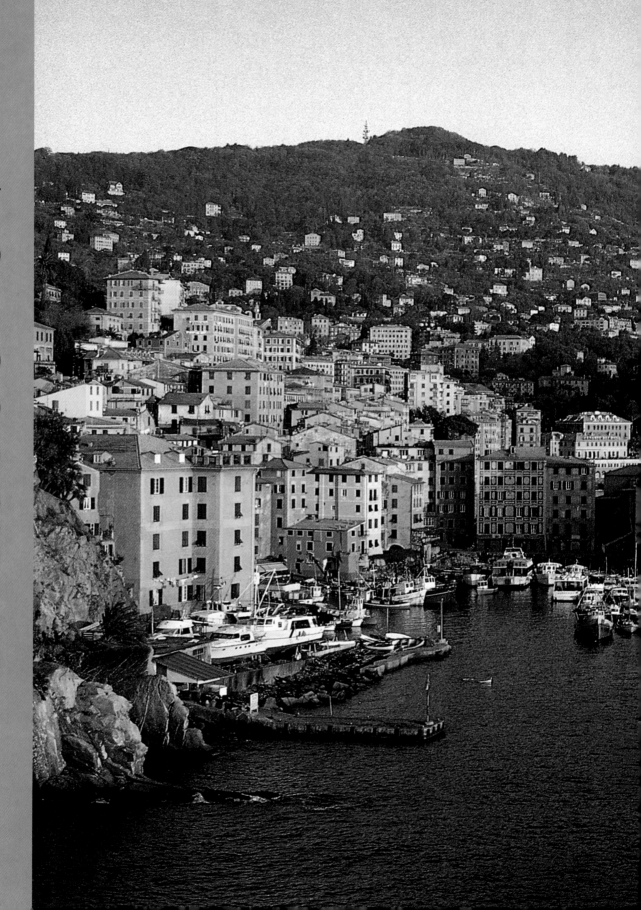

INTRODUCTION

Behind the typical Ligurian dish of pasta filled with greens and ricotta in a walnut and cream sauce is an antique map of Liguria with an inset of the port of Genoa.
Opposite: The fishing port at Camogli.

I t is impossible to speak of the landscape," wrote Sigmund Freud from Liguria in 1905, "without being a poet or quoting one." On this point Freud and I actually agree. The words of poets appear often in these pages. Shelley lived in and adored Lerici ("I still inhabit this divine bay; Reading dramas and sailing and listening to / the most enchanting music"). Byron fell in love with Genoa, though much of his time there was spent dreaming of Corinth ("There shrinks no ebb in that tideless sea / Which changeless rolls eternally") and writing *Don Juan.* I have tried not to abuse the quantity of inspired verse available, but few places have been so thoroughly canvassed down the centuries by sensitive souls. Elite tourism was pioneered in Liguria centuries ago and today the region ranks among the least unknown on earth. "Nothing is more agreeable in traveling up the Riviera of Genoa than to find oneself gradually transported from a cold air to an agreeable warmth," wrote a rapturous James Boswell in December 1765 in his *Journal on the Grand Tour.* "By the time I got to San Remo I sat with the windows open in a room without fire and basked in the rays of a benign sun." Tourism is still a prime industry today, though it only scratches the surface of Ligurian life. Paradoxically, few people outside Italy seem to know where or even what Liguria is. I say "Liguria" and not "the Italian Riviera." The problem is one of terminology. Liguria is the name of the region that lies between Tuscany and Provence, while the Riviera refers only to Liguria's boomerang-shaped coastal strip on the northern edge of the Mediterranean, a

"If a person wished to retire . . . it should be in some of the little villages of this coast, where air, water and earth concur to offer what each has most precious."

THOMAS JEFFERSON

strip perhaps a mile wide. On it are celebrated fishing and resort villages like the Cinque Terre and Portofino and many others worthy of note such as Cervo, Noli, Tellaro and Portovenere that get mysteriously little press.

The Italian Riviera is actually split in two. The jagged, eastern Riviera di Levante zigzags from Tuscany to Genoa; the Riviera di Ponente draws a smooth arc from Genoa west to France. Together they embrace about three hundred miles of cliffs, rocky shore and sand or pebble beaches. Much about the two Rivieras is subtly different—the dialects, food, landscape, climate and above all the history. The Riviera di Levante has traditionally been associated with Genoa. The Riviera di Ponente is its own entity and if anything leans slightly toward Nice and Provence, with which it has had commercial and cultural ties for millennia.

But Liguria is more than the two Rivieras. To speak solely of them means leaving out the capital city of Genoa, a maritime city-state once known as La Superba (meaning the proud or haughty). "There is no important city in Italy which is so misunderstood and undervalued," wrote Roloff Beny in the mid-1970s and that is especially true today. Everyone knows about Venice's Serenissima Repubblica, for instance, but few have heard of Genoa's equivalent Dogate, which lasted about five hundred years. The neglect in recent decades of one of Italy's most appealing cities is easily explained. The Genoese are a proud people and decided some time ago that their city must remain a working port and that tourism would be left to the Riviera. This division of tasks, so to speak, has its up side. The refreshing lack of a tourism industry gives Genoa a special atmosphere—genuine, mysterious, at times baffling; Genoa belongs to the Genoese. However shy they are of tourists, the Genoese are nonetheless delighted to share their extraordinary city with travelers.

Neither can one ignore the intricately pleated, mountainous interior that covers nine-tenths of the region's land area. Here you can honestly use that favorite lead of travel writers and speak of undiscovered, unsung and secret spots—leafy valleys, perched villages and nature reserves of astonishing beauty like the Monte di Portofino.

That is why this book is divided into sections covering the Riviera, the interior and the city of Genoa, as well as the architecture, lifestyle and cuisine of the region as a whole. The passion for trompe-l'oeil decoration throughout Liguria, for example, remains undiminished after five centuries and practically every Ligurian home plays endless real and faux variations on the themes of slate, marble and terra cotta. The *mezzaro*, a printed cotton fabric, has been in

Opposite: Ligurian trompe-l'oeil window decoration depicts neoclassical details and a balustrade in typical Ligurian colors.

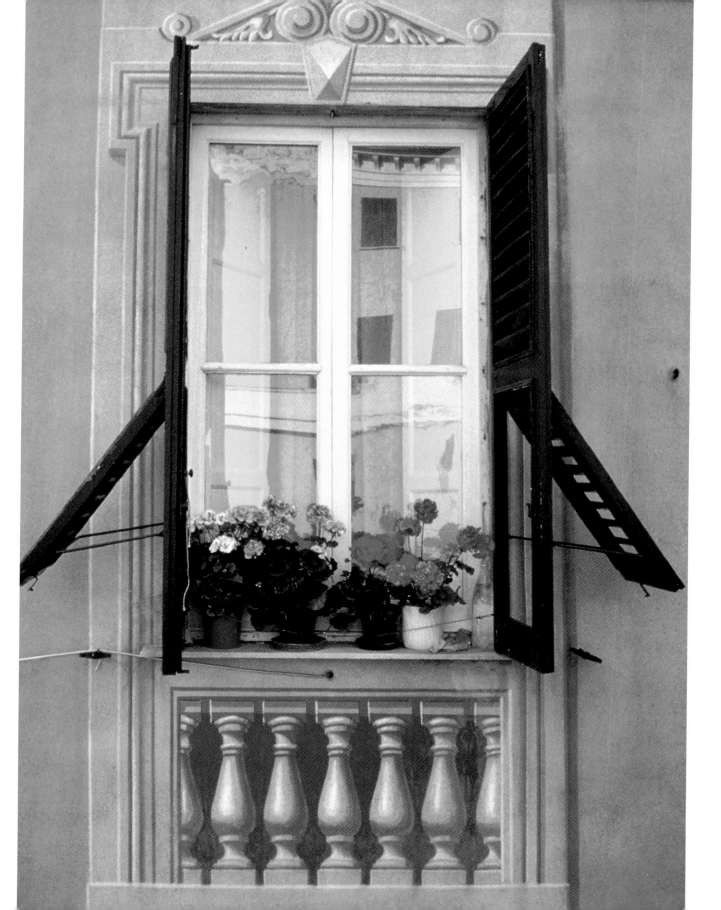

Flowers flank a ceramic image of the Madonna on a mountain pass.

use since the 12th century, is still made in Genoa and also appears in most Ligurian interiors, either as a bedspread or wall hanging. Genoa's pesto may be the region's signature dish but it is just one of hundreds of Ligurian specialties. You may encounter some dishes everywhere in the region, from the ancient Roman town of Sarzana on the Tuscan border, to Ventimiglia near France. Many others are strictly local. In this, Liguria's cuisine mirrors the surprising diversity of this small region whose total land area is about the size of Delaware and whose year-round population is just under two million.

Diverse is the only word that comes close to describing the Ligurians themselves. A century and a half ago French historian Jules Michelet called them a "strong, small, tough race with an iron will." The description, however simplistic, seems to have stuck. Modern historians from outside Liguria quote it to this day. In fact the Ligurians are a hodgepodge of Mediterranean and European peoples: few regions have been invaded so often. The name *Liguria*, variously spelled, is thousands of years old and originally referred to a vast territory which included much of Provence, Lombardy and Piedmont and was occupied by a number of related native tribes. Ask old-timers in Provence about *les Liguriens* and they will tell you of their common ancestors. Dionysius of Halicarnassus stated in the 1st century B.C. that "the Etruscan nation emigrated from nowhere; it has always been there" (in Tuscany). The same could be said of the Ligurians. Traces of their civilization go back to the Bronze Age, but before that, nobody knows; prehistoric sites on the coast have been dated as about 200,000 years old. From various ancient sources, we know that the tribal peoples of pre-Roman Liguria were shepherds, hunters, warriors and pirates. They left few monuments and, unlike the Etruscans, no written language. Near the Tuscan border, on the coast, lived the Apuani tribe; the Friniates and Veleiates held the interior. The Genuates lived in Genoa (and gave the city its name), the Tigulli in Rapallo, the Veituri and Langenses inland of them and the Stazielli to the northwest. Around today's city of Savona on the Riviera di Ponente the Sabazi and Alpini tribes were dominant; Albenga belonged to the Ingauni; the coast and interior near them were controlled by the Stazielli, Epanteri and Vagenni. Around Imperia lived the Entemili (which led to the city of Ventimiglia), as well as the Oratelli, Vedianti and Vagenni.

The number and variety of these early Ligurians hint at the complexity of the region's history. Two thousand years ago the Romans incorporated Liguria into the Empire. A thousand years later the Genoese incorporated the Romanized Ligurians into the Commune, then the Republic of Genoa. Yet many

tribal traits and traditions survived. To this day the region's food, language and culture vary along lines traced long ago, preserved both by force of will and by geographical isolation. Liguria's terrain is almost entirely mountainous and until recently was ill-served by roads. This fostered self-sufficiency and led to the growth of micro-cultures. The Commune and Republic of Genoa ruled Liguria for nearly a thousand years, from the 9th to early 19th centuries. It is easy to forget that the modern state of Italy has been in existence only since 1861. "We have made Italy," statesman Massimo D'Azeglio declared at the time, "now we must make the Italians." Ligurians are indeed Italians, but they have preserved an unmistakable regional identity and they recognize and appreciate their diversity.

This is not a history book; Ligurians do not live in the past. However, history undeniably lives on in everything from religious rites to recipes and a certain sort of taste in interior decoration. When your family has been in the same city, perhaps even in the same building, for the last, say, nine hundred years; when your great-grandmother baked the same delicious pandolce and focaccia that you make; when your great-great-great-uncle was a sailor just as your grandfather and father were; it is only natural to feel a degree of attachment to your ancestors and their traditions. The ancient monuments of the city of Rome are like dinosaur bones in a natural history museum. Genoa, on the other hand, is younger but feels as ancient because the past is present. Many of today's families have been there since the Middle Ages, among them the Dorias, Spinolas, Cattaneos, Pallavicinis and Grimaldis—names that constantly turn up as you visit villas and palazzi or simply stroll the streets of a Ligurian town.

For these reasons I have woven into the fabric of this book strands from Liguria's rich, colorful past. The fate of the region as a whole has long been tied to Genoa, and so it is in the chapter on Genoa and the Republic that historical references are most plentiful, though certain characters and episodes reappear elsewhere—Christopher Columbus and Andrea Doria, for example. Columbus is too famous to need identification. The Genoese are understandably bemused, however, when foreigners think of Andrea Doria only as the trans-Atlantic passenger ship that sank in 1956 off Nantucket Island. The unfortunate liner was named after the late-Renaissance admiral who is revered to this day as "The Liberator and Father of His Country"—the country being, of course, Liguria.

Pandolce, the classic Ligurian Christmas cake, crowned with laurel leaves (made by the Panarello Bakery in Genoa). *Overleaf:* a view of the coast at sunset from San Rocco.

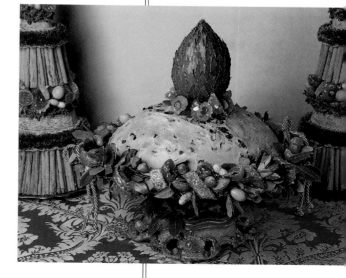

A SEA FOR ALL SEASONS

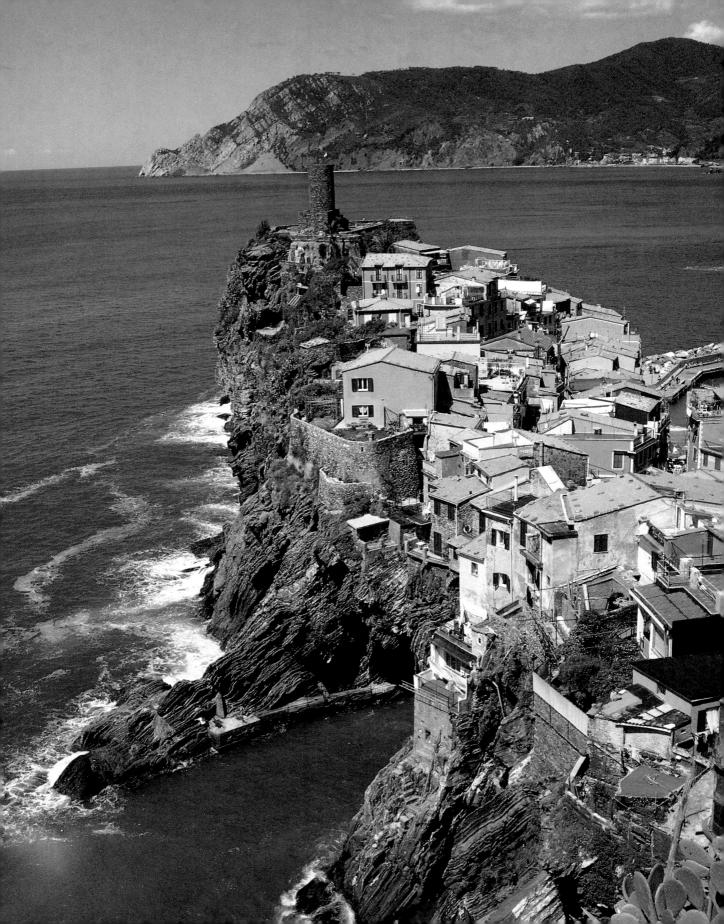

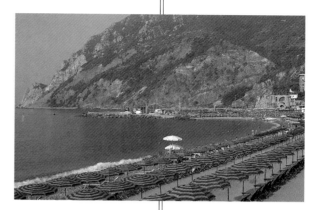

There is one seemingly banal experience lasting mere seconds that wordlessly distills the magic of the Ligurian seaboard. On a December day, drive from the icy, fog-bound plains of Lombardy or Piedmont on the *autostrada* toward Genoa and after what seems an interminable succession of ill-lit Apennine tunnels you will suddenly emerge from darkness into light, from winter to spring, from the cold continent to the warmly familiar Mediterranean. It is both instructive and wickedly amusing to watch the stunned, speechless northern Europeans—foremost among them the Milanese—who pull off at the first rest stop on the turnpike and blink into the blinding sun. At their feet opens Liguria, that eternally green "cupid's bow, a slice of watermelon, an amulet, a Christian halfmoon curved along the sea" that mesmerized French poet Valéry Larbaud earlier this century. The *autostrada* has only been around a few decades, but mule trains of pale, forgotten poets like Larbaud—and too many philosophers, painters, writers and lesser spirits to tally—have been marching on the Riviera for centuries to escape the Continental winter. To draw a rough North American parallel, you might say that Liguria became the Florida of Europe with the Grand Tour in the mid-1700s. You might reasonably add, though, that beyond its mildness, natural beauty and romantic ruins, Liguria offered art, food and culture on the side. To the resolutely Eurocentric travelers of old, the Mediterranean was the cradle of Western civilization, a source of inspiration. Liguria's twin Rivieras—Levante in the east, Ponente in the west—were its quintessence.

Rows of sun umbrellas await swimmers on the beach in Monterosso. *Opposite:* The dramatic promontory village of Vernazza in the Cinque Terre.

This familiar sea, nicknamed Mare Nostrum (Our Sea), unifies this otherwise disparate region.

"If a person wished to retire from his acquaintance, to live absolutely unknown and yet in the midst of physical enjoyments," wrote Thomas Jefferson in 1787, "it should be in some of the little villages of this coast, where air, water and earth concur to offer what each has most precious." Thousands of proto-tourists and adventurous retirees, most of them English, seem to have taken Jefferson at his word. They so efficiently colonized sections of the western Riviera di Ponente throughout the 19th century that towns like Bordighera, Ventimiglia, San Remo and Alassio had more foreign than local residents until the outbreak of the First World War. These expatriates had their own hotels, villas, botanical gardens, restaurants, hairdressers and churches, and looked down their noses at the picturesque but untrustworthy locals about whom they knew little and cared less.

The first waves of 18th-century Riviera enthusiasts were peculiarly genteel travelers: English kings, German emperors, Russian Tsarinas and their courts; romantic poets and their sycophants; bona fide botanists and mad British butterfly hunters; aging American Revolutionaries and Victorian lady watercolorists. Most of them did not travel light and required considerable infrastructure to move their baggage—cultural and otherwise. Luckily for them, the railroad blasted its way across the length of the coast in the mid- to late 1800s, making for an easy two-day trip to semitropical shores from inclement Paris, Berlin or Saint Petersburg. The railroad also transformed the narrow, seaboard landscape with remarkable panache, since there was little room to hide it. To this day, express trains rattle merrily through what were the gardens of scores of villas, including Admiral Andrea Doria's celebrated Palazzo del Principe in Genoa, and within twenty feet of a gorgeous rococo church in the seaside resort of Laigueglia. But the advent of the railroad was not entirely negative. In its wake came the wonderful, wedding-cake casinos and Grande Dame hotels that later were imitated around the globe. The prototypes of the style are in Liguria: San Remo's Hôtel de Londres or Rapallo's former Grand Hôtel (now a condominium complex) are two.

What these early travelers had in common was timing: they graced the Riviera's shores exclusively from fall to early spring, which was considered the only proper time for a sojourn. They (and many locals to this day) would not have been caught dead swimming or sunning themselves in summer on a Riviera beach. The climate, come May, was said to be too hot and unhealthy, the water too warm to be good for you. Most of the grand hotels built after

the mid-1800s would shut their doors just as the sea was reaching swimmable temperatures and the first heat-hazy days were transforming the mountainous coastline into an exotic, vaguely oriental scene.

The opposite has been true since the 1950s postwar economic boom: most visitors miss that magical passage from Continental winter to Mediterranean spring and form instead a cheerful, heat-seeking horde. They descend upon the region from July to August armed with cellular telephones, speedboats and sports cars. "Decidedly, millions of people dragging themselves out onto the roads is a phenomenon of modern times," sniffed French novelist Raymond Queneau from the Riviera in 1962, the height of the boom. "And very similar to the Barbarian invasions." Queneau's gibe was picked up by local commentators throughout the sixties and seventies. "Barbarian" was replaced with the generic term "Milanese," since it was from that populous, new-rich city just a few hours north that the greatest number of invaders seemed to come. From the Spiaggia delle Uova, named for its egg-shaped pebble beach on the French frontier, to the chic pleasure port at Bocca di Magra where Tuscany begins, in high season every accessible inch of the anfractuous Ligurian shore is given over to the pursuit of sun and fun.

Barefoot contessas and befuddled Hollywood or Cinecittà filmmakers romp in both fact and fiction, and every month is enchanted, not just April.

Though tourism has actually been the main industry for at least a century in dozens of seaside resorts, a great deal of hypocrisy and snobbery towards it remains. Given the choice a hundred years ago between heavy industry or middle-class tourism—seemingly the only viable economic options on the Riviera's narrow, steep coast—the answer seemed obvious. Genoa and a handful of cities like La Spezia and Savona opted for steam and steel, the rest of the Riviera for flowers, olive oil, wine and holiday entertainment.

Long before the advent of mass tourism, though, few places on earth had so thoroughly integrated nature and civilization so early on. Since the late Middle Ages the Riviera has been an almost uninterrupted succession of fishing villages, small cities, villas and resort areas. It was the plutocrats of the Genoese Republic, picking up where the ancient Romans had left off with their credo of *otium*—what we think of today as free time—who turned leisure into a way of life. Travelers' tales from the 14th century onward sing of "gilded houses strewn along the strand" (Petrarch) and "beautiful, painted houses" (Montaigne in 1581) strung end-to-end creating "a most beautiful effect" (Montesquieu in 1739). Those villas and houses, painted bright colors to be easily seen from the

Painted facades along Portofino's celebrated waterfront.
Opposite: Pliny's Portus Delphini.

sea, were the retreats not of the colonizing British but of the wealthy Genoese. As you roller-coaster along the Via Aurelia coast highway today you may catch glimpses of their crenelated towers and shady loggias half-hidden by pine woods down narrow lanes. Cruise along the coast by boat and entire landscaped promontories are revealed, their imposing mannerist villas or turn-of-the-century faux-medieval fantasy castles overlooking the sea. Some are now hotels, museums or condominium complexes, but many have remained in the same families since they were built. This is where the descendants of Genoa's old families, industrial aristocrats and successful professionals spend their weekends or live year-round in some of Italy's most extraordinary homes.

Given the centuries-long love affair that Liguria has carried on with the world at large, it seems remarkable how intact, clean and attractive most of the Riviera remains. The Levante in particular has been protected from developers by wooded mountains and sheer cliffs falling into the sea. But tourism also has its appeal: anyone with a curious eye and a sense of humor can appreciate the colorful symmetry of the umbrella-swirled beaches of, say, Sestri Levante or Monterosso, the Cinque Terre's biggest village. Dozens of other family resorts provide good, clean fun. Beyond the broiling strand and its fun-fair atmosphere, in the dark, cool historical centers of these ancient towns, are cobbled piazzas, patrician palazzi built over Roman villas, stern Romanesque and gilded baroque churches bursting with paintings and sculptures—and an intense village life shared by the people who live there. Noli, a sort of San Gimignano by the sea, is down from its original ninety-five medieval towers to five, plus one ruined castle and a warren of arcaded streets scented by the wisteria that grows riotously all over the area. The architectural and artistic wealth of Albenga, an outwardly unpromising resort, is surprising to say the least. It includes a 5th-century paleo-Christian baptistry with Byzantine mosaics and a half-dozen medieval house-towers still occupied to this day. A glance at a map of Liguria reveals a considerable number of rugged wilderness areas scattered along the coast. Those at Finale Ligure, the Monte di Portofino, the Cinque Terre and Monte Marcello are the best known. Even at the height of the summer season they and other inland park territories are virtually empty, deserted in favor of the sunny beaches. As a consequence Liguria's interior has become a refuge for wild boars,

solitary hikers and the *contadini* whose families have farmed the rocky, terraced landscape for generations.

Exclusivity ensured by a daunting price tag and limited parking is the specialty, instead, of the reinvented Ligurian fishing villages favored by today's beau monde. In the Levante, D. H. Lawrence's beloved Tellaro and Fiascherino are carved from jagged cliffs just south of Lerici, where Byron wrote immortal lines and Shelley left his mortal remains (he drowned in the gulf that was later rather aptly named il Golfo dei Poeti). Unsung but not-undiscovered Varigotti in the Ponente is the playground of the Milanese and Turinese literary sets. These charming sites feature gaily painted houses clustered around tiny ports where weathered fishing boats bob among the yachts of millionaires. The most exclusive of all, of course, is the horseshoe-shaped, festively frescoed Portofino, impregnated with the perfume of jasmine hedges and cascading walls of wisteria. In gardens and piazzas shaded by intoxicatingly sweet-smelling pittosporum trees, barefoot contessas and befuddled Hollywood or

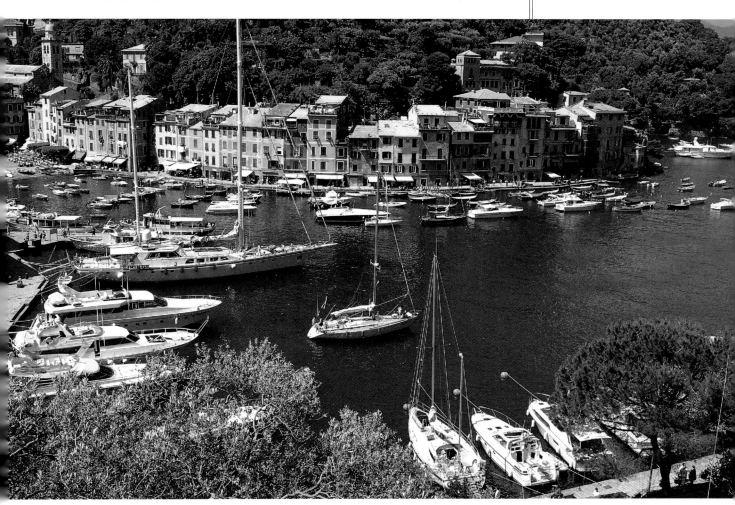

Cinecittà filmmakers romp in both fact and fiction, and every month is enchanted, not just April.

Ligurians no longer seem troubled by the current fashion for summer holiday making. On the contrary, many now excel at it, especially the young. Others close up their houses in July and August and head for the cooler hills, to secluded Apennine villages around Santo Stefano d'Aveto in the Levante, Baiardo near France or inland areas like Voltaggio and Gavi which now are in Piedmont but formerly were Ligurian. They know that by mid-September the heat and the crowds will be gone and the Riviera will return to its natural rhythms. Fleets of speedboats will again yield to vintage trawlers and wooden

Portofino, the First Resort

The history of colonial holiday-making will have to be written elsewhere, but one special case on the Riviera di Levante is worth briefly describing: Portofino. It is impossible to speak of the Italian Riviera and the Ligurian Sea without first admitting that tourism as we know it today was born here. Say "Riviera" and with Pavlovian certitude anyone anywhere in the world will immediately bark "vacation," "beach," "sun" and "sea."

Britain's consul in Genoa in the 1840s, Timothy Yeats Brown, staked out the exquisite site early on, buying and rebuilding the medieval Fortezza di San Giorgio and renaming it Castello Brown (it was the setting of the recent film *Enchanted April*). The rush on other romantic ruins in the neighborhood, like the Castello di Paraggi, bought and transmogrified by Brown's son Frederick, was only to be expected. Soon the Browns and their worldly friends were lording it over the land. Even the cove on the northwest side of Portofino's olive-shagged promontory was renamed Spiagga degli Inglesi—Englishmen's Beach. Paradoxically, Portofino owes its preservation largely to the far-seeing foreigners who fell in love with it and bullied local authorities into protecting everything from the color of its houses to the kind of vegetation that could be planted on, and improvements made to, the Monte di Portofino at its shoulders.

The world's most celebrated fishing village, Portofino was already so expensive in the late 1500s that traveling aristocrat Giambattista Confalonieri complained that "you were charged not only for the room but the very air you breathed." Nowadays that is called paying for the atmosphere. Never mind that most modern visitors are more concerned with the designer boutiques or hundred-dollar servings of sea bass than with the splendid architecture or two-thousand-year history of what Pliny dubbed *Portus Delphini*—the refuge of dolphins.

gozzi, the broad-beamed fishing boats made here since the Middle Ages. Fishermen will mend their nets on empty beaches and shout to one another in dialect about the weather and the catch. When the sun umbrellas and refreshment stands disappear, sea front promenades once again become outdoor salons where seniors play cards or toss bocce balls and children race on rollerblades. The terraced orchards that rise from sea to mountain crest turn a kaleidoscope of colors with the coming of fall and truck farmers trundle their produce and wild mushrooms into the marketplaces of now-sleepy coastal towns. In the Cinque Terre and dozens of other villages perched over the sea, vintners and olive oil makers commence the age-old cycle of harvesting, production and pruning that will occupy them until spring.

Save for the occasional squall, the weather on the coast is always mild; in a good year you can swim until mid-October and begin again in May, when the water is crystal clear and invigorating. On clear days in between, the Alps and Apennines seem to float on the horizon, snow-capped, while a morning mist rises from the churning sea, wrapping itself around the lighthouses and old stone watchtowers that punctuate the coast. As native poet Camillo Sbarbaro said it so sweetly a few decades ago, "Liguria, you who have winter skies as tender as in spring!" In fact spring is ushered in not with the calendar but the vernal equinox. Once the days start getting longer, winter is over before it has begun. Bougainvillea is often still in bloom at New Year's, surrounded by rosemary, daisies, Christmas roses, geraniums and wildflowers. Cyclists in their bright racing uniforms suddenly swarm onto the winding Via Aurelia coast highway on the first Sunday in January, the first weekend of "spring." Kids wearing T-shirts fish from rocks, and hikers in shirtsleeves fan out across the landscape.

Liguria's beaches and sea indeed draw the summer crowds, and it is their custom that keeps the Riviera alive. But the true character of the region and its people has always resided in the year-round daily rituals and age-old professions of this ancient maritime nation. Ligurians are children of the Mediterranean. This familiar sea, nicknamed Mare Nostrum (Our Sea), provides not only transportation, commerce and food, but also inspires art, religion and folk culture. The sea unifies this otherwise disparate region where language, history and cooking change from valley to valley, from east to west and from coast to interior. Liguria is a mere six miles wide at Pegli, near Genoa, and perhaps three times that at its widest, behind Imperia. So the Mediterranean is always present—seen, smelled or sensed. Given the region's mountainous

topography, mild coast climate and maritime economy, it is not surprising that nine of ten Ligurians live on the densely populated seaboard. What they seem to miss most when they move inland to Italy's economic and political powerhouses—Milan, Turin or Rome—is not family, friends or even food. It is the sea. In practically every Ligurian home you will find a shipping broker, maritime insurance agent, harbor pilot, captain or sailor, fisherman, boat builder or chandler—someone still working directly with the sea. Steamer trunks, nautical instruments, ship paintings, flags and merchant marine certificates are as omnipresent in their homes as the mortars and pestles once used to make pesto.

The days of the trans-Atlantic passenger ship may be over, but cruise ships and ferries from Corsica, Sardinia, Sicily and Africa still swing past the seven-hundred-year-old Lanterna lighthouse, Genoa's symbol, and dock daily at the endearingly shabby

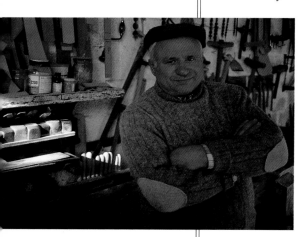

Stazione Marittima. Much of the oldest part of town is a way-station for immigrants who bring with them not only social challenges but an enriching dose of foreign culture. Genoa, from which millions of Italians departed for the Americas in the 19th and early 20th centuries, is now on the receiving end. East of the city's old harbor area, the fisherman's wharf is a round-the-clock bustle of trawlers unloading and trucks being packed with fish for the seemingly insatiable markets of Milan and Turin.

Thirty miles southeast of Genoa in Lavagna time suddenly stands still as you wander beyond the yacht harbor and into master boat builder Mariano Topazio's small shipyard. Topazio and his son Francesco craft wooden *gozzi*, *leudi* and launches using techniques and tools handed down over the last thousand years. Here local *maestri d'ascia* and *calafatai* (boat builders and caulkers) built similar boats for the personal fleets of the Fieschi Counts of Lavagna and for crusaders, kings and merchants. Many of the latter were shippers of the slate that has been quarried nearby since antiquity and remains an important local industry. "I don't know what the metric system is," quips the deadpan Topazio,

Boat builder Mariano Topazio does not use glue or epoxy in his wooden *gozzi*, but he insists the boats will last "several lifetimes." *Opposite:* The frame of one is shown in his Lavagna workshop.

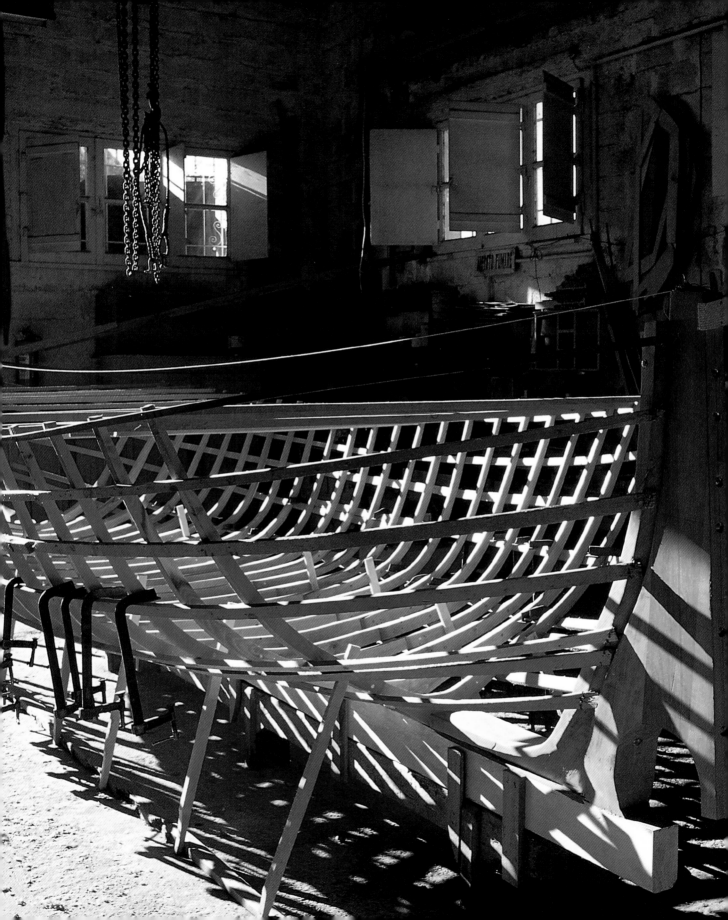

who has been knighted by the Republic of Italy for his efforts to preserve his craft. "I use the old measurements: *once, palmi, govi*," he adds with a boyish wink, aware that almost no one knows that twelve *once* make one *palmo* (nine and one-half inches), and three *palmi* make a *govo*. His boats measure fourteen to forty *palmi*—eleven to thirty-three feet—and their single concession to modernity is a twenty-horsepower inboard engine. Like his grandfather before him, Topazio takes about one year to shape local acacia into frames and to bend pine, from behind the Cinque Terre, into planks. It is a ritual involving saints and lunar cycles: the trees are felled only in the dead of winter during a waning moon, and the wood must never be touched on August 10, the feast day of San Lorenzo. "Otherwise the boats won't last a year," he insists. So perfect are Topazio's joints and finishes that no epoxies or glues are needed and the *gozzi* last a lifetime. "Several lifetimes," corrects the maestro.

Given the luxurious surroundings, it is even more surprising to find the series of distinctly unpicturesque workshops at the far end of Portofino's parking lot where Giacomo Viacava, another master boat builder of ancient descent, makes similar boats using similar techniques (though he now spends most of his time refurbishing yachts and worrying about being evicted by the village council, because some chic locals consider his workshops unaesthetic— a blight on this otherwise pristine resort). The kinds of humble sea craft made by generations of Viacavas and Topazios may be less glamorous than the sleek sailboats now associated with the Riviera, but they are a common sight nonetheless. They are the hard-driven *lampare* lamp-boats that are towed out of port at dusk single file, lure fish with their bright lights throughout the night and return laden at dawn, towed in by an equally hard-driven *gozzo*. They are the launches and tenders and small ships that have been here forever and will endure when the plastic- and fiberglass-hulled fleets of recent decades are gone.

Though Topazio, Viacava and perhaps half a dozen others are recognized as the region's best builders of wooden boats, there are scores of other talented artisans and industrial shipbuilders here producing sailboats, luxury speedboats, freighters, trawlers and tugs. Trains and trucks have not put the local shipping industry out of business as was once feared. La Spezia and Savona—among Liguria's most active commercial ports—compete with Genoa for container-ship traffic. But since the city's automated port facility at suburban Voltri came into its own a few years ago, the capital has won back a sizable share of the Mediterranean's cargo market. For the first time in

decades Genoa is giving Marseilles and Rotterdam a run for their money.

For centuries, the spiritual needs of the many Ligurians who live and work on the sea have found expression in the innumerable chapels scattered along the coast and spangled with the region's singular ex-votos—votive offerings, usually paintings, made to the Madonna. Each tells a hair-raising tale of shipwreck and thanks the Madonna for rescuing wounded or drowning sailors, calming stormy seas and interceding on behalf of the faithful. Though similar ex-votos are found in other regions of Italy, Liguria has long been the country's most active maritime region and it is only natural that this form of popular religious art reach its apex here. Ships are evocatively shown locked in ice, dashed against rocks or rent asunder by explosions amid acts of great courage. Under each dramatic image a brief account of the disaster commemorates the men and women involved. Scores of sanctuaries celebrated for these maritime ex-votos—among them Montallegro and Genoa's Madonna della Guardia—stand like sentinels on ridges, strategically visible far out to sea. They continue to offer solace, if not protection, to today's mariners and their families.

The naval museums at Pegli and Camogli, originally conceived to glorify the exploits of Genoa and its satellite cities, are secular pilgrimage sites for Riviera families. Though rarely visited by tourists, these museums offer invaluable insight into the Ligurian mind. Past the industrial suburbs of eastern Genoa the coastal road winds uphill to the old center of Pegli, once a leisure colony of the patrician Genoese and still studded with a surprising number of handsome properties. On a rise, beyond the romantic gardens of the Villa Durazzo-Pallavicini, stands the equally sumptuous Villa Centurione Doria, Liguria's flagship naval museum. Under cycles of mannerist frescoes whose classical scenes immortalize the exploits of the villa's first owner, Genoese banker Adamo Centurione, are the maps, ship models and navigational equipment you would expect to find in such a museum, as well as a fine portrait of Christopher Columbus by Ghirlandaio. The maritime miscellanea show Genoa in its true colors as the bully of the Riviera. The city ruled the region from about the 9th century on and terrorized the entire Mediterranean, where it waged war with myriad rivals from the Middle Ages until the 1600s. The list of Genoese conquests and defeats—and the history of its colonial expansion throughout the Mediterranean, Caspian and Black seas—would fill several thick volumes that few modern readers would be prepared to tackle. The Genoese and their

In terms of cunning, courage and cruelty, Doria makes Columbus seem like a pushover.

Overleaf: The formal Gardens of Villa Durazzo overlook Santa Margherita's chic marina.

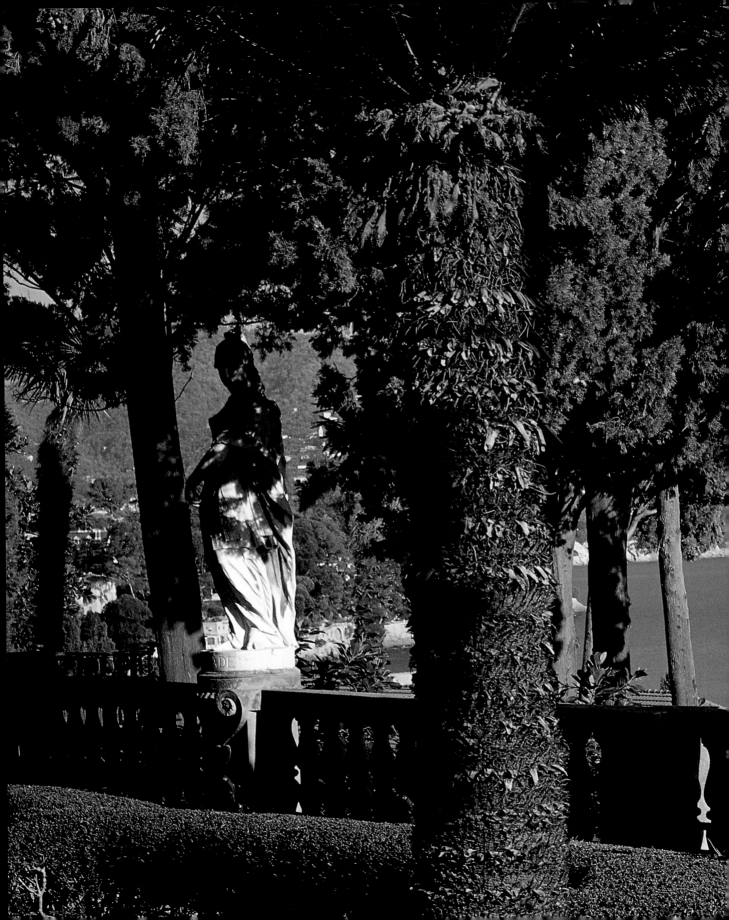

Riviera subjects were consummate pirates, arms merchants and adventurers; ruthless colonizers and monopolistic spice and sugar traders who occasionally dealt in slaves. Sea exploration was a particular obsession of the Ligurians from the early Middle Ages on, not only because it held the promise of colonial riches. It seems to have been a necessary response to the peculiar Ligurian condition of being trapped on a crowded tongue of land surrounded by inhospitable mountains beyond which pressed larger, more powerful nations. From a purely survivalist standpoint, the adventurous children of the Riviera had little choice but to set sail—to Corsica, Caffa, Smyrna, the Canaries, Iceland and finally America. Some contemporary Genoese historians and sociologists, such as Massimo Quaini, suggest that the combination of an open sea and a mountainous landscape exerted such psychological pressure on the inhabitants that those predisposed were driven to seek what lay beyond the horizon.

There are plenty of examples of Genoese who spent their lives commanding ships; often they were from large, wealthy clans.

Over the last thousand years or so the narrow strip of rocky Ligurian coast has produced a disproportionately large number of explorers and sea captains. They were much more than mere church-steeple navigators who sailed from one coastal village to the next, always in sight of land. One of them happened to be an obscure weaver's son, Christopher Columbus. Celebrated or damned around the globe, he was not particularly popular in his native land: when Rodolfo del Ghirlandaio painted the portrait now hanging at Pegli's museum he did not represent Columbus under the Republic's ubiquitous banner of St. George, a red cross on a field of white. For centuries it was a flag of convenience, leased from Genoa by countries like Britain as protection against pirate attack in the Mediterranean, which the Genoese dominated. Genoese painters, on the other hand, almost always showed Columbus with the flag, overlooking the embarrassing detail that the Senate of the Republic had refused to finance his expedition, and his lucrative discoveries in the New World were made for Ferdinand and Isabella of Spain. As many Genoese historians now point out, the Republic's money-lenders and bankers who underwrote Spain's debt indirectly financed Columbus and in fact the usury on the loans amounted to a third of the gold and silver of the American colonies. Yet the Ligurians and Genoese in particular are still ambivalent about their most famous native son, perhaps because he left Genoa young, expressed no interest in the city and never returned.

Not so Columbus' contemporary, Admiral Andrea Doria. He will remain forever close to the Ligurian heart. A few decades after Columbus'

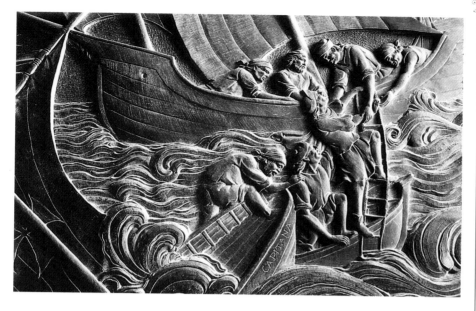

A slate relief by sculptor Francesco Dallorso.

exploit, Doria became overall commander of the French royal fleet. He later switched allegiance to Spain, under whose protection he ruled Genoa at the head of an ostensibly independent republic until he died when nearly one hundred years old in 1560. In terms of cunning, courage and cruelty, Doria makes Columbus seem like a pushover. He broke pacts, he tortured and murdered opponents and destroyed their family homes, he outwitted French king Francis I and Spanish emperor Charles V and in many ways was more powerful than either. He ruled his city-state as a dictator and ensured a hereditary succession of power in what was supposed to be a republic. He also happened to be a great patron of the arts and was the man who lifted Genoa from the Middle Ages into the modern age. No wonder it is Doria, not Columbus, who has been held up as a role model to young Ligurians for the last five centuries.

Strange as it may seem today, until recently most Ligurians had a love-hate relationship with the Mediterranean. The sea was a provider, but it also stood as a constant reminder of the hardships of life: toil, discomfort, seasickness, monotonous food and the fear of death by drowning, battle or shipwreck. The idea of sunning and swimming, then supping on fresh fish, would no more have crossed the minds of the Ligurians of old than that of jumping off a cliff. The villa housing Pegli's naval museum, built by a banker, points to another paradox: the main source of Genoa's wealth since the Renaissance was actually banking and finance, almost always related to the sea. They may never have set foot on a ship, but the Genoese financed Europe's great sea journeys, foreign

navies, colonial expansion, war and every imaginable form of trade, shipping and exchange. Later, Genoa's clever financiers diversified into maritime insurance, which was invented by Lloyd's of London in 1687 and developed in Liguria in the 19th century.

Of course there are plenty of examples of Genoese who spent their lives commanding ships; often they were from large, wealthy clans whose other members stayed home to run the family bank or business. There is one such captain whose presence is constantly felt in Genoa to this day, Enrico

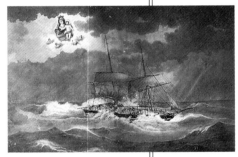

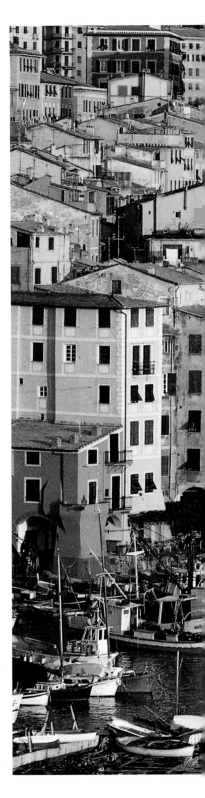

Alberto d'Albertis. His mad exploits match the fanciful castle he built at the turn of the century in Genoa, positioned to be visible from miles around, and an unavoidable landmark ever since. The genially eccentric d'Albertis was the first Italian to sail through the Suez Canal; he also re-enacted Columbus' journeys using only Renaissance navigational instruments which he had built himself (they are now on display at the Pegli Naval museum). D'Albertis circumnavigated the globe several times, collecting extraordinary friends and unusual objects, which he brought home to the amusement—and occasionally the dismay—of Genoa's rather conservative elite. His castle, bristling with towers and stuffed with souvenirs from these travels, has been under restoration for a decade and will soon become Genoa's museum of ethnography.

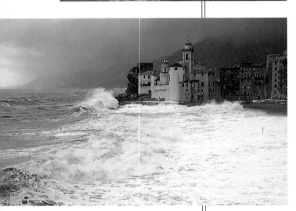

Top: the Bozzo family ex-voto showing one of their sailing ships in a terrible storm. The ship was saved despite the gale force winds. *Above and Opposite:* Camogli during a winter storm, and a summer sunset.

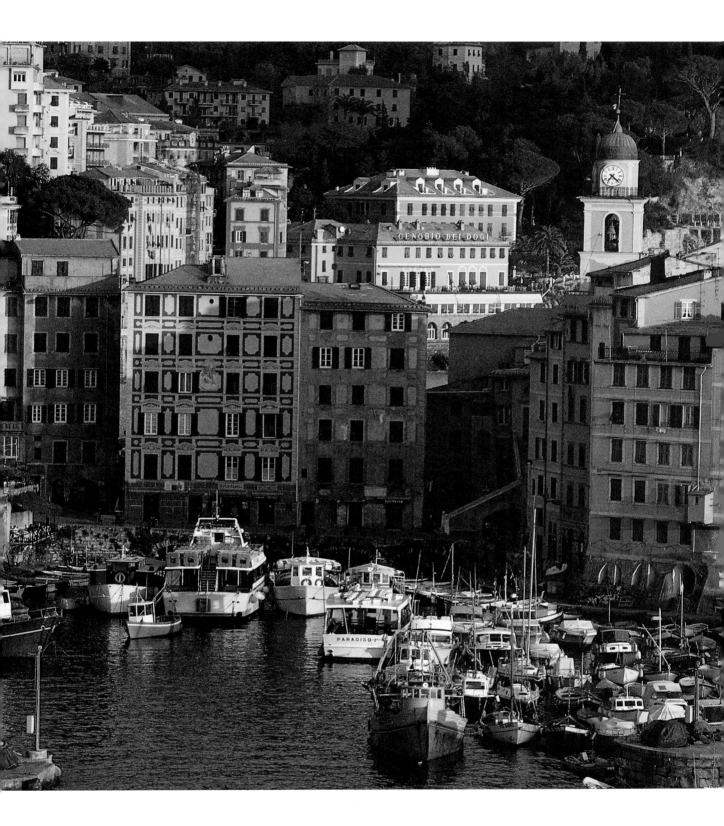

\mathcal{D}espite extraordinary personalities like d'Albertis, though, most of Liguria's sea captains, sailors and fishermen have not come from Genoa. The true sea folk of the Riviera have always hailed from Recco (Nicoloso da Recco claimed the Azores for Alphonso IV of Portugal in 1331), Varazze (Lanzarotte Malocello reached the Canaries in 1339), Noli (Antoniotto Usodimare "discovered" the Cabo Verde islands in 1456), Savona (Leon Pancaldo was Magellan's pilot for the first circumnavigation of the globe in 1520) and especially Camogli on the northern side of the Monte di Portofino. Charles Dickens called Camogli the "saltiest, most piratical town" on the Mediterranean—for good reason. By 1860 this small town had one of the largest merchant fleets in Europe, hence its nickname, The City of a Thousand White Sailing Ships. Actually Camogli had considerably more than a thousand ships, most of them based in Marseilles, since there was no room for them at their tiny home port.

Eschewing rival Genoa, Camogli set up its own Merchant Marine Academy in 1875 and it is still going strong, attended by young men and women from all over the Riviera who become the pilots, commanders and crews of the world's merchant marines. It is strangely moving to see passenger ships and freighters longer than Camogli itself sweeping by, blowing their horns as a salute. Look up from the old painted stone houses that rise as high as nine stories over the seafront promenade and on the surrounding hills you see scores of villas and castellated mansions, some magnificently kitsch. They were built in the 1800s by the city's maritime dynasties, the Bozzos, Mortolas, Schiaffinos, Ferraris and Molfinos—all of them still involved in shipping and each immortalized in Camogli's Museo Marinaro. This singular museum, founded by Gio Bono Ferrari earlier this century, is in an unprepossessing building below Camogli's main street. It holds Ferrari's collection of hundreds of paintings and scores of scale models of the sailing ships that were the pride of Camogli. Ferrari's many books of seafaring tales from Napoleonic times to the 1930s paint a picture of indomitable characters straight out of *Moby Dick* (Melville was awed by Genoa and the Riviera) or *Heart of Darkness* (the famous iron-sided *Narcissus*, which Joseph Conrad sailed on and wrote about, was later bought by a captain from Camogli).

Given the town's maritime heritage, it is no coincidence that the last working *tonnara* fishing net in the northern Mediterranean is anchored between Camogli and Punta Chiappa to the south, a tongue of solid stone that juts several hundred yards into the sea. For the last four hundred years

fishermen have set out with their *gozzi* at least three times a day from April to September to haul in the *tonnara*, a complex trap suspended from floats and several small boats. Fish swimming along the shore enter the maze of nets and are pulled up before they can find their way out. The technique has not changed much since the 17th century: a team of five or six men, balanced on boats at each end of the trap, pull in the net by hand, then sort the catch into crates. In the last twenty years the fiber nets once made from reeds that grow wild on the Monte di Portofino have been substituted with hemp or nylon ones, and the *gozzi* have been equipped with motors as well as oars, but the method is otherwise as it always has been. Every day the *tonnara* yields a variety of flavorful small and medium-sized market fish. Locals on the shore and the steep hills above, including the chefs of various nearby restaurants, watch the *tonnara* with binoculars and spy glasses and prepare their menus accordingly.

The Riviera's most heartfelt maritime religious festival, Stella Maris, also takes place between Camogli and Punta Chiappa. It is a parable of life on the Riviera. On the first Sunday in August, when the sea is almost always calm and warm, an eclectic flotilla of garlanded fishing trawlers, kayaks, ferries, speedboats, *gozzi*, dinghies, air mattresses and rafts heads from Camogli's port to the open-air altar on Punta Chiappa where the motley fleet is blessed by local priests. The atmosphere throughout the day is part picnic and part parade, a mingling of religiosity and irrepressible summer fun. When darkness falls, participants light some 20,000 candles in paper cups and float them on the sea. Each candle represents a mariner's soul. Gentle tides carry them north from Punta Chiappa and south from Camogli's beach until they meet in the middle of the gulf. To the Ligurian families whose life and history are inextricably bound to the Mediterranean, the Stella Maris festival is both a joyous and solemn occasion. To the delighted vacationers looking on from restaurants and cafés up and down the shore, the magical spectacle seems just another amusing event dreamed up by the local tourist board. But as long as it does not rain, the festivities always seem to have a happy ending for each of Liguria's parallel worlds.

Locals on the shore watch the tonnara with binoculars and spy glasses and prepare their menus accordingly.

Overleaf: A dry stone wall and old rural house typical of the *entroterra*.

THE *Sculpted* *Landscape*

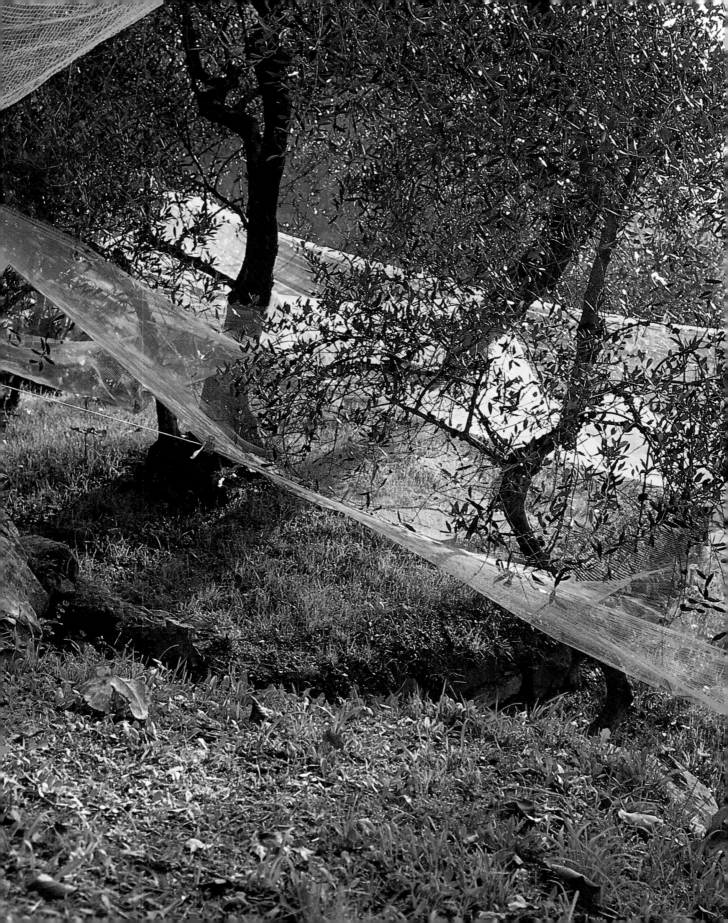

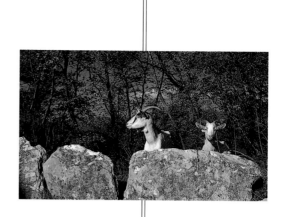

Goats graze near an ancient stone boundary marker.
Opposite: Nets suspended between olive trees catch falling fruit in the harvest season.

*O*n his sea voyages between Tuscany and Provence some six hundred and fifty years ago, Petrarch initiated the concept of picture-postcard writing. Dipping his pen into the purplish Mediterranean while marveling at the scenery around Genoa, he noted for posterity that "wherever you look you will see beautiful valleys, rushing streams, pleasingly tall mountains clothed in green, gilded houses strewn along the strand, and you will be astonished that such a city has not succumbed to the delights and beauties of its surroundings." Since then Genoa has indeed succumbed. Like the stylized bucolic backdrops of Renaissance painters, Petrarch's Riviera sketch has been retraced and embellished by lesser poets, writers and tourism promoters, becoming the archetypal view. It is a romantic's view of nature's majesty that, however accurate, does not penetrate beyond the narrow, spectacular strip of land pinched between the first range of coastal mountains and the Mediterranean—in other words, the Riviera. Even as the second millennium approaches, modern travelers rarely set foot in Petrarch's beautiful valleys, nor do they scale his pleasingly tall mountains. They only gaze at them from cruise boats and sunwashed beaches or glimpse them like subliminal cuts between train and *autostrada* tunnels. Those who do take the trouble to venture beyond the strand soon discover the unexpected complexity of Liguria's sculpted landscape, an unlikely agricultural world groomed over thousands of years into a vast, vertical garden of Mediterranean delights.

Claude Monet left the promenades of Bordighera to wander into the Sasso Valley where he was dazzled by the "diabolical colors."

No great effort is needed to reach this other Liguria. It begins where the cities and seaside resorts end, in the folds of the hills and mountains. Hike uphill half an hour from Portofino's horseshoe-shaped harbor, for example, beyond sumptuous villas turned like sunflowers toward the sea, and you stumble

Terraced olive groves.

upon weathered, one-story farmhouses chased into stone terraces. Goats graze on wild rosemary and thyme under olive and fig trees tangled with grapevines. The setting is as worthy of Homer as of Petrarch, and equally ancient, for while the Greeks, Phoenicians and Romans had their temples and villas on the coast, much older native Ligurian peoples lived in the rural hills above them. Hesiod, in the 8th century B.C., called them the people at the farthest western reach of the known world. Three centuries later Herodotus reasoned that the neighboring Etruscans had come to Italy from Lydia, while the even more ancient Ligurians were already established as sea traders, pirates and warriors.

Successive layers of civilization have been applied to this classical background, from paleo-Christian to postmodern. A further hour's hike from Portofino up winding trails lifts you past a cool, whitewashed country chapel dedicated to Saint Sebastian, then on to the 2,000-foot summit of the Monte di Portofino, where a high-tech transmitter sits on the ruins of an old lighthouse. The promontory's craggy, seaside flanks bristle with a perfumed Mediterranean scrub of rock roses, broom, strawberry trees and umbrella pines. Looking southeast you see the abrupt cliffs of the Cinque Terre; to the southwest is the slightly gentler Ponente shore from Savona to Capo Mele. Turn your attention inland, beyond the coast and the screen of centuries-old chestnut woods on the mountain's north face, and the sight-lines change dramatically. An infinite regress of Apennine ridges and valleys seemingly foreshortened for theatrical effect stretch to the horizon. Perched sanctuaries, villages and clusters of brightly colored houses cling to narrow terraces from valley floor to mountaintop. As far as the eye can see, terraces scale the steep slopes like the staircases of Titans—olive trees, vineyards, chestnuts, fruit trees, terraces covered with hothouses and cultivated flowers, terraces with kitchen gardens, grains and potatoes. Among them run chase-your-tail one-lane roads, mule tracks and footpaths that rise as steeply as ladders, ensuring residents near perfect isolation—desired or not. Shift your perspective from the Monte di Portofino to the sanctuary of Montallegro behind Rapallo or to the Monte Bignone behind San Remo, and the terraces seem to have been following you.

An estimated 25,000 miles of these terraces contour the entire region. Locals call them *fasce*, bands, perhaps because they bind the mountainsides together with stones and seem to keep them from tumbling into the sea. Each

fascia is ten to fifteen feet wide and held up by dry stone walls six to ten feet high, built by generation upon generation of *contadini*, subsistence farmers with nothing to till but this supremely untillable land. There are those who say the only good soil here was brought back by sailors in sacks and hauled up the mountains. If that is true the soil probably washed away soon after like the rolling rock in the myth of King Sysiphus. Virgil in his *Georgics* quotes the ancient saying "adsuetum malo Ligurem," meaning that Ligurians are well accustomed to hardship and toil. Indeed, the region's mountains and hills, which cover 99 percent of its territory, are a farmer's nightmare: they are steep, rocky and bone-dry in summer. Not surprisingly, from Virgil's days to the middle of this century, most practical-minded observers could only revile the "arid nakedness" and "useless pompousness" of this purely visual paradise that offered "dessert, a treat for the eyes, but no lunch."

Today a mere 10 percent of Ligurians occupy 90 percent of its land, all of it mountainous, much of it inaccessible. The beginnings of Ligurian civilization are in these mountains, for the region's natives were nomadic hunters and shepherds who preferred the interior to the coast. As you circle up the aptly named Strada Panoramica southeast of Genoa, up the nubbly flanks of the towering Monte Fasce, you are suddenly in a wilderness where stone walls snake across windswept pastures with see-forever views. Up here the world seems made of stone: stone walls, cobbled stone paths, striated rock mountains that give birth to boulders after a rain storm. "Le pietre crescono," say the country folk—the fields grow stones. Long ago, probably in the Bronze Age, the biggest, heaviest stones became the foundations of cyclopean walls, nestling in dovetailed layers. Flatter, wider stones were piled edgewise on top of them, turning the dry walls into crenelated barriers dividing up the hills.

East of the Monte Fasce, a handful of shepherds' huts—mortarless, slate-roofed— huddle in wind-protected pockets. Scattered around them are curious piles of lichen-frosted rocks erected in squares perhaps eight feet high, their centers filled with smaller rocks and chips sifted and screened from the soil. These walls, huts and piles are monuments to the back-breaking work of shepherds who over the last

A slate-roofed house perched high on a hill in the mountainous interior.

three thousand years have struggled to clear enough pastureland of stones to raise a few sheep, goats and free-ranging pigs. The first permanent settlements of the Ligurian tribes of old probably looked something like this. The ancient Romans called these primitive fortress communities *castellari*. They were always positioned in strategic locations and were filled with wooden huts which have long since disappeared.

The Romans first drove Liguria's native peoples of obscure origin down to the coast in the 3rd century B.C. and eventually brought them to heel. In 180 B.C., ten thousand Ligurians were rounded up and deported to southern Italy by the occupying Legions, an early example of what today is euphemistically called ethnic cleansing. A bronze plaque unearthed in 1506 at Isola, in the Valpolcevera valley behind Genoa, was cast in the year 117 B.C. by victorious Roman consuls who had stepped in to settle a dispute over pasture rights between the rival Genuati and Veturii tribes, whom they had subdued. By the 1st century B.C. Strabo could claim that the fierce Ligurians of the *entroterra* had finally been Romanized, though it had taken some eighty years. Augustus Caesar finished the job on the remaining section of western coast by defeating the Capillati tribe on the border of what is now France. He promptly proclaimed Liguria a Roman region and established the boundaries that correspond almost exactly to today's: the Varo River in the west, the Magra and Trebbia rivers in the east (with additional inland territories, as far north as the Po River, which are now part of Piedmont and Lombardy). Wherever you see what seems a perfect spot, with a church, monastery, villa, castle or luxury hotel on it, dig down and you will probably find something ancient underneath. A temple of Mithras lies below the church of San Giorgio in Portofino; a Roman villa provided the foundations for the San Fruttuoso abbey a

A Rough Landscape

"Montagne senza legni"—treeless mountains—is how the old gibe about Liguria's supposed wasteland interior begins. "Montagne senza legni, mare senza pesci, donne senza vergogna." Barren hills, fishless seas and shameless women—and the saying is wrong on all three counts, of course. In truth some of the region's most extraordinary, evocative scenery lies inland and is actually green most of the year. It is also a repository of things Ligurian, including cuisine and rural culture. The landscape mirrors the rough-cut character of this tiny nation: angular, impenetrable, essential.

few miles north of there and a Bronze Age *castellaro* hides in the gardens of Camogli's luxurious Cenobio dei Dogi hotel.

When the Empire fell and the barbarian invasions of the early Middle Ages began, the Romanized Ligurians who had settled on the coast fled to their mountains and started building the villages and sanctuaries that to this day crouch on crests and inaccessible peaks. These are the easily defensible natural fortresses that the Grand Tour travelers of the mid-1700s dubbed Rock Villages, because they are hewn out of the mountainsides. Dolceacqua, Baiardo and Apricale, behind Bordighera, became tourist attractions two hundred years ago among intrepid British naturalists—until the end of last century, when the disastrous earthquake of 1887 led to their almost total abandonment. On a scorching hot day it is eerily cool inside the spiraling alleys that lead to the ruined castle of the Dorias that rises above the village of Dolceacqua. This is where Rossese wine is produced, a delightful light red little known outside Liguria. As you wander down chiaroscuro lanes you stumble upon old wine barrels and in the harvest season cross rivulets of red. Just north of Dolceacqua is Apricale, a medieval village halfway up the hills. It tumbles dramatically down a crest, its houses offering key-hole views down the river valley. A few miles further northeast as the crow flies—but many times that on a serpentine road—is Baiardo. To my mind this is the most atmospheric of all the Ponente hill towns on the border with France. Set against the backdrop of the Maritime Alps at 3,000 feet above sea level, it is the very definition of isolation. Here the earthquake of 1887 struck dead a quarter of the population. The roof of the medieval church at the village's highest point, built over a pagan temple, collapsed and was left as a memorial to the victims who sought shelter inside it. A Romanesque porch still stands, with a restored baroque side-chapel, dedicated to Saint Anthony, staring at an open sky. For a century, displaced survivors and Italians from other regions have trickled back into Baiardo, Apricale and Dolceacqua. In recent years these villages have been dramatically restored and reoccupied, becoming chic summer resorts favored by the British, Dutch and Germans.

It was the millennial isolation of Liguria's mountain villages that led to the development of distinct dialects, which vary from valley to valley and from coast to interior, with particularly wide differences between the Levante, Genoa and Ponente. All derive from Latin, but they are pronounced with an inimitable accent that has allowed linguists and ethnologists to trace the vast territories of pre-Roman Liguria with remarkable precision. Customs, religious festivals and

Like his fictional characters, Calvino was ashamed of the "palm trees, casinos, hotels, villas" of the glitzy Riviera.

Caravaggio sanctuary.

cooking developed the particularities that distinguish the region even today. Many towns have their own singing teams of *canterini*, for instance, specializing in popular Italian or dialect songs of the *Trallalero* repertoire—roistering polyphonic compositions for basso profundo and falsetto voices as well as a chorus. Every village has its patron saint's day or other religious festival, too, an excuse for feasting, fireworks and a typically Ligurian procession of the immensely heavy, ornate portable crucifixes called *Cristi*, or religious sculpture groups called *casacce*. But it is cooking that highlights the amazing diversity of Liguria's inland territories: a Baiardo home cook's *marò*—boiled fish or meat topped with a sauce of crushed fava beans, garlic, fresh mint, olive oil and grated Pecorino—seems as exotic as stewed Tibetan yak to someone from Sarzana, only a few hours away on the *autostrada*.

Though this remote landscape continues to be little more than a scenic backdrop for most visitors, it has long lured intrepid travelers from the coast. Claude Monet left the promenades of Bordighera to wander into the Sasso Valley where he was dazzled by the "diabolical colors" of almond and peach trees growing amid palms and lemons and olives "in delicious harmony." A century before him, the eminently level-headed Thomas Jefferson was effusive about Liguria's olive trees and frowning peaks, and was delighted to discover that he could change the seasons at will "from summer to winter by ascending the mountains." That is a very handy trick indeed in the heat of July and August, but the region's many micro-climates, created by its pleated topography, are equally astonishing at cooler times of the year. Away from the perpetually mild coastal strip the seasons are more distinct. Clouds swirl off the sea and mist swathes the mountains and valleys. Burnt orange, yellow and ochre leaves carpet inland terraces where wild mushrooms grow under the formerly cultivated chestnut groves that for centuries supplied food, fuel and shelter to entire communities. In winter, snow dusts the pastures and broad-leaf and conifer forests only a few miles from beaches where locals play *bocce* in short sleeves and northern European vacationers bask in the sun.

The striking opposition of the sun-washed, sophisticated coast and the leafy, retiring landscape behind it has given rise over time to a dual culture. The seafaring *marinai* of Riviera villages and cities have traditionally had little intercourse with the *contadini* who work the land in their backyard. Though they may look out at the Mediterranean all their lives from their terraced aeries, older *contadini* still often do not know how to swim, rarely eat fish and cherish

their isolation. Dozens of hamlets remain accessible only on footpaths; some older residents continue to carry supplies on their head, shunning the backpacks, shopping carts and high-tech tractors favored by younger, more affluent and open-minded generations. Even many celebrated resort villages on the Levante's coast, like those of the Cinque Terre, belong to the realm of *contadini*. Since antiquity people have been growing grapes and olives on the 1,250 miles of terraces strung along the precipices between the Cinque Terre's five villages—Monterosso, Vernazza, Corniglia, Manarola and Riomaggiore. A man I met on a path above Vernazza some years ago insisted that he had never been swimming on the beach below; the woman I rented a room from overlooking the fishing port had never ventured into the surrounding vineyards and was unsure where the footpath was for Monterosso, a few miles north.

Out of season, the Cinque Terre and their knife-slit alleys seem trapped in a time warp. On the panoramic path from Volastra to Cornigilia—used only by

Gathering fallen olives in the Cinque Terre.

locals and adventurous hikers—you wind among olive groves, basil-scented kitchen gardens bounded by fig trees, and vineyards suspended over the sea, a cascade of gravity-defying dry walls. Wherever the terraces have become overgrown the dense *macchia mediterranea* takes over, a heady blend of pine, heather, broom and wild herbs. When hot days alternate with flash rainstorms this scrub emits the intoxicating scent of wildflowers, essential oils—thyme, rosemary, pine—and sea salt that drives you to drink in the air greedily. Locals scurry to gather

fallen pine nuts after each storm. Here cold is never a problem; it is the wind that dries the soil and pushes the grapevines and olive trees to their limits of resistence. Windbreaks are still made as they were a thousand years ago, with dried tree-heather that is woven together and secured to branches. Nothing is wasted: grapevine cuttings are buried under the vines as natural fertilizer. "E' il cibo delle vigne," an old woman tending her vines once told me: the food of the vines. The Cinque Terre's meticulously tended grapes are ready to harvest in September. The first olives from the trees around them ripen in November. On average, it takes seven kilos of olives—about fifteen pounds— to produce one liter of olive oil in the Cinque Terre, only a third of Tuscany's or Provence's yields. As in most of the region, the *contadini* alternate picking

olives and pruning their grapevines, so that both activities continue into December. The heather windbreaks, the green and yellow and orange nets stretched under olive trees to catch falling fruit, the dry-walled orchards and mazes of paving stones turn the mountainsides of Liguria into open-air galleries of living land-art.

A parallel history of Liguria lies beyond the coast, a history forgotten by the chroniclers of the Republic of Genoa and its heroic sailors, and largely ignored to this day. Despite the extreme isolation of inland communities and their near autonomy, they have always ultimately turned to the cities as markets for their wine, oil and labor. Medieval villages like Campoligure, Baiardo and scores of others started as redoubts but soon became way-stations on a network of salt routes served by mule trains between Ligurian ports and the plains of Lombardy and Piedmont. Some, like Varese Ligure, still have the ample porticoes that once served as night refuges for mules and their drivers and as marketplaces by day. As these villages prospered and grew they fell under the control of Genoa's powerful, authoritarian clans—the Spinola, Fieschi, Grimaldi and others—who built castles to defend against rival feudal lords and to control the local populace.

Varese Ligure is the archetype of this kind of settlement. The only way to appreciate its horseshoe-shaped, porticoed Borgo Rotondo, whose wide, tile-roofed structures lean on buttresses that fly across narrow alleys, is to see it from above, as a guard posted on top of the neighboring 5,000-foot Monte Góttero would have. Short of that you can visit the town's castle and look down at the buildings at your feet. Though at least a thousand years old, Varese Ligure took its current form in the early 13th century; the stone fortress guarding its northern end dates to a few hundred years later, when the Fieschi Counts of Lavagna made it their market fief on the road to Parma. Today the town is famous for its Tuesday produce market and is one of the great wild mushroom centers of Italy. Half a dozen upscale food shops on the main road flanking the Borgo Rotondo specialize in them. Across the way, on the north side of the village, mushroom hunters deposit their sacks of pungent porcini in tiny green-grocers' shops hidden down narrow streets. On November 11, San Martino's feast day, the town hosts a sort of Renaissance food fair, with fresh, dried and pickled porcini; local cheeses made from cow, sheep and goat's milk; and game, especially hare and wild boar.

Long before Columbus sailed to America and opened new markets to the Europeans, the ambitious country folk of strongholds like Varese Ligure left to seek their fortunes in Genoa, Chiavari, Savona and a dozen other coastal

cities offering a modicum of freedom from feudal overlords. Many of these migrants were not only farmers but also skilled artisans and masons. During the Republic of Genoa's Golden Age in the 16th and early 17th centuries, they helped build the villas of the merchant princes, and the corkscrew roads and humpback bridges that stitched together the region for the first time in a thousand years. Before then, it had been impossible to cross Liguria by road since the fall of the Roman Empire and the ruin of the original Via Aurelia coast highway, completed under Augustus Ceasar to link Rome to Gaul. While Admiral Andrea Doria was busy freeing the Republic from the French yoke and ensuring the prosperity of its bankers and merchants for a century to come, new techniques in olive tree growing and oil production led to an agricultural boom that repopulated Liguria's *entroterra* for the first time since the Middle Ages. The cycle of boom and bust that saw Genoa become the richest city in Europe, only to collapse into a centuries-long depression from the 1630s to the mid-1800s, had similar effects on the countryside. Roads washed out, bridges collapsed

Literary Liguria

This is the rural, seaside world that forged Liguria's greatest poet, Eugenio Montale, who as a youth spent his summers before the First World War at Fegina, part of Monterosso. When Anders Österling backed Montale for the 1975 Nobel Prize he commented that his "lyrical style has absorbed a lasting character that seems drawn from the severe outlines of the Ligurian coast, with a stormy sea that crashes against sheer rock bastions." For Montale, the area's endless stone walls, hidden gardens and false ridges—hiding hermetic, unknowable secrets—became a metaphor for the human condition.

This harsh and beautiful landscape also produced the wiry prose of Italo Calvino, who grew up in the twenties and thirties behind San Remo, on the Riviera di Ponente. The clash of coastal and inland civilizations seemed to Calvino to mirror an age in which industry, tourism and commercial flower-growing were gradually stifling the agricultural livelihoods of his ancestors. *Ubago* is the dialect word Calvino used to describe this dark hinterland turned north, away from the Mediterranean sun. "I write from the depths of the opaque," he confessed with undisguised contempt for the Riviera. Like his fictional characters, Calvino was ashamed of the "palm trees, casinos, hotels, villas" of the glitzy Riviera and fled from the narrow alleys of old San Remo up through the geometrical fields of carnations engulfing the old terraces, then further up through stands of pine trees. Beyond them lay the safety of the chestnut woods. Seen from them, the glinting, glaring sea seemed a mere "stripe between the two green wings" of the surrounding hills.

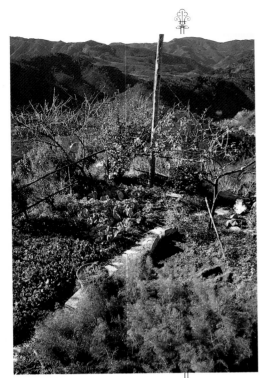

A suspended kitchen garden at hilltop Cornice.
Opposite: Looking inland across rocky pastures from the "Panoramic Road" in springtime.

again and the *entroterra* gradually reverted to its former isolation. In his 1765 *Travels*, Tobias George Smollett complained that the Via Aurelia had disappeared under landslides and ascribed this to the "abject, self-serving and absurd policy" of Genoese merchant-princes who would do anything to maintain the populace "in poverty and subjugation."

Whether or not such a conspiratorial policy of oppression existed, the region's roads were not substantially improved until the unification of Italy, and again in the 1930s. Older people will tell you of the difficulties of inland travel as recently as the 1940s, when the famous brigands of the Passo del Bracco south of Sestri Levante regularly waylaid motorists. By the time the Ligurian interior had finally become passable by car and truck in all seasons, the modern exodus of the rural population to the coast—where jobs in tourism and industry beckoned—seemed irreversible. This was the world Italo Calvino evoked in his fiction, a world inhabited only by aged holdouts—farmers, woodcutters, artisans—who had "turned to stone," seemingly absorbed into the walls of the terraces and houses they were destined never to leave.

Though tourism and industry began making a mark on the region more than a century ago, some remote Ligurian villages and their inhabitants seem petrified to this day. In Lorsica, a thousand feet above the Val Fontanabuona behind Chiavari, you feel you have reached the back of beyond. The local trattoria serves wild boar from the impenetrable woods around this ancient settlement of six hundred souls. The only sound in the armspan-wide main street is the swish and clack of an old loom, muffled by thick stone walls. Once upon a time there were hundreds of looms in Lorsica but now there are two, both wedged into a centuries-old workshop. Weaver Ameglia De Martini was born here and has worked here all her life, from dawn to dusk, turning out about six yards of silk or cotton damask a day, six days a week. She won't give her age but her father was born here in 1872, so she probably saw the turn of the last century. Yet she has rarely descended to the coast and has never crossed to the other side of her valley, let alone trudged up the steep, rocky path to the Apennine pastures another thousand feet above her village.

In the sawtoothed mountains surrounding Lorsica, slate quarrying has been the main industry since the Middle Ages. The landscape is riddled with

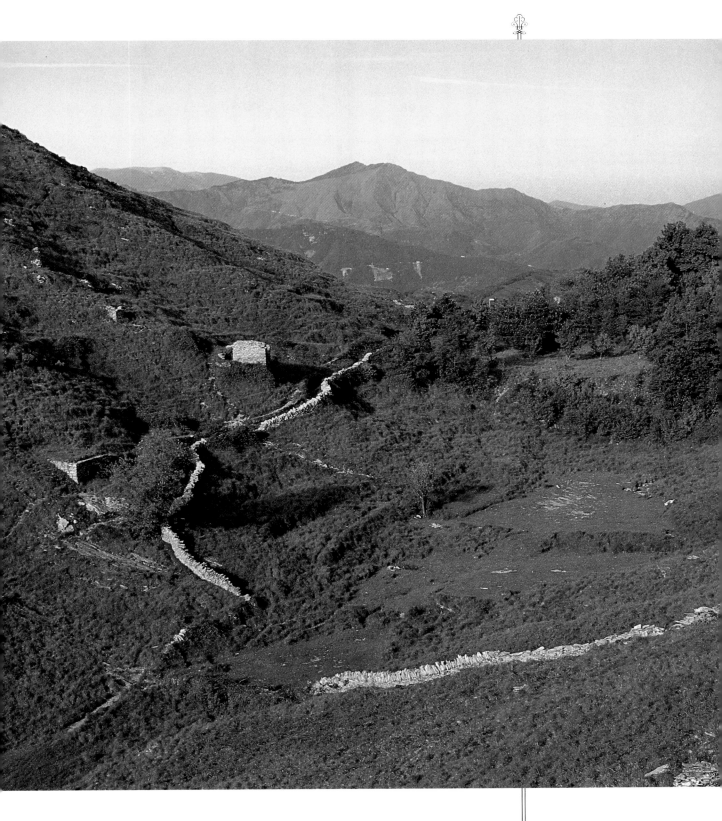

caverns and tunnels; forest roads are littered with slate leavings around which the roots of trees have knotted, and houses built with these discards blend into the hills. In recent years, a good number of the pool tables and blackboards of the world have come from here, as well as the traditional roof tiles, lintels, steps and door frames that have fitted out the entire region since time immemorial. Dynamite, saws and bulldozers are now the tools of the trade, but in the days before the postwar economic boom the brittle gray stone was still chipped out by hand in layers. Women, who were stronger, more sure-footed and cheaper to employ than mules, carried the slabs on their heads to the docks at Lavagna, miles below on the coast.

On Lorsica's main street, set above a mailbox, a roughly carved stone head stares with a startled expression at passersby. Heads like this one scattered around the *entroterra* are called *teste antropomorfiche*, grotesques with human faces whose task it is to ward off evil spirits. At Groppo di Sesta Godàno, north of Lorsica and no more than ten miles inland from the Cinque Terre, similar sculpted heads protect an ancient stone building attached to the village church. Though most Ligurians, especially those in the *entroterra*, are devout Catholics, features of paganism and Christianity survive side by side. Churches stand over temples, and pagan feasts have been reclaimed as saints' days and holidays. Talk to a *contadino* in these remote areas and you will discover that the phases of the moon are followed religiously. When it waxes, sow seeds and cut grass so it will grow back quickly; when it wanes, cut trees and shrubs and harvest fruit, grains and potatoes so that they last longer in storage. In the Middle Ages the Church thought these were pagan, diabolical rites and fought to root them out, yet they have remained a part of daily life in Liguria.

Anachronistic curiosities aside, the wealth of recent decades has revolutionized the lives of most of these rural people as well as the landscape itself. Farming has found forms of expression that extend beyond olive trees and grapevines. Specialty vegetables and herbs are one, nurseries another. Behind San Remo and its Riviera dei Fiori rise hundreds, perhaps thousands, of hothouses glinting in the year-round sun. Through the white-washed glaze you catch glimpses of roses, peonies, lemon and orange trees, lilies, orchids, hydrangeas, jasmine, bougainvillea and a thousand other flowering or green plants that are grown here and shipped around the world. In spring, poppies grown for their seeds paint the landscape with a kaleidoscope of colors. Among the terraces, escapees from the hothouses thrive in the open air, a free-form flower show.

Just as in Provence, dozens of once-abandoned Ligurian villages have sprung back to life. Follow the meandering Vara River along its dramatic gorge upstream from La Spezia and double back at the confluence of a mountain stream where a road just wide enough for a small car leads to the village of Cornice. As you make your way up through the lush chestnut woods veined with the paths of mushroom hunters, ever more tantalizing views appear through the branches. After what seems an interminable climb the road ends. The village is silent save for the rushing Vara and Malacqua rivers twelve hundred feet below. Walk through a stone tunnel into a warren of alleys lined with weathered wooden doors and suddenly you hear cows mooing in barns hewn from the mountainside. An elderly farmer appears from a cavern, carrying a shovel and basket and heads to his "hanging garden." In Cornice that means a kitchen-garden terrace the size of a handkerchief on the edge of a sheer drop into the river valley. Some of the houses are empty, others are being restored and many have already been transformed into luxurious holiday homes. Today younger generations who have made good in Genoa or La Spezia are returning to family homes which have become desirable commuter bases, or weekend retreats.

In many remote areas, including the Cinque Terre, new technology and the renewed consumer interest in quality food and wine are reviving the landscape. The vintners of Corniglia and Vernazza, for example, use miniature monorails to shuttle up and down their terraces, making their job less quaint but more economically feasible. From the Tuscan border to the French frontier, new or replanted vineyards are producing excellent wines and for the first time in decades Ligurian olive oil is winning back its reputation as among the world's best. The new Ligurian *contadino* seems to have realized at last that the heritage left to him by his ancestors can be not only safe-guarded but also built upon, reversing the process of rural abandonment that began more than a hundred years ago. Still, as the 21st century dawns, the only way to begin to understand this singular, sculpted landscape and its inhabitants is to venture beyond the Riviera's beaches and, as Eugenio Montale put it, "clamber up like goats among the terraced vineyards stepped over the sea."

An elderly woman climbs a shady path between mossy dry walls.
Overleaf: The city of Genoa seen from the loggia of the d'Albertis castle, with the port and *lanterna* as backdrop.

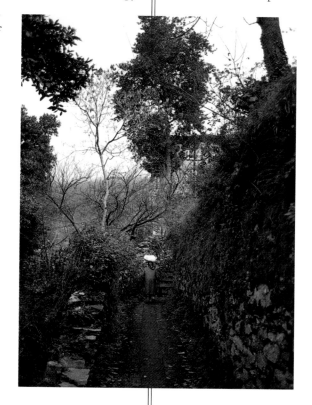

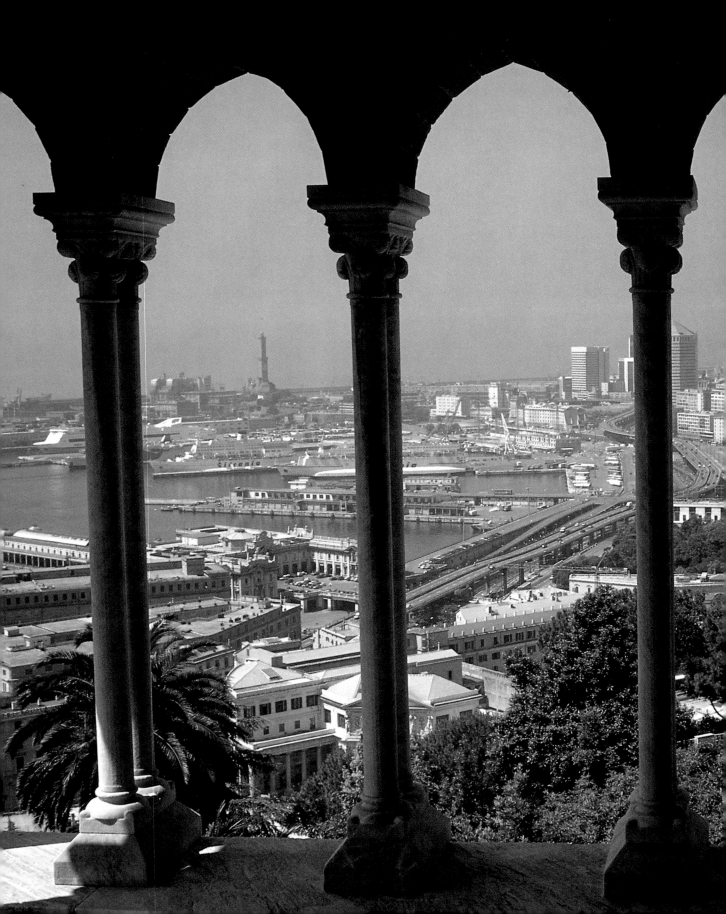

GENOA AND THE REPUBLIC

The Romanesque bell-tower of old Genoa's Nostra Signora delle Vigne church. *Opposite:* The main staircase of the d'Albertis Castle.

he fancy of architects and randomness of nature mean that some cities make sense only when seen from the air while others offer stunning street-level perspectives. To understand Genoa you must approach it not by airplane, or via the train and car tunnels linking it to the interior and Riviera. You must come instead by ship, as its visitors have for the last 2,500 years. From a distance, Liguria's capital, a city of three-quarters of a million, seems a modern port like many others. Cranes and freighters and warehouses give way to layers of residential buildings; a handful of high-rise towers punctuate the slate-roofed skyline while freeways curl along the shore and the steep hills behind. As you enter the sprawling harbor, however, you begin to get a better sense of Genoa's singular cityscape: an experiment in verticality, stacked and teetering on tiers caught between the Mediterranean and an amphitheater of castle-crowned mountain peaks 2,000 feet high.

Herman Melville likened this setting to Satan's fortified encampment. It has always seemed much more benign to me, an opera set with dramatic decors secured at improbable angles—but always for the delectation of those arriving by sea. Looking up from the inner harbor you clearly see the theatricality of the gaily painted house-towers pressed against stern churches amid a crazy jumble of architecture spanning the last millennium, from soldier-of-God Romanesque to the latest variations on high-tech. This is Renzo Piano's home town, after all, and the architect of the Pompidou Center in Paris has been eager to leave his mark: the ultramodern, hugely popular

"It abounds in the strangest contrasts. Things that are picturesque, ugly, mean, magnificent, delightful, and offensive, break upon the view at every turn."

CHARLES DICKENS

aquarium and spiderlike Bigo, a crane with a panoramic terrace, are his, for example. Follow the crowds out of the renovated Porto Antico, a tourist wharf, under the 1960s elevated highway into Genoa's *carruggi*—a warren of narrow alleys an armspan wide—and you will have entered Europe's largest and most densely populated medieval city. These serpentine streets seemingly quarried from the mountainside are the probable birthplace of Christopher Columbus, the seat of the world's first modern bank and the home, for the last eight centuries, of some of Italy's wealthiest families. Once inside the *carruggi* you wind your way through manmade gorges almost always out of sight, but not smell, of the sea. Above and around old Genoa rises the city of recent centuries, under which car and train tunnels bore through solid bedrock. Huge municipal passenger elevators with entrances disguised as those of ordinary buildings rise from low-lying sidewalks to the ramparts above. Bright red *funicolari* scale daunting grades to peaks such as Righi, from which you can view this extraordinary cascade of urbanism.

> "*It is an introverted city, a secret city, a prudent city*"
> RENZO PIANO

A city whose secrets must be savored slowly, discovered and uncovered a day at a time, Genoa remains a rough-and-ready working port in the age of tourism. Beyond the Porto Antico and its canned music there are few sun-burned postcard sellers or souvenir shops. Restaurants do not advertise *menu turistico* in four languages; some do not even post them in Italian, preferring Genoese. The small, cluttered shops and longshoremen's trattorie of the arcaded Sottoripa, for instance, a street directly across from the Porto Antico, have been around for about eight hundred years and seem frozen in a pre-industrial time warp. When I first visited in 1976, drawn by family history and curiosity about Columbus, much of Genoa's vast old town looked like a work by the artist Christo, swaddled in the green netting used to catch falling masonry. I could not find an up-to-date map; the tourist office's brochures were decades old. "Nothing has changed," I was told, "so why bother to change the brochures?" This made perfect sense to me. My quest to find the city of Columbus, however, quickly turned to farce. The square, statue and street bearing his name were smog-blackened and undistinguished. The reliquary at city hall that supposedly holds his ashes was firmly locked away (Paganini's violin was proffered instead). The Casa di Colombo was an unlikely ivy-clad pile of bricks near the 12th-century city gate, the Porta Soprana. The explorer reportedly spent his childhood here, toiling alongside his father, Domenico, a weaver, but Columbus could not possibly have lived here. I soon discovered the truth: In the early 1890s, with the 400th anniversary celebrations of Columbus'

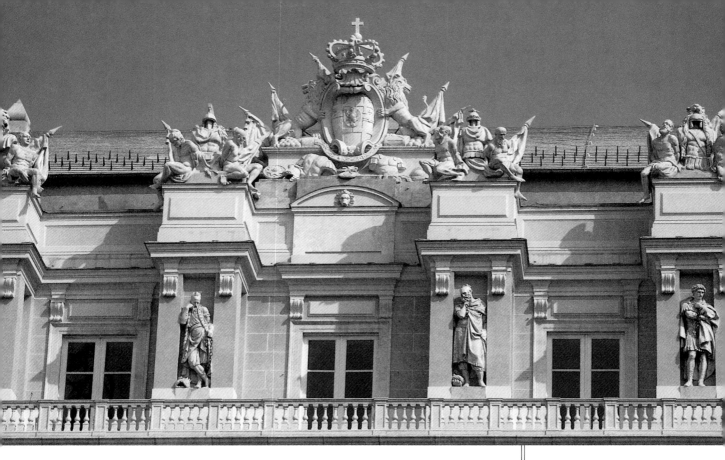

voyage to America in mind, wily city fathers fell upon this early-18th-century hovel and dubbed it Columbus'.

Detail of the Palazzo Ducale.

The 500th Anniversary Expo of 1992 marked a turning point in Genoa's recent history. In 1990 the Italian government finally began the $4 billion building and restoration projects that have transformed formerly blighted neighborhoods into showcases of urban renewal. Of course the statue, street and square honoring Cristoforo Colombo were quickly scrubbed and repaired, but the improvements have gone far beyond that. An enduring cliché has it that the Genoese are the Scots of the Mediterranean and, as architect Renzo Piano put it, "With the genial tight-fistedness typical of Genoa the city has used the Expo to get someone else to pay for the reclamation of the port." High-tech industry has gradually supplanted obsolete steel works, and Fiat has completed an automated container port in the western suburb of Voltri. The customs barrier that for centuries isolated the Porto Antico was also removed, uniting the waterfront with the historic center of town. Most striking of all, perhaps, the colorful facades of many medieval buildings have emerged from the grime of neglect, including the thousand-year-old Palazzo Ducale, for centuries the seat of Genoa's Doge. Even the handsome, neoclassical Carlo Felice opera house, silenced in 1943 by RAF

Christopher Columbus

Like many a visitor from the New World, I was surprised by the Genoeses' lack of sympathy for their most famous son. They do not even have a grade-school jingle by which they can remember the date of his first voyage. Sixteen years after my own discovery of Genoa, when the 500th Anniversary Columbus International Expo finally came around in 1992, the indifferent Genoese greeted it with a philosophical shrug. By then I understood why. Columbus and La Superba, as the haughty Republic of Genoa was known in the navigator's day, had little in common. He sailed away a young man, blundered upon America while flying the Spanish flag and died abroad.

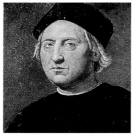

A contemporary portrait of Cristoforo Colombo by Ridolfo del Ghirlandaio, at the Naval Museum of Pegli.

Columbus was far from the first, and would not be the last Genoese explorer, to seek a foreign sponsor. Locals are just as likely to know that Ugolino and Vadino Vivaldi sailed past the Columns of Hercules (Gibraltar) in 1291, circumnavigated Africa and probably reached India, though they never returned; that Emanuele da Passano became an admiral of Dionysus of Portugal in 1317; that fourteen years later Nicoloso da Recco claimed the Canary Islands and the Azores for Dionysus' successor, Alphonso IV; or that Antoniotto Usodimare performed a similar service for Prince Henry the Navigator, acquiring the Cabo Verde islands in 1456. Seen in this light, Columbus' now-controversial exploit was the result of a natural progression of exploration of the kind that had characterized this maritime nation's history from its beginning.

bombs, raised its curtain fifty years later to a wildly enthusiastic public and is now vying for customers with Milan's La Scala.

The most important and gratifying change of all, however, has been psychological. Famously retiring, the Genoese seem finally to have awakened from decades of fitful slumber. Though they would never say so themselves, it is not too much to speak of a renaissance, the latest in a long series marking the city's tumultuous past. As Jules Michelet wrote in 1854, "The history of Genoa is singular and full of grand events to the point of excess. It is as uneven as her territory, a constant up and down." That turbulent history, taken with the topography and cityscape of stone, have forged the Genoese character. A Latin inscription on the crenelated Porta Soprana city gate has provided insight into the origins of the locals' mind-set since it was chiseled there in 1155: "I am full of strong-willed men," it warns, "and surrounded by strong walls." The city's natural bastion of mountains has been reinforced over the last thousand years by concentric sets of walls and gates, making Genoa seem like an oyster jealously guarding its pearl. Something of this siege mentality survives today

among Genoa's older, patrician citizens. "Closed, retiring, rich in Englishness," says one of the city's foremost novelists, Nico Orengo, of his fellows, meaning that privacy and discretion are valued highly. While Milan bills itself as dynamic and cosmopolitan, and Rome boasts of its *dolce far niente* lifestyle, Genoa maintains a clear sense of identity and separateness. Over the years it has successfully resisted attempts at gentrification or quantification, which is precisely why I find it so compelling. "It is an introverted city, a secret city, a prudent city and it's not clear whether it was the character of the Genoese that made the city the way it is, or if it was Genoa that shaped the character of its inhabitants," says Renzo Piano. "At any rate they are made for each other." Nevertheless, the young Genoese I know are as happy-go-lucky, hospitable and adventurous as other Italians their age, and make an art of enjoying their Mediterranean city's pleasures: an enviable climate, delicious food and the Riviera in their front yard.

"It abounds in the strangest contrasts," wrote Charles Dickens in his 1846 *Pictures from Italy*. "Things that are picturesque, ugly, mean, magnificent, delightful, and offensive, break upon the view at every turn." Surprisingly little has changed since Dickens' day within Genoa's 12th-century bastions, between the Porta Soprana and the Principe train station. Imposing stone buildings nearly a thousand years old shoot up seven, eight or even nine stories over a puzzle of streets. Near the Porta Soprana a knife grinder sharpens scissors on a pedal-powered grinder in a cupboard-sized shop. In a marble-lined *triperia* a butcher drapes milk-white strips of tripe from huge steel hooks. Behind city hall, at the height of day, down dark passageways, prostitutes hang out crude lamps to attract passing sailors.

The famously laundry-strung *carruggi* are shady and cool even on a summer's day. Pots of pale basil balance on window sills, reaching toward slits of blue sky framed by eaves far above. "Oh, the sun will be here next month, at about noon," a cheerful shopkeeper once told me as I noticed the play of light on a marble tabernacle high on a wall. It was here, perhaps, that Dickens had his "feverish and bewildered vision of saints and virgins' shrines at the street corners, of always going up hill, and yet seeing every other street and passage going higher up."

A greengrocer's shop in the *carruggi*; the building is a blend of architectural styles, with a Renaissance portal and filled-in arches.

Top: Piazza Banchi, where banking got its name.
Above: Shrine of John the Baptist, the patron saint of Genoa, with the Genoese flag.

Cars cannot enter this realm, a landlocked Venice, and the silence is striking. The squares, however, teem with activity, even the smallest of them, like the Piazza Banchi near the port, where banking got its name. In the Middle Ages money changers and shipping brokers each had their *banco* here, a simple wooden bench. Nowadays on this square booksellers hawk everything from leather-bound first editions to comic books. On half a dozen squares like it scattered throughout the *carruggi* hardware and clothing stands flank vegetable and fishmongers' stalls in merry confusion. Fragrant basil, tiny tender artichokes and varieties of baby lettuces tumble from one stand, while next door a live octopus stretches its tentacles toward heaps of the tiny *bianchetti* fish favored by locals. In wider lanes, such as the Via San Luca, immigrants do a brisk trade in fake Gucci and Louis Vuitton bags. Around the corner in the perennially fashionable Via Luccoli, designer boutiques sell the real thing to well-heeled Genoese who stop to sip aperitifs in the Kleinguti and similar centuries-old cafés.

This is the Genoa of the Genoese, a city populated by the flotsam and jetsam of the seven seas—and by the cream of polite society, who continue to live and work in magnificent palaces secreted behind discreet facades. Here are the homes of the Doria, Spinola, Cattaneo, Adorno, Pallavicino and a dozen other merchant, banking and seafaring clans who have shaped the history of Genoa for centuries. One branch alone of one of these families reportedly owns a thousand properties in the city, nearly half the real estate in Brasil and has holdings in South America so vast that it takes four hours to tour them by airplane. Other clans of less ancient residence, like that of art patron Luca Lanzalone, or the Fera family of architects, have moved into the *carruggi* to restore and animate neighborhoods that had slipped into decay.

\mathcal{P}erhaps nowhere else in the world is history written so literally in stone, an architectural record open for those who know how to read it. Genoa's towers, palazzi and especially its churches offer scores of Latin or Italian historical inscriptions, such as the 1307 carving on the nave of the Cathedral of San Lorenzo. It claims that Genoa was founded by Janus, Prince of Troy, in the time of Abraham. Fantasies aside, Genoa is certainly a venerable city: archaeological finds under the Via XX Settembre downtown date to the 5th century B.C., a respectably ancient pedigree even by Italian standards. No historian has yet determined if it was the Phoenicians, Greeks or Etruscans who laid the city's foundation stone and we will probably never be sure. In any case indigenous, pre-Indo-European Ligurian tribes like the Genuati, who gave the city its name, lived here thousands of years

An auction house
on the 16th-century
Palazzo Imperiale's
ground floor.

before the city was actually established. Unlike many Italian cities, however, there are few immediately visible signs of the pre-Christian era. Genoa's core is that of a medieval city built from the quarried ruins of ancient Rome, then studded with mannerist and baroque jewels. The buildings themselves speak volumes about the Genoese. Frescoed facades of palatial town houses rear up between weathered tenements. Bits of ancient sarcophagi pilfered during foreign conquest jut from massive walls. In dizzying succession, fluted Roman columns support medieval arcades fitted with Renaissance portals, surmounted by mannerist loggias and crowned by stories added over the last three centuries. Carved black stone lintels and decorative panels frame the doorways, many of them depicting the city's patron, Saint George, slaying the dragon. Most bear dates from the glorious days of the 16th century, when Andrea Doria liberated Genoa from the French. Only the Republic's great patriotic families like the Dorias were allowed these portals of Saint George.

Each medieval clan had an autonomous quarter in the *carruggi*, called a *borghetto* or *consorteria*, with its own church, square, loggia and house-towers built to withstand siege. The della Volta and della Corte families, for example, attacked each other time and again with catapults and battering rams. These fortified towers grew so tall that in 1197 their height was curbed to eighty feet, in hopes of calming civil strife. As Genoese architect Stefano Fera notes, while the buildings of other European capitals were but a few stories high and often half-timbered until the 1600s, Genoa's imposing stone high-rises gave it the skyline of a medieval Manhattan. The Doria family *borghetto* is the best preserved

of the city's medieval clan quarters. You can still walk into the family's cloister and church, San Matteo, in whose crypt Andrea Doria's tomb lies, then cross the square and gaze up at the loggias and house-towers of lesser heroes like Branca, Domenicaccio and Lamba Doria. The *borghetto* is built with alternating layers of local black pietra di promontorio sandstone and white marble shipped from Tuscany or Sardinia. These stripes were once a sign of wealth, nobility or—ostensibly—religious fervor, their owners having participated in the Crusades. Now they lend distinction to the apartments of wealthy tenants, and a caché of chic to the offices of professionals such as Renzo Piano, whose central Genoa headquarters are here.

San Lorenzo, Genoa's cathedral, looms up on a rise a few hundred yards from Piazza San Matteo. Unlike most Italian cathedrals it boasts no great piazza of its own. You see it only when you are standing directly in front of its facade. The fierce stone lions abreast its staircase stare into a small square where traffic cops ticket illegally parked cars. Typically Genoese, the cathedral was cobbled with supreme frugality from recycled materials and reshaped so many times over the centuries that a series of Romanesque arches ended up above the younger, Gothic nave. Since the Crusades, travelers' tales and guidebooks have billed the ashes of Saint John the Baptist and the Sacro Catino (supposedly the emerald vessel given by Solomon to Sheba, from which Christ drank at the Last Supper) as the cathedral's greatest treasures. A cantankerous John Ruskin, though, writing in his 1840 diary, scorned the chalice, calling it "a miserable fake made of glass." Perhaps Ruskin missed the point; but then, he loved Venice, Genoa's long-time foe, and does not seem to have had much enthusiasm for La Superba. The Ruskins of history have unwittingly helped San Lorenzo maintain the unself-conscious bearing of a simple parish church. The relic many Genoese seem to esteem above others, in fact, is the yard-long British naval artillery shell that crashed through the cathedral's walls on February 9, 1941, but miraculously did not explode.

As the *carruggi*'s jumble of stones attests, history has given Genoa quite a ride. Between "the time of Abraham" and the beginning of the Empire, the Romans managed to subdue the fierce Genuati and turn them against neighboring Ligurian tribes who

Below and opposite:
San Lorenzo Cathedral.

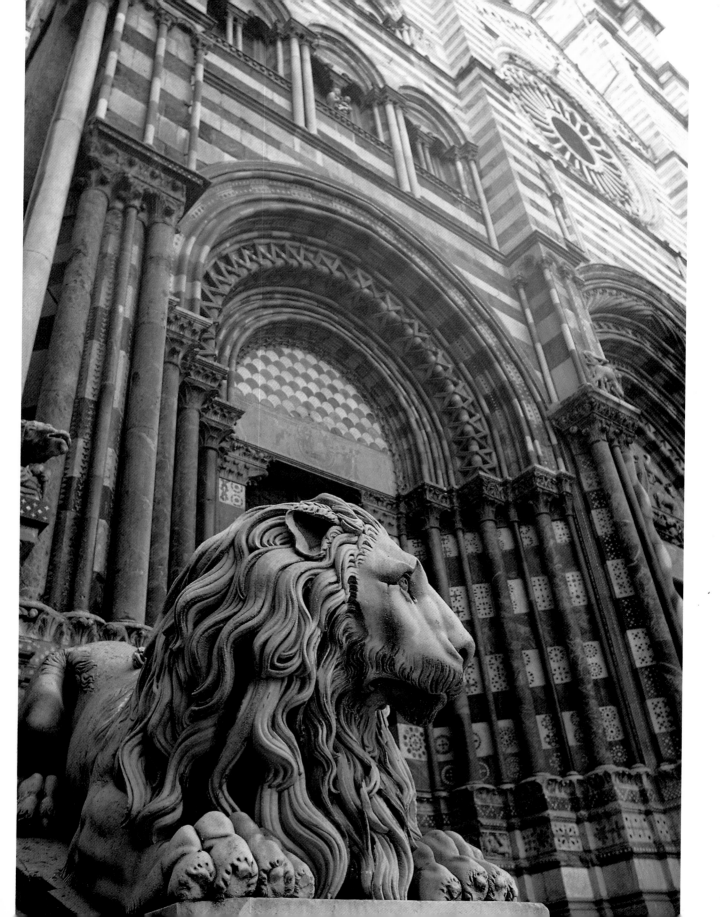

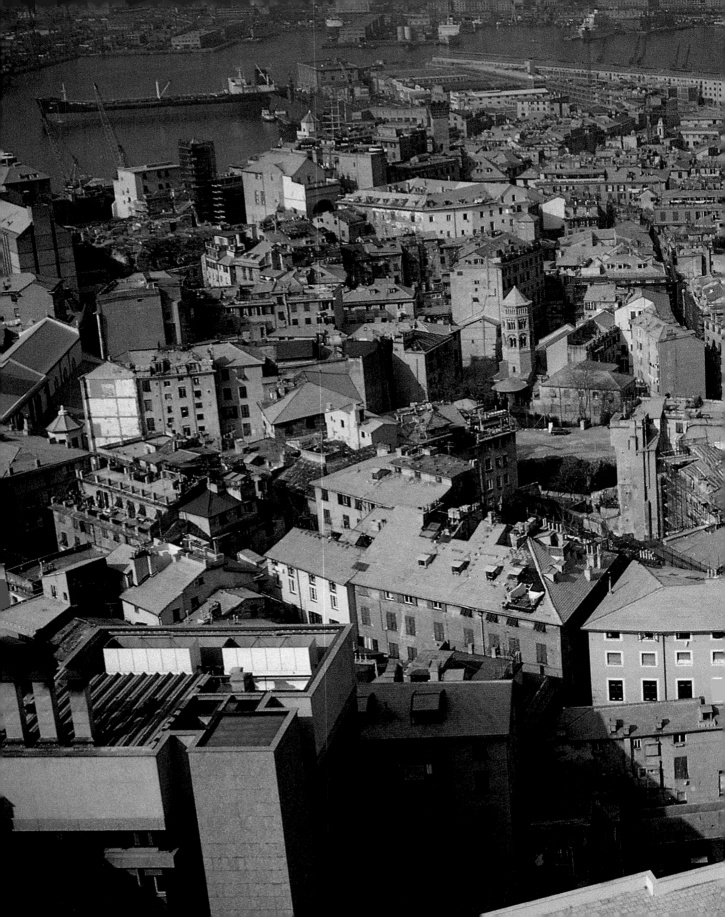

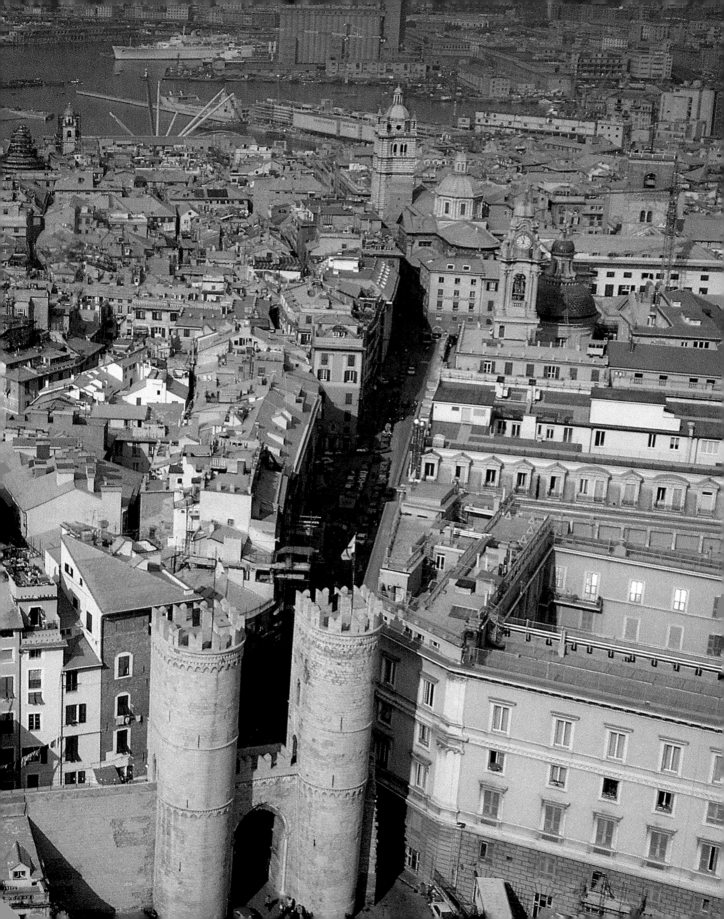

had allied themselves with Hannibal during the Punic Wars. As a result Roman Genoa was promptly razed by Hannibal's forces. Rebuilt, the city became a prosperous *emporium*, a trading post and warehousing port on the crossroads to the Lombard plain. Little is known of Roman Genoa, other than the fact that it produced excellent olive oil and wine and was surrounded by indomitable natives who continued to wage guerrilla war on the Legions for centuries. In the early Christian era came the invasions that devastated the Italian peninsula as a whole. A few particularly disastrous assaults are worth mentioning, starting with that of Theodoric and the Goths in 538, followed by Alberic and the Lombards in 588, Rotharis and his hordes in 670, the Franks in 774 and the Saracens of North Africa in 936.

In short, this idyllic Mediterranean settlement was pillaged, burned and rebuilt repeatedly before its heyday in the late Middle Ages began. By the first millennium, Genoa, like Venice, had become an independent maritime city-state, recognized as a Commune by the Holy Roman Emperor and ruled by an oligarchy. Its history would mirror that of its ancient foe: the Middle Ages for both the Serenissima Repubblica and La Superba were bloody indeed. The Genoese Commune's savage war with Pisa lasted two centuries, from 1070 until the sea battle of Meloria in 1284 that turned Pisa into the provincial backwater it has remained ever since. The Crusades brought the Genoese tidy profits. At the Commenda di Pré, a church and hostel still standing near the seafront, industrious friars accommodated the faithful on their way to the Holy Land, including Godfrey de Bouillon, who left in 1099 joined by thousands of zealous Genoese volunteers. One of them, Guiglielmo Embriaco, built the siege tower that allowed the crusaders to enter Jerusalem and establish a beachhead. As a reward to the Embriaco clan their house-tower was allowed to remain taller than any left standing in Genoa after the 1197 edict. It still raises a crenelated head above the city's oldest church, Santa Maria di Castello, where the family had its clan quarters. *Castello*, by the way, was the vulgate name for the Roman *castrum*, the city's first known fortress-neighborhood, which was scavenged in the Middle Ages to construct the buildings in the center of town.

From the Holy Land the Genoese gospel of trade spread with almost religious fervor across the eastern Mediterranean and into the Black and Caspian Seas. Because it was prevented from expanding inland by Milan, Turin and France, and unlike Venice had no *terra firma* of its own to develop, the Commune directed its economic and military might toward continual foreign conquest. By the early 1200s Genoa was simultaneously battling Venice, Pisa,

Preceding pages:
The medieval center of Genoa and the Porta Soprana.

ᴇNCHANTED ℒIGURIA

Marseilles, Provence, the Saracens and the Sultan of Egypt. Perhaps even more than Pisa, Venice became the redoubtable object of hatred; when the Venetians destroyed the Genoese stronghold at Tyre in 1251 and shipped the stones back to the lagoon city as war trophies, the rivalry reached new heights. Fifteen years after this offense, the Genoese took the Venetian fortress of Pantocratore, tore it apart, freighted it to Genoa in swift galleys and incorporated its stones and decorative lions' heads into the Palazzo del Capitano, at the time their seat of government, later renamed the Palazzo San Giorgio. Contrary to common belief, it was not in the dungeons of this pile that Marco Polo cooled his heels, a Venetian surrounded by Venetian stones (a plaque to this effect on the building perpetuates this erroneous claim). Even Jean Cocteau, punning in his 1954 *Clair Obscur*, thought Polo had been imprisoned here: "Dans la prison de Gênes / Marco faisait le point / Or la vérité gêne / On ne l'y croyait point." Polo in fact was locked up in a tower, the Palazzo Criminale, which is now part of the Palazzo Ducale and houses Genoa's archives. At any rate Cocteau was right in that the Genoese did not believe Marco Polo's tale then and do not believe it now. They had colonies in China two generations before Polo's voyage and are convinced that they, not the cooks of the Khan of the Tatars, invented the pasta that Polo described.

The Palazzo del Capitano became the Palazzo San Giorgio in 1408 and remained the headquarters of the Banco di San Giorgio—Europe's first bank—until 1814. The bank essentially ran the Republic of Genoa, its colonies and much of Europe with the well-oiled efficiency that was woefully absent in state affairs. Having survived seven hundred years of warfare and strife, the palazzo was heavily damaged during the Second World War. It has taken the work of several generations to re-create the leaded windows and heavy timbers of the oldest brick wing, as well as the 1571 Renaissance Grand Hall, with its evocative, half-ruined statues of the "Protectors of the Republic," among them the Dorias, Spinolas and Grimaldis. The lions' heads of Saint Mark, Venice's patron saint, remain as trophies, though the rivalry between the cities ceased long ago.

The Genoese Commune's medieval war-mongering was not limited to colonial ventures on distant shores, for it was constantly forced to quell rebellions along the Ligurian coast, which it dominated with startling brutality beginning in the 9th century. Not surprisingly, this oppression led many Ligurians to resent the Genoese and their economic hegemony, and some still do. To give only the egregious example of Savona, the great domestic nemesis, Genoa attacked and subdued it in 1153, 1170, 1202, 1227, 1241, 1255, 1317, 1332,

1397 and 1440. When in 1527 Savona struck a deal with the French to crush Genoa, the Genoese, led by Andrea Doria, retaliated mercilessly the following year, filling in Savona's harbor, destroying its fortresses and decimating its treasonous inhabitants. Savona has never recovered.

When they weren't fighting enemies near or far, La Superba's rival Guelf and Ghibelline factions were slaughtering each other at home. In the year 1190, a Genoese hereditary aristocracy was created for the first time within the Commune. As historian Robert W. Carden noted a century ago, "Probably since the day when Ephraimite lips refused to pronounce the Shibboleth of Gilead no single word in any language has brought so much shame, bloodshed and disaster to a nation as *Noble* brought to the Genoese." The newly formed nobility split into Guelfs, aligned with the Pope and represented in Genoa by the Fieschi and Grimaldi clans, while opposite them and plumping for the emperor were the Ghibellines, whose most illustrious families were the Spinolas and Dorias. Of

Admiral Andrea Doria

Genoa's true hero is not the peripatetic Christopher Columbus but rather the late-Renaissance Admiral Andrea Doria, who liberated the Republic from despised France, came to a clever compromise with the Spanish emperor Charles V and ruled until he died at the age of ninety-three. To the Genoese Doria is Napoleon, Washington and Garibaldi rolled into one. The admiral's extraordinary life could fill several reels of swashbuckling drama. Not only did he command Charles V's vast fleet, he also ensured that Genoa's incredibly rich banking families would continue to underwrite Spain's huge imperial debt. Reading between the lines, he was what modern commentators might call a pirate and a pawn of usurers. To maintain profitable peace within the fractious Republic he devised

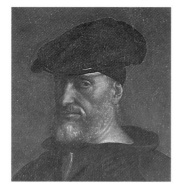

a complex system of checks and balances with senators, governors, procurators, supremos and a censor. Nominated censor for life and given the title "Father and Liberator of his Country," Doria became an enlightened autocrat: the emperor gave him the title of Prince, and the prince immediately banned noble titles and declared everyone an equal citizen. Henceforth only twenty-eight clans of *nobili cittadini* with approved surnames could exist, with all members having the same rank. This bureaucratic legerdemain simply gave rise to an infinity of double-barreled names adopted by those outside the twenty-eight clans, names you may encounter to this day in Genoa's beau monde.

course, both factions switched loyalties continually and played off each other when convenient. Eventually, in an attempt to extinguish the smoldering civil war, a doge was elected (in imitation of Venice) and the Commune was supplanted by a semi-democratic Republic. Though it was never as magnificent as its Venetian counterpart, the Genoese Dogate was certainly more startling. Beginning in 1339 with Simone Boccanegra (immortalized in Giuseppe Verdi's celebrated opera), it lasted until 1805. Yet between Boccanegra and Admiral Andrea Doria's ascension to power in 1528 only four doges were legally elected. The remainder called in foreign powers like Milan or France to back what were in essence military juntas. Violent coup d'états occurred on average several times a year and on one record-breaking day there were three. Standing today on the restored Palazzo Ducale's sweeping marble staircase, it is difficult to picture such a riotous past: the palace's frescoed and elaborately stuccoed salons are now a genteel venue for international art exhibitions and the bustling bookshop and café in the colonnaded entrance are favorite haunts of the local intelligentsia.

Despite the turmoil of the late Middle Ages, Genoa grew rich from the Mediterranean trade and merchant banking. At least one Latin motto coined then about the city still holds true: *Genuensis ergo mercator* (Genoese, therefore a trader). Never was there a nation more ready, willing and able to do a deal. For perhaps nine hundred years, Genoese galleys plied the seas, loaded with spices, sugar, wheat, salt, gold, silver and slaves. But the tiny city-state was not rich enough to satisfy the needs of all its ambitious children. This is the Genoa Columbus left, unable to garner local backing for his voyages. It is no small irony that the decline of Genoa's fortunes as a trading nation accelerated after Columbus arrived in the New World. La Superba was at daggers drawn with the Ottoman Turks and by 1492 had lost its colonies at Constantinople, Pera, Famagosta and Caffa. Gradually traders shifted to the Atlantic, to the lucrative routes to the Americas or around the Cape of Good Hope. The Republic suffered. As the Renaissance dawned, the great nation-states of modern Europe moved inexorably to the forefront and the Republic of Genoa looked increasingly like an undersized anachronism caught between Spain and France, the Austro-Hungarian Empire and England. During one of the Republic's skirmishes with these new power blocks, a spiteful Louis XI is said to have roared, "The Genoese give themselves to me, and I give them to the Devil!" No love was lost between the regal French and their feisty republican neighbor.

\mathcal{D}uring the brief Golden Age at the end of the Renaissance, Andrea Doria built the celebrated Palazzo del Principe Doria at Fassolo, once outside Genoa's walls but now just a few hundred yards from the downtown Principe train station. Inspired by Doria's example at Fassolo, the Republic's wealthy families began building villas by the score along the Riviera. Within the city walls, the Grimaldi, Spinola, Lercari, Lomellini and Pallavicino clans banded together and commissioned Perugian architect Galeazzo Alessi and others to build a street worthy of their social station. Inaugurated in 1558, Alessi's Via Aurea (later called Via Nuova, now the Via Garibaldi) quickly became the talk of Europe. Along the wide, flat artery above and away from the labyrinthine *carruggi* rose thirteen frescoed palaces as astounding today as they were when they were built. So impressed was Peter Paul Rubens by the modernity of the perfectly proportioned buildings and their complementary facades that during his stay in Genoa from 1604 to 1608 he drew and described them in detail as models of architectural excellence to be imitated by the great families of Antwerp—which they promptly did. A century after Rubens, a stunned Goethe remarked that "each palace would suffice a king and his court," while Charles Dupaty raved that he was "shaken, struck, ravished, I am no longer myself. My eyes are brimming with gold, marble, crystal, columns, capitals, ornaments of every kind, of every shape. . . . If you want to see the most beautiful street in the world, go to the Strada Nuova in Genoa. . . . The outsides of the palaces are paintings in themselves."

The Via Garibaldi is still one of the most harmonious and least publicized grand streets of Europe, graced by colonnaded entrance halls, loggias, hanging gardens and statuary. As Paul Claudel noted in his 1915 *Journal*, all you have to do is "push open a door and everything is rose and golden like the grotto of Amphitryon." Most of the palaces have been converted into offices and art galleries, banks and auction houses; the largest, Palazzo Tursi, was built by Niccolò Grimaldi and is now the city hall. Genoa's chamber of commerce, in the Palazzo Carrega-Cataldi, has a gilt hall of mirrors Marie-Antoinette would have swooned over. The city's showcase museums are here, too, the Palazzo Rosso and Palazzo Bianco, formerly the residences of the Brignole-Sale family. Look from the frescoed and gilded ceilings of Palazzo Rosso, to Anthony Van Dyck's splendid portraits of the family, hanging in the spot in which they were painted, and then out over the crowded *carruggi*, and the period's irreconcilably different lifestyles will become clear.

A few hundred yards west of the Via Aurea, construction began at the turn of the 17th century on what was hoped would be an even more sumptuous street of palaces, the Via Balbi. Seven enormous mansions were built here by the plutocratic Balbi family. Among them was Palazzo della Corona, which became the Palazzo Reale in 1830 when it was bought by the House of Savoy. It is now a fine art museum worth a visit for the interiors alone. Opulent, frescoed and gold-encrusted, this Genoese Versailles is situated above the bustling *carruggi,* a stone's throw from the train station. Madame de Staël, the 18th-century woman of letters and celebrated wit, reportedly quipped that the palaces of the overblown Via Balbi had been built for a convention of kings. The Balbis and their kinsmen were kings indeed, rulers of Europe's financial world. The business-minded Flemish portraitist Van Dyck followed Rubens' lead and spent six busy years, from 1621 to 1627, as the darling of the opulent Republic. It was de rigeur for each family to have at least one portrait by the star student of Rubens. In addition to action-filled, masculine depictions like that of horseman Anton Giulio Brignole-Sale (on display at the Palazzo Rosso), Van Dyck captured the glamorous ladies of the merchant-princes' courts. Caterina Durazzo, Elena Grimaldi-Cattaneo, Ottavia Balbi and Paolina Adorno Brignole-Sale, among many others, sat for him. Dozens of these subtly damning portraits, where the gleam of gold resonates in voracious eyes, remain in Genoa's museums and private homes (one family jealously guards over a dozen of them in its outwardly unremarkable palazzo). Others have been dispersed, some of the best ending up in the celebrated Van Dyck room of the National Gallery of Art in Washington, D.C.

While the Van Dycks and Rubens have changed hands countless times, what you will always see in the capital and all up and down the Riviera are portraits, religious paintings and frescoes by the ubiquitous Bernardo Strozzi and other members of the Republic's home-grown school of mannerist and baroque painters. Most are known only to art historians and hard-core aficionados. Like the region's wines, its art did not travel well. Only two Genoese painters ever produced important works outside Genoa: Luca Cambiaso and Lazzaro Tavarone, commissioned by Philip II to paint sections of the Escurial. It was the harsh observation of J. A. Symonds in his classic *The Renaissance in Italy* that "nothing is more astonishing than the sterility of Genoa and Rome. Neither in painting nor in sculpture did these cities produce anything memorable." Many reputable contemporary critics would disagree. To my mind the genius of the Genoese School found its highest expression in the exquisite architectural trompe-l'oeil, stucco work, frescoes and statuary of the Republic's palaces and villas. However, even art

"Silver is born in the Americas, passes through Spain and dies in Genoa."
17TH-CENTURY SAYING

In the image, a plaque reads:

IN QUESTA CASA OSPITE ALBERGO
MODESTA ALLORA COME GLI UOMINI E I TEMPI
IMMINENTE LA PARTENZA
DEI MILLE
SI CONOBBERO SI VOTARONO
COME COSPIRATORI
MOLTISSIMI CHE NELLA SCHIERA
CAPI POI O GREGARI
FURONO FRATELLI

IL COMITATO PER LE PATRIE MEMORIE
AUSPICE
IX FEBBRAIO MCMX

Blue jeans, which originated in Genoa, dry above a plaque honoring Giuseppe Garibaldi.
Opposite: The Palazzo Rosso's majestic trompe-l'oeil frescoed apartments confound the eye (in the foreground is a Parodi mermaid).

experts may be excused for a certain degree of confusion as to exactly who painted what, and when. That is because the best of the Genoese School's works are generally attributed to nine members of the Piola family of painters, seven Carlones, four De Ferraris and Parodis, and three Castellos. Old hands finesse the attribution problem by simply invoking the artist's last name. ("Ah, that's a marvelous Piola!") But there were other distinguished Ligurian practitioners of the arts in Genoa's mannerist, baroque and rococo heyday, including Antonio Semino, Teramo Piaggio, Giovanni Andrea Ansaldo, Domenico Fiasella and Alessandro Magnasco. These names may mean nothing to the uninitiated but once you have visited the lavish former homes of patrician Genoese—the Palazzo Rosso, Palazzo Spinola or Palazzo Reale, for example—you will appreciate the skill of many of these artists in transforming architectural settings into works of art reflecting the psychology and lifestyles of their period.

From Andrea Doria's death to the unification of Italy three centuries later, the good ship *Superba* sailed through relentlessly turbulent seas. Banking, high finance and bold-faced usury gradually replaced shipping, manufacturing and agriculture as the city's main industries. A morality tale lurks herein. For while the city-state was bursting with the gold and silver of the Spanish-American colonies, misery ravaged the lower strata of society. The patience of debt-strapped foreign powers was stretched to the limits by the avidity of the Banco di San Giorgio and private lenders known for their miserliness. "Silver is born in the Americas, passes through Spain and dies in Genoa," runs a 17th-century saying. In fact for nearly two centuries, from the early 1500s until about 1700, one-third of the Spanish Empire's precious metals ended up in Genoese coffers. Fernand Braudel claims that the Banco di San Giorgio discreetly dominated the whole of Europe in the 16th century and continued to wield unparalleled power until the 1630s; contemporary Genoese historian Giorgio Doria, a descendant of Andrea, points out that Genoa financed more than half of Emperor Charles V's debt for imperial expansion and nearly 90 percent under his successors. In the year 1626 the Spinola clan alone had twelve palaces in town, villas scattered across Liguria and an estimated net worth of 16 million

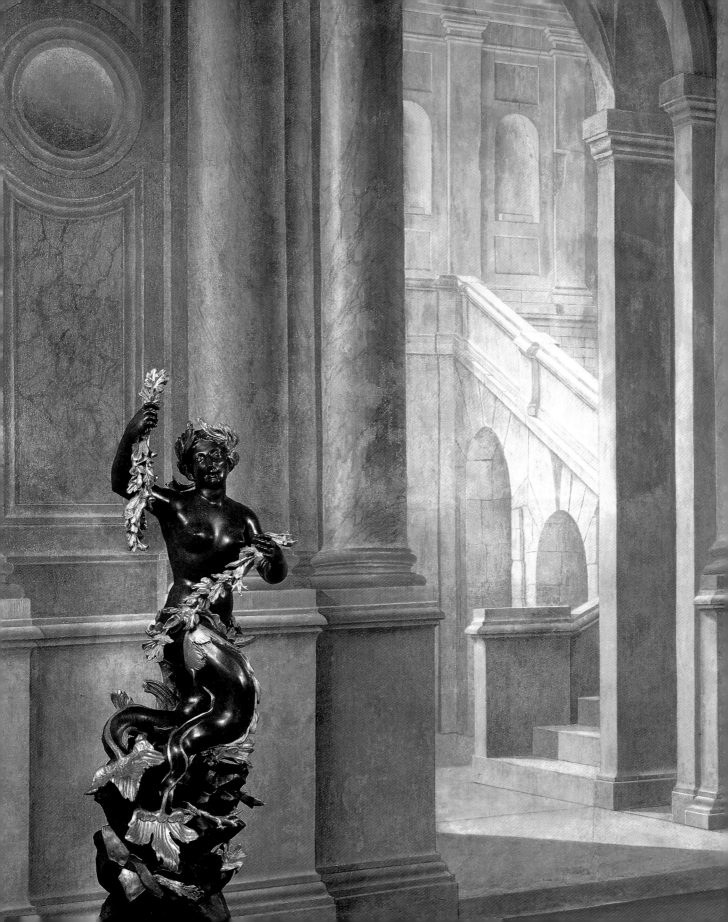

lire, an astronomical sum at the time. You need only stroll through the sumptuous salons of the Galleria Nazionale di Palazzo Spinola near the port, now a house-museum, to form an impression of this family's power. As in most of Genoa's richest mansions, there are two complete *piani nobili*—one floor to receive ambassadors and the occasional monarch, the other reserved for the family's apartments. It is difficult to judge which is the more astonishing for its gold encrustations, encomiastic frescoes of battles and heroic feats of the Spinolas and sculpted or inlaid marbles.

Genoa was not only the richest city in Europe in the early 1600s. It was also the murder capital of the world, the weapon of choice being the stiletto. Given the volatile mix of poverty and extravagant wealth, it is surprising to learn that it was the noblemen who excelled in violence. Medieval clan warfare had ceased but the vendetta had come into fashion. "This beautiful city is more stained with horrid revenges and murders than any one place in Europe," wrote John Evelyn in 1644, "or haply in the world." Genoese historian Francesco Enrico Rappini and his colleagues at the University of Genoa are currently exploring scores of secret passages in the center of the city that cover an estimated one hundred twenty-five miles. It is thought that Genoa's gallant merchant-princes would set out to sea then sneak back at night through these tunnels to eliminate their rivals under cover of darkness.

As in all morality tales, the crash was inevitable and spectacular. It came in the 1630s when Spain was defeated in a series of disastrous military campaigns just as the precious metals from the Americas began to run out. Faced by what we would now call a budget crisis, the emperor suspended loan payments to the Genoese. By then Genoa no longer had a manufacturing or shipbuilding base to fall back on and no navy of its own to enforce payment. The building boom went bust by the middle of the 17th century, primarily because the rich families simply hoarded their stockpiles of gold and silver in their fortresslike palaces—palaces that began to crumble around them. "A doleful mixture of plaster and marble," wrote Alexandre Dumas, "of grandeur and misery." With insouciant flair, the Genoese wrote off their own Republic as too high a risk. The divide between idle rich and starving poor grew untenable as famine and disease spread, followed by the plague of 1656, which indiscriminately killed 40,000 Genoese. In a decade La Superba's population was halved and for the next 150 years the French, Spanish, Neapolitans, Austro-Hungarians and Savoys took turns bombarding, pillaging and then ruling the strife-torn Republic.

To cite one famous, colorful example of big-power bullying, in 1684 Louis XIV softened up the Genoese with a ten-day naval bombardment, then summoned Doge Francesco Imperiale-Lercari to Versailles the following spring for a dressing-down. French chronicler Jules Janin in his 1838 *Voyage en Italie* tells the story of the fiercely proud plutocrat's forced visit to the Sun King's court. "When the Doge was shown the palace he was asked what most astonished him. 'Finding myself here,' he quipped. And why should he have been astonished by Versailles? Because of the stone palace? He had one made of marble. Because of the marble columns? He had porphyry columns. Because of the porphyry columns? He had walls of lapis lazuli. By the architect Mansart? He had architects like Francesco Falcone and his brother Andrea, and Carlo Fontana who had erected the Obelisk of Rome and built the most beautiful staircases of Versailles. The statues of Coysevox? He had statues by Michelangelo. Lebrun was Louis XIV's painter, but the Doge of Genoa had Paolo Veronese. He had his wife and children drawn by Van Dyck . . . he had Titian, Correggio and the Carraccis on his payroll . . . Tintoretto and Albert Durer at his orders. . . . Why should this ruler of a tiny Republic have been astonished?"

Doge Imperiale-Lercari may not have been astonished but he and his successors were chastened, if not broken. It seemed only natural that in 1797, when Napoleon became emperor of France and king of Italy, La Superba, like Venice's Serenissima, ceased to exist. Attempts to revive it failed and the Congress of Vienna in 1815 delivered the coup de grace: the Savoys' Kingdom of Sardinia claimed all of Liguria, instantly demoting it to a subservient duchy, the Ducato di Genova. Unlike the redundant Venice, however, Genoa had already produced two of the great revolutionary patriots responsible for the creation of modern Italy: Giuseppe Mazzini and Giuseppe Garibaldi. It was from Genoa's tiny fishing port at suburban Quarto dei Mille that Garibaldi and his Thousand launched their Sicilian expedition in 1860, an exploit marked by a statue on the rocky shore now favored by sunbathers and sport fishermen. When the Savoys were crowned as kings of United Italy in 1861, Liguria, now a mere administrative region, lost its autonomy once and for all.

"Pisa and Venice perforce must live in the past," wrote Robert W. Carden in the 1890s. "Genoa, like the fabled Phoenix, arises once more from her own ashes." Carden was right. Genoa steamed proudly into the 20th century, forming, along with Milan and Turin, the so-called Industrial Triangle which

> *"Pisa and Venice perforce must live in the past. Genoa, like the fabled Phoenix, arises once more from her own ashes."*
> ROBERT W. CARDEN

Overleaf: The sumptuous interior of a privately owned 16th-century villa in Genoa's fashionable Albaro neighborhood.

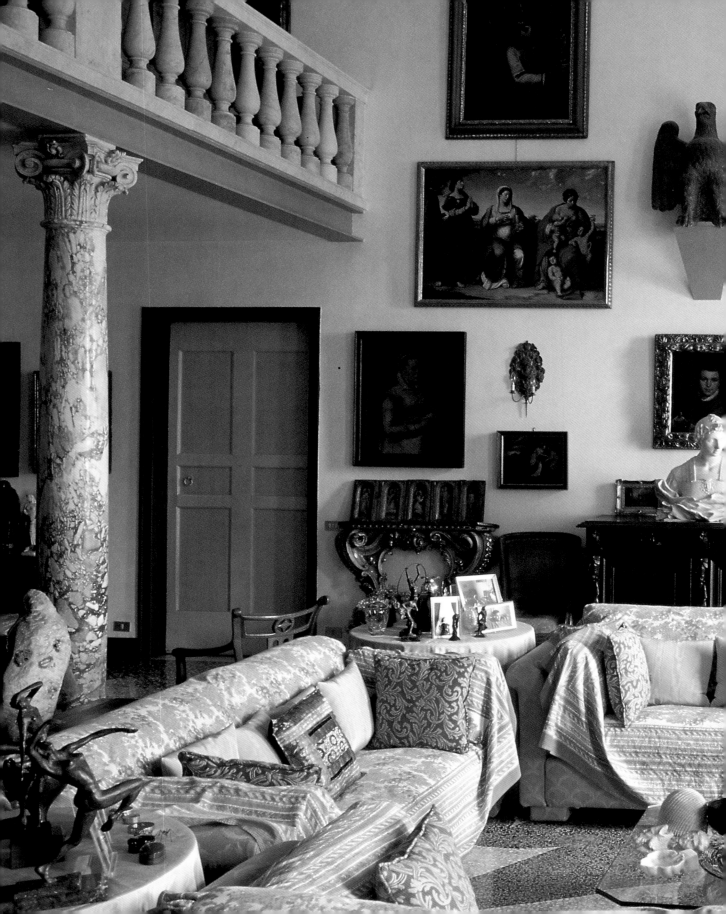

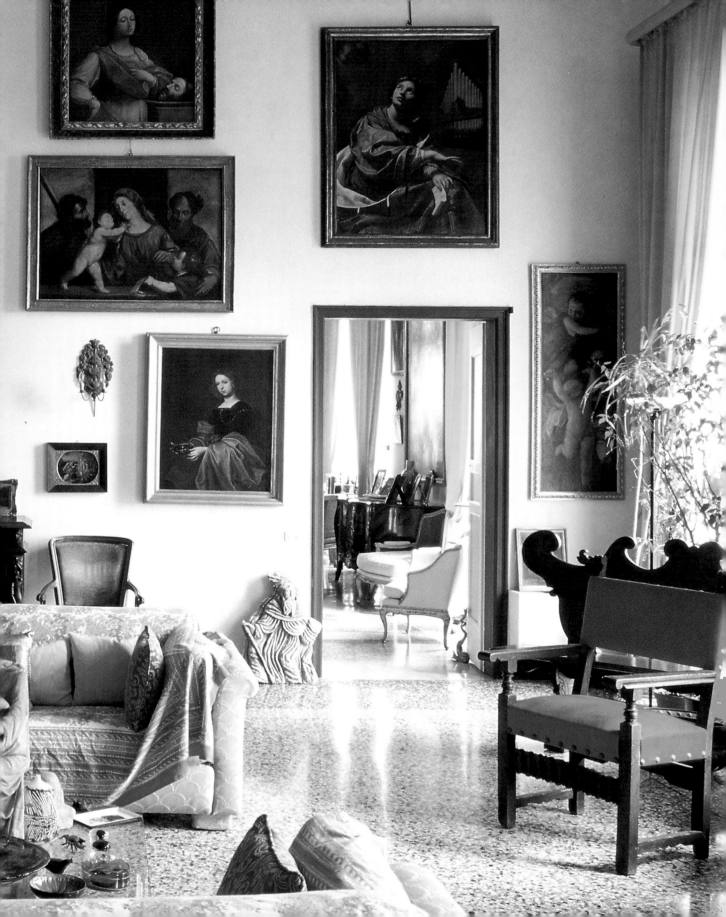

drives Italy to this day. The harbor boomed; steel works and shipyards mushroomed where sleepy seaside villages or genteel retreats like Cornigliano, Sanpierdarena and Pegli had been. The Via XX Settembre, a grand porticoed boulevard, was driven like a great sword into the heart of the old city, linking the Brignole neighborhood with the spacious Piazza de Ferrari and Palazzo Ducale. These have been Genoa's thoroughfares and shopping districts ever since, the city's modest answer to Paris' Champs-Elyseés. Above them, massive palazzi and fantastic castles crawling with mythical creatures and floral decorations scaled the steep hillsides. Streets and staircases twined around them to form the central city you see today. Like all booms, though, this one came with a price tag: the urban renewal projects for the 1892 Columbus Expo alone, for example, did more damage to the old town than Louis XIV's naval bombardment. Churches were dismantled and moved to unlikely spots (Santo Stefano ended up above the Via XX Settembre; Sant'Agostino's cloister was repositioned ridiculously between the phony Columbus House and Porta Soprana). Baroque facades were "restored" to a supposedly lost medieval look that had never existed.

This was the reborn Genoa of the 20th century, and for half of this century it prospered. But the boom-to-bust cycle continued. Heavy industry rusted into obsolescence and instead of being renewed was gradually nationalized by the Italian government and operated at a loss. During the Second World War the harbor drew Allied fire and much of the catastrophic damage done to the city was left in disrepair for decades. Even the port, once rivaled in the Mediterranean only by Marseilles, fell on hard times. Until 1992 a single labor union had the monopoly on freight handling; gradually it choked off competition and forced shippers to move to La Spezia and Leghorn. Like Columbus, the ambitious youths of the postwar period were forced to leave Genoa to seek their fortunes. And little by little, private investors took their capital to Milan and other, more dynamic cities, leaving Genoa to die a slow death. With the end of the era of trans-Atlantic passenger ships in the late-1950s, Genoa seems to have slipped off the map of Europe. "Genoa is a decadent city," wrote Piero Ottone a decade ago. "But might it not be that decadent cities, like decadent families, are the most endearing, the noblest of cities?"

Perhaps, but apparently most Genoese no longer think so: the city is booming again.

The municipal elevator at Piazza Portello whisks you to the fashionable Castelletto neighborhood's belvedere, where you can look out over the

whole of this great, soulful metropolis suspended between mountains and sea. When the soft blue light of the Mediterranean washes over Genoa's frescoed facades, slate roofs and olive-green gardens, it seems extraordinarily beautiful despite and perhaps even because of its checkered past. As the architect Renzo Piano says, "the beauty of this city is that no one planned it." Indeed it is not an embalmed marvel of centuries gone by but rather a vital place where people work as hard as they play. Day and night the harbor and Porto Antico are alive with freighters, ferries and pleasure craft. On Genoa's eastern edge are Albaro and Nervi, seaside resort neighborhoods within the city limits, where you scent the Riviera's orange blossoms and breezes long before reaching Portofino. Down in the mysterious *carruggi* it is no longer only the chic Via Luccoli and palace-lined Via Garibaldi that draw strollers and shoppers. The Piazza di Sarzano and Sant'Agostino neighborhoods south of the Porta Soprana have become Genoa's *Quartier Latin*, enlivened by students at the University of Genoa's architecture department. Everywhere you look, restaurants, boutiques and cafés are springing up like wildflowers among the old stones. Sitting at a panoramic Castelletto café today you cannot help but agree with what Honoré de Balzac wrote about Genoa a century and a half ago. "Let us confess, when in that moment the scented breeze fills your lungs and your thoughts, when voluptuousness, visible and moving as the air, nails you to your seat while with a spoon in hand you dip into ice creams and sorbets with the city spread at your feet and beautiful women facing you, in that Boccaccio-like moment it is impossible to be anywhere but in Italy on the Mediterranean."

"*Genoa is a decadent city. But might it not be that decadent cities, like decadent families, are the most endearing, the noblest of cities?*"
PIERO OTTONE

Overleaf: A typical Ligurian trompe-l'oeil facade.

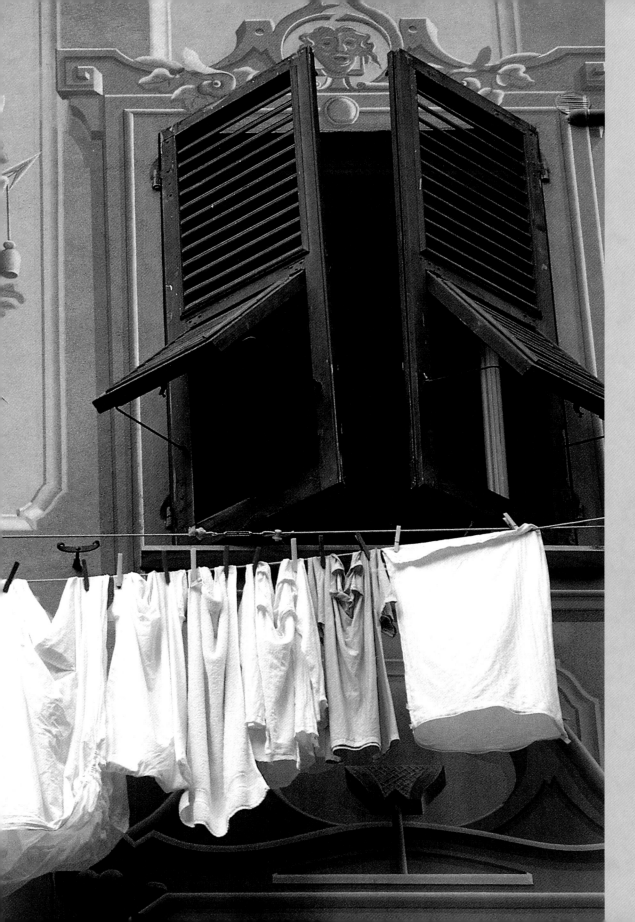

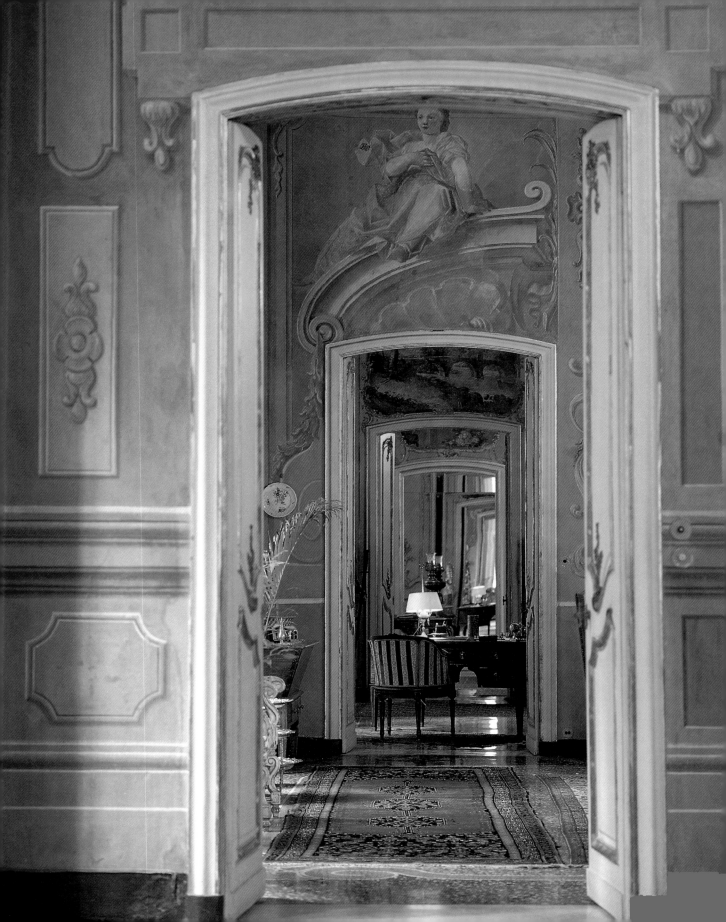

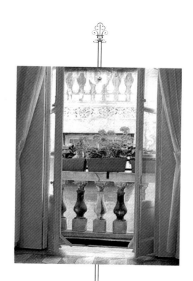

\mathcal{A}t times, sitting under a pergola in a port by the sea, or in a bustling café in Genoa's *carruggi*, you may be forgiven for thinking you are hallucinating. That door you were expecting someone to open turns out to be a painted trompe-l'oeil. The shuttered green window you were sure was fake pops open like an advent calendar and a head appears. From the windows of villas poised on terraced cliffs, the distant Apennines seem to rise right out of the garden while the Mediterranean, theoretically underneath you, in fact lies a thousand feet below stepped olive groves and vineyards that are out of sight. A village that seems to be a stone's throw away is actually perched on a ridge several valleys away, at the end of a ribbon of road festively done up in loops and spirals. Wherever you look, on the coast or in the rugged *entroterra*, artifice and nature conspire to confound.

The verticality of Liguria's terrain has long been exploited wherever possible to create dramatic urban backdrops.

 Enter a Ligurian home and the dizzying effects continue. Suites of rooms with a window on one end and a mirror at the other create an infinite regress of rooms, doorways and windows. Perhaps it is the climate or the beauty of the surroundings, but both in cities and in the countryside Ligurians seem somehow to need to expand their living quarters into the outside world. Painted trompe-l'oeil landscapes bring the exterior indoors; frescoed ceilings open the roof to the sky. Consider, too, the wrought-iron pergolas, often with domes, that shade roofs or balconies eight or nine stories above the street; because of the steepness of the landscape, when viewed from inside they seem to spring from nearby hillsides. Wisteria or jasmine or bougainvillea blossoms are repeated indoors by floral motifs painted on walls; bouquets of fresh, dried

A marble balcony faces a trompe-l'oeil balustrade on the opposite wall. *Opposite:* A seemingly infinite series of rooms in Genoa's historic Palazzo Saluzzo.

Trompe-l'oeil

The Ligurians did not invent trompe-l'oeil, but they adopted it and made it their own. Cynics say it was devised as a way to save money: it costs less to paint a colonnade or a balcony than to build one. But that misses the point, and in fact there are plenty of real columns and balconies around, usually hidden inside courtyards. Trompe-l'oeil was a vehicle to show off an artist's bravura as well as a means of making the impossible seem real. It captured the uneasy exuberance of an age of extraordinary wealth, progress and religious tumult, and when that age was over it remained stubbornly in fashion. Architects Stefano and Francesco Fera point out that the narrowness of Ligurian streets made it difficult to accommodate protruding structures. The mastery of the medieval masons who built the region's seemingly indestructible historic centers was such that later generations could neither cheaply nor easily modify perimeter walls. So instead they built on top and in between.

The resulting jumble of alleys and helter-skelter buildings has been celebrated for centuries by travelers like Charles Dickens. "Wherever it has been possible to cram a tumble-down tenement into a crack or corner, in it has gone," wrote Dickens. "If there be a nook or angle in the wall of a

church, or a crevice in any other dead wall, of any sort, there you are sure to find some kind of habitation; looking as if it had grown there, like a fungus. . . . [T]here are irregular houses, receding, starting forward, tumbling down, leaning against their neighbors, crippling themselves or their friends by some means or other, until one, more irregular than the rest, chokes up the way, and you can't see any further." Given this pell-mell cityscape, it is easy to understand the appeal of trompe-l'oeil on stucco: it could achieve what chisels could not, smoothing over alterations and bringing complexity and relief, false though it may be, to straight, undecorated walls in a chaotic avalanche of urbanism.

The Fera brothers in their architecture studio in the *carruggi*.

and artificial flowers mixed together with diabolical skill keep you guessing. Gardens continue this visual trickery, for while there are dozens of beautiful romantic parks scattered along the Riviera and even in Genoa, the true Ligurian garden is neither orderly nor spacious. It is an extension of the home. In the countryside that means a semiwild, terraced kitchen garden planted with olive and fruit trees, herbs and grapevines. In town it is a hanging garden in a decoratively cobbled court with a moss-covered fountain or grotto over which fly balconies, loggias, terraces and walkways knotted with vines and scattered with flowering shrubs and potted plants.

The verticality of Liguria's terrain has long been exploited wherever possible to create dramatic urban backdrops. You need only wander into Genoa's old town to see how entrance halls and staircases play up the topography, becoming architectural statements in themselves. Palazzi seem to have been stacked in a cubist jumble conceived a thousand years before Picasso and Braque by anonymous builders in the Middle Ages. Back then a rocky, steep piece of property was worth more than a level one because it provided the building material—with solid bedrock foundations to boot. From a purely practical standpoint, in Genoa and the towns and villages of the Riviera, the Renaissance found little room for its wide, flat piazzas and perfect proportions, the embodiments of reason. A century after Brunelleschi's dome had risen over Florence, the Ligurians suddenly dropped Gothic and embraced Mannerism with rare passion, perhaps because its distortion and exaggeration better corresponded to their character; or perhaps because it had already been embodied here in the landscape. This is when trompe-l'oeil, so typical of the region, was perfected.

Genoa and its Riviera territories became rich for the first time in the Middle Ages, then in the cinquecento and again after the unification of Italy, when eclecticism predominated. The great buildings and interiors of Liguria date to these periods. The less said about the slipshod architecture of the last fifty years the better, though in fairness it was the postwar boom that raised the quality of life to its current high level and has given new generations the means to restore the vast patrimony abandoned by their parents. As in most of Italy, the skill of architects, interior designers and artisans expresses itself best today in adapting the old to the new. Restored palaces, villas, castles and even simple fisherman's cottages with whitewashed walls, tiled floors, graceful arches and elaborate wrought-iron railings are where discerning locals once again want to live. The prevailing philosophy in Liguria is to conserve and improve with minimalist touches. Naturally, the older the neighborhood the greater the

challenge. Imagine inheriting and making livable a property that has been in your family since it was built in the 12th or 13th century. The excavation of Troy seems simple in comparison for here lies Ligurian cultural history in a nutshell. Peel away the first few undistinguished layers of plywood and plaster and under handsome neoclassical stucco work you might find, say, a Mannerist fresco applied over a black-and-white marble Gothic arch, part of a portico walled up about the time Columbus left town. Each layer has a tale to tell. The black-and-white pattern, typically Genoese, was a sign of wealth and importance; it also symbolized good and evil, day and night, life and death, reflecting the age-old symbolic interpretations of these two colors. The black *pietra di promontorio* sandstone was quarried on the spot; the white marble probably came from an ancient ruin—a Roman colony in Tunisia, perhaps—scavenged by Genoese traders and used as ballast in a medieval sailing ship before becoming part of the wall. The fresco, on the other hand, might have been painted by a Genoese School artist to celebrate the wedding of a banker to a shipbuilder's daughter in the golden age of Andrea Doria. The stucco was brazenly laid over it by a trendy aristocrat of the Napoleonic period who had been to Paris and wanted to show off the latest in interior design. What do you do with this palimpsest— remove the stucco to reveal the fresco or dig down to the medieval portico? Your greatest anxiety will probably be that the authorities from the Fine Arts Administration, in a well-meaning attempt to safeguard the site, will wrap you in so much red tape that your grandchildren will still be bound by it.

There are thousands of such ancient buildings up and down the Ligurian coast. Most started life as blocks of stone towers owned by the same clan, a *borghetto*, later knocked together and straightened up to form the immense palazzi you see to this day. "The huge palaces of Genoa are each supposed to be occupied by one family," wrote Mark Twain, "but they could accommodate a hundred, I should think." Despite the challenges involved in living in them today, these historic properties are much sought-after. Visit the museums in Genoa's Palazzo Rosso and especially the Palazzo Spinola and you will see why. The *piani nobili* flats on the second and third floors of these breathtaking buildings often have twenty- or even thirty-foot ceilings and plenty of Versailles-like French windows to let in the light. These are the floors where the patrician families of the Republic once lived and entertained the royalty, diplomats and bankers of Europe in high style. As you might expect, it is here that the decorations are richest. An especially fine example in private hands is the Palazzo

Opposite: A mannerist trompe-l'oeil in the loggia of the Palazzo Rosso.

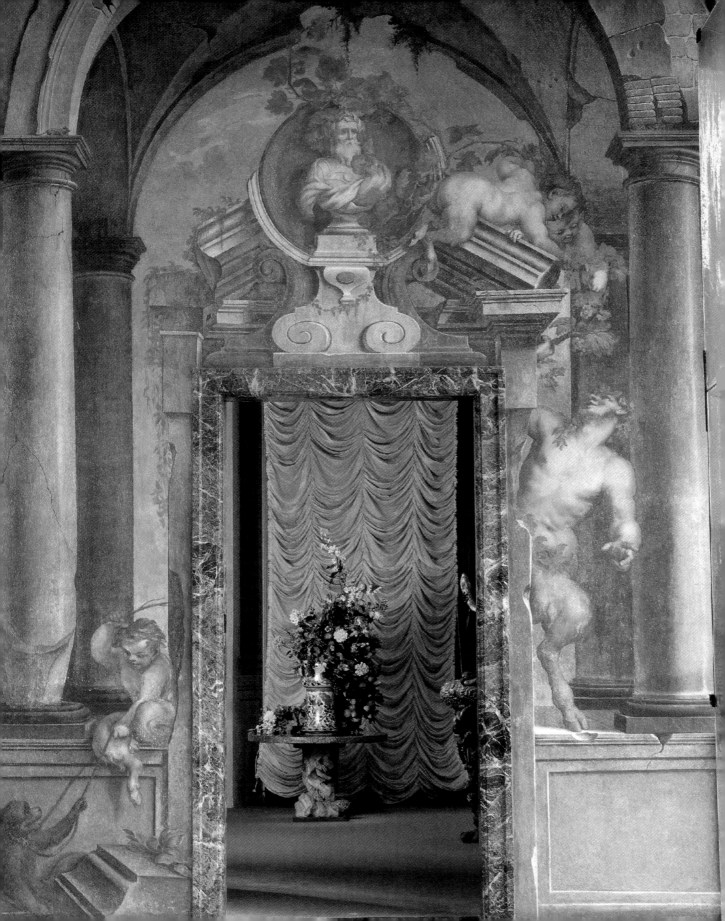

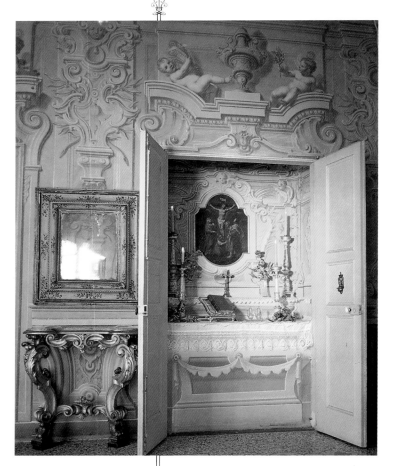

A cupboard chapel in Santa Margherita's Villa Durazzo, decorated with faux molding.

Saluzzo, located just a few hundred yards from the San Lorenzo cathedral in Genoa's *carruggi*. One of its two *piani nobili* was bought in the early 1980s by the art-loving lawyer Felice Antonio Lanzalone, restored to its extravagant, early-17th-century glory and is now maintained by his son Luca and his wife, Alessandra. In the Salotto Rosso, so named because the walls are covered in antique red Ligurian damask, splendid frescoes by Domenico Piola show an innocent youth rescued from sinful Bacchanalia by two helpful cupids. Other salons and the dining and ball rooms, are done up in trompe-l'oeil with scenes from Ovid's *Metamorphosis* or cycles of classical myths painted by Genoa School artists like Giovanni Andrea Carlone, Giacomo Antonio Boni or Giuseppe Palmieri.

This and many other palaces in Genoa and cities on the Riviera have nothing to envy in the finest works of the Mannerist period in Italy. Scores of similar *piani nobili*, many of which have lost their original interior decorations yet retain their imposing structure, are being re-transformed from offices or warehouses into the spacious apartments they once were. Discreet modern furniture and clean detailing made with traditional materials like slate, terra cotta, marble and solid wood flank family heirlooms. Though usually unadorned, penthouse apartments with roof gardens are also desirable, primarily because they are elevated above the shady medieval streets to capture the brilliant Mediterranean light. In Genoa, looking down from Castelletto at the old town, you can see dozens of widow's walks, terraces, pergolas and pocket-sized hanging gardens, unseeable and unimaginable from street level in the manmade canyons below.

The craving for light and open space is what led the prosperous inhabitants of these historic neighborhoods to build villas outside them very early on. While the rest of Europe was still cloistered within fortresslike city walls, poets

and writers in the 14th and 15th centuries were already raving about the magnificence of the many Ligurian country mansions that outshined even Genoa's celebrated marble palaces. Most were a brief mule's ride from the center of town, within striking distance of the sea but rarely right on the coast, for fear of the marauding pirates that plagued the Riviera's waters until the 19th century. Their owners would shuttle by mule or boat from town to country houses much the way people today commute by car. There are hundreds, perhaps even several thousand, historic villas scattered around the region. One of the oldest and best preserved is the Villa Spinola-Doria-d'Albertis at Quarto dei Mille in Genoa's eastern suburbs. For the last century it has been in the d'Albertis family of celebrated sea captains and entrepreneurs, but the first mention of it goes back to 1414. I like to think it might have been one of the Riviera's "gilded houses" described by Petrarch, houses whose "luxury and delights in the midst of forests and remote countryside" made "the magnificence of the city" pale in comparison. Like almost all the villas of Italy, the Villa Spinola-Doria-d'Albertis was

Detail of the frescoes on the ballroom ceiling in the Palazzo Saluzzo. *Overleaf:* (*left*) A wing of the Villa Spinola-Doria-d'Albertis, built in the mid-1700s. (*right*) The Red Damask Room of the Palazzo Saluzzo.

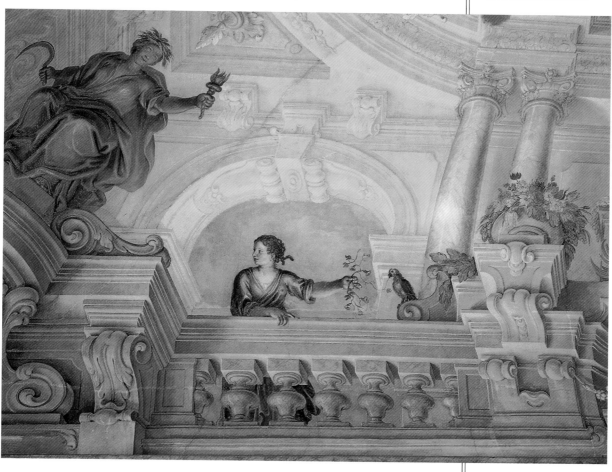

transformed and embellished over the years, growing from a fortified farmhouse (producing olive oil and wine) to a vast, U-shaped cluster, delicately frescoed and stuccoed in the 18th century. The Spinola and Doria families of old entertained the ambassadors and aristocrats of Europe here, as do the d'Albertis-Scotti Counts today. The immense ballroom with thirty-foot ceilings and the innumerable suites of salons come alive when they fill with guests. As in most villas of its kind, the family lives in comfortable, sunny apartments secreted away in towers and garden wings. When the French windows are thrown open the ballroom extends into the hanging garden and orchards behind and seems to float over the roofs below. An *allée* lined with ancient holm oaks, terraced olive groves—and a romantic park with palm trees and a serpentine drive—isolate the property from the bustle of the surrounding Quarto dei Mille neighborhood. Like most patrician villas and palaces in Liguria, this one was designed to be largely self-contained. It still has its own private chapel in which the owners were baptized, married and had funeral masses said for them.

\mathcal{S}ome of the most typically Ligurian homes I know are of more recent vintage and less princely dimensions. They are largely the result of the economic boom that followed the unification of Italy in the mid-1800s and continued, with ups and downs, well into this century. Among the best examples of them are the massive stone buildings of Genoa's upper city, which are piled like building blocks along avenues that wind up from the medieval *carruggi* to the ridges high above town. For the last hundred years or so the city's best address—other than the perennially chic, palace-lined Via Garibaldi—has been Castelletto, a belvedere built where a castle once stood, and the Circonvalazione a Monte that rings the hills halfway up. Walkways link rooftops to streets so that you can enter below and ride an elevator up or enter on top and ride down to your flat at your convenience. Externally the buildings resemble the old palaces of the Via Garibaldi and *carruggi*, palaces that because of their age embrace a variety of styles. Ungenerous critics refer to Liguria's 19th-century bourgeois buildings as imitations of a pastiche, yet they remain solid,

The Villa Spinola-Doria-d'Albertis: mid-18th-century grotesques. *Opposite:* The grotesque above the door to the chapel depicts Hercules cutting off one head of the three-headed watchdog of Hades.

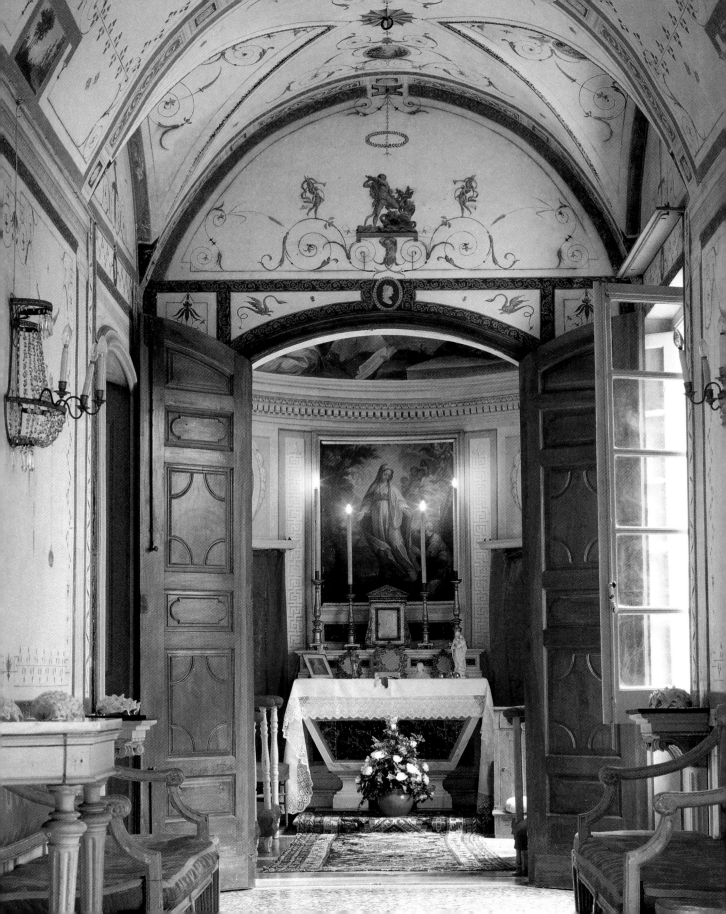

imposing and remarkably comfortable. Rather than designed as dwellings for single patrician families, they were divided into vast flats for the professionals, bankers and industrialists of the new state of Italy. Suites of a dozen rooms or more usually wrap around half a floor to form a U, though it is also common to find several floors occupied by extended families in the Genoese tradition. By modern standards, these 19th-century marvels are extremely luxurious. Most have the characteristic *pavimenti alla genovese* (ground-marble floors) and elaborate stucco-, stone- and ironwork of the palaces of old. They are the objective correlative of the foibles and fancies of their period. Parsley-green or Pompeii-red damasks appear as drapes, wall coverings and upholstery, creating the kind of cozy shell destined to accommodate decorative art objects, carved wooden armoires, soulful-sounding clocks, travel souvenirs and family memorabilia. These were—and remain—family homes, handed down the generations for whom collecting was as much of an obsession as in Victorian England. Many of these apartments boast private museum-quality holdings of exquisite Genoese *barocchetto* 17th-century furniture (less ornate than baroque), in particular the *bamboccio* chest of drawers decorated with finely sculpted heads.

A feature of the Ligurian home found from the 16th century to this day, in everything from Genoa's Palazzo Spinola to a country cottage behind Portofino, is the solid marble kitchen basin with clothes washing surface and dish drying rack attached. These elaborate kitchen units are still custom-made, with marble shelves and brass rails, and used in remodeling jobs where quality and authenticity are the prime concerns. The ubiquitous marble-top Ligurian kitchen table dates to about the same period. It is equipped with a rotating wooden kneading board and a round compartment to hold the yard-long rolling pin still wielded today by home cooks to make fresh ravioli, *trofie, pansotti* and vegetable tarts.

Despite the popularity of standardized modern designs and prefab units of all kinds throughout Italy, there are many recurrent architectural and decorative elements in Ligurian homes that have been popular for centuries. Every pre-war building in the region is made of hewn stone mortared and stuccoed with lime and sand, and then—ideally—painted *affresco*, while it is still wet. Rose, Pompeii red, ochre and pale straw yellow are favorite exterior colors to which trompe-l'oeil windows and decorations like friezes are applied; shutters can be any color as long as it is green. Roofs are covered with either slate (in Genoa and the Levante) or terra-cotta tiles (in the Riviera di Ponente), though many beautiful stone-roofed structures survive in remote mountainous areas.

Piazzas, courtyards and garden paths are often cobbled with potato-shaped stones gathered from riverbeds or rocky beaches then arranged in black-and-white patterns using a mortarless technique called *risêu*. Nearly every Ligurian interior will also have black-and-white tile or marble floors; slate lintels, steps, and perhaps a bas-relief sculpture or two; ultra-light wood-and-cane chairs from Chiavari; wrought-iron bedsteads with curlicues; silk damasks, lace and macramé; blue-and-white Albissola ceramics and colorful tiles; and, since about the 12th century, printed cotton fabrics called *mezzari*. This is the roll call of domestic Ligurian identity cards that lets you know immediately that you are not in France, nor in Tuscany and nowhere near Piedmont or Lombardy.

*G*iven the huge numbers of historic properties filled with antiques and the pronounced preference for traditional interiors even among those with modern homes, it is fortunate that many centuries-old local crafts are still alive today.

A section of decorative *risêu* pavement at Genoa's Madonnetta church shows the Doria eagle.
Overleaf: A marble kitchen unit from the early 19th century, with brass overhead racks. The ingredients for pansotti are spread out on a pasta-maker's table, with an antique mortar and pestle and the long rolling pin used to stretch sheets of dough.

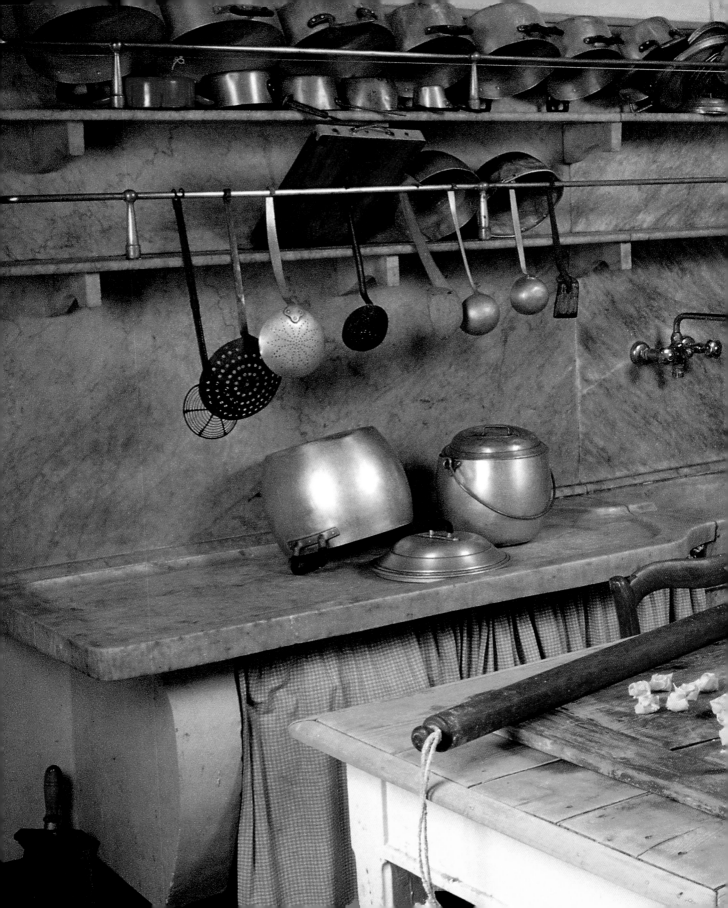

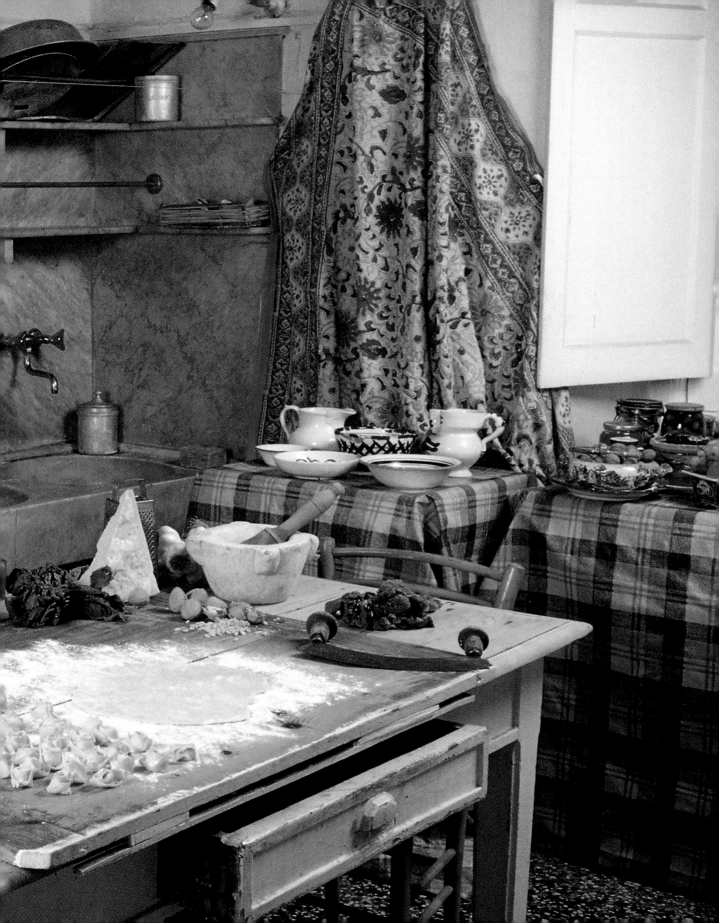

Cabinetmakers, smiths, stonecutters, weavers, masons and trompe-l'oeil decorators are much in demand for restoration work as well as new commissions. In some fields, like silk weaving or macramé, only a handful of practitioners remain, most of them elderly, while artisans in other fields are more numerous, either because knowledge has been more efficiently handed down the generations or because the crafts have been revived by scholars and young artisans. There is nothing phony about these proud artists, most of whom began their apprenticeships as children. The dusty, dark quarries of the Val Fontanabuona continue to yield slate which is transformed not only into pool tables and blackboards, but also is found in Ligurian homes in a variety of applications. Artisans in and around Chiavari and Lavagna, at the base of the valley, carve the fragile, flaky stone into traditional forms—steps, lintels—as well as fireplaces, kitchen surfaces and a maddening array of less useful knick-knacks. Specialized local sculptors like fine arts professor Francesco Dallorso and his students use the best blocks of slate to create everything from altarpieces for churches to maritime bas-reliefs to decorate the walls of sea captains' homes.

An antique Albissola vase displayed against a trompe-l'oeil in a private mansion in Genoa.

Walk into a patrician ballroom or a farmhouse down a footpath in the *entroterra* and you will probably find several specimens of the celebrated blue-and-white ceramics of Albissola. Though no longer as subtle or complex in design and coloration as those from their heyday in the 16th to 18th centuries, when the Grosso and Conrado families produced priceless museum pieces, these fine ceramic flower vases, drinking mugs and decorative plates are still made by hand. Albissola's local ceramics museum gives an excellent overview of the history of the craft and illustrates how the early monochrome blue coloring gave way in the mid-1700s to mauve tints on a white background, sometimes with green or yellow highlights. Ceramic-making in Albissola was originally encouraged by the business-minded Genoese government to stem the flow of foreign imports and alleviate the balance of payments.

Majolica tiles, initially imported from Spain from the late Middle Ages until the 1700s, became a

local form of ceramic making that flourished on the Riviera di Ponente for hundreds of years. So it comes as no surprise that decorative floor and wall tiles, often in kitchens or stairwells, are yet another common feature of the region's houses. The tile maker's craft practically died out earlier this century but has been revived in recent years with surprisingly good results. The best contemporary tiles I have seen repeat Spanish and old Ligurian designs, though some new designs are remarkably attractive. They no longer come from the Riviera di Ponente but are now custom-made by workshops in and around Genoa. The top two Ligurian tile makers are Marcella Diotto and Simona Marinari. Though most of the raw tiles Diotto and Marinari use are industrially manufactured, some are handmade and fired on the spot. In either case all are hand-decorated with floral motifs, geometric designs or arabesques, landscapes or Book-of-Hours-style scenes that in superior examples manage to avoid the saccharine look so common in such products throughout Europe today.

Once upon a time there were an estimated 25,000 silk, cotton and velvet weavers in Liguria, including, apparently, Christopher Columbus' father, Domenico. Perhaps the young Cristoforo took to the sea to escape the maddening din of the looms, for whether they are hand-operated or motorized the clacking noise is deafening. Today only about a dozen Ligurian weavers turn out the gorgeous traditional fabrics for which the region is known, catering to the top end of a specialized market of restorers, architects, interior decorators, fashion designers and tailors. The isolated inland village of Lorsica above the Val Fontanabuona has been producing some of Italy's most sought-after linen, silk and cotton cloth for almost a thousand years. Today only the De Martini family of weavers is left in Lorsica, a village of two hundred. Nonetheless, Lorsica has become a pilgrimage site for damask-lovers from around the world. Clients must be willing to wait up to two years for a consignment of lustrous damask or lampasso woven by octogenarian Ameglia De Martini. The comb of De Martini's vintage loom is hand-threaded with 15,000 silk strands. She produces just six yards of the dense, low-relief material a day, using the fifty or so typically Ligurian patterns that her family has handed down the generations. Each remains in demand today, especially for restoration jobs. Some of the most typical patterns are Prezzemolo, a light-green damask with a parsley-leaf motif; Pallavicini, a flowery pattern on a green background designed centuries ago and named after the patrician Genoese family that first commissioned it; and Atene, a luscious red damask with red and yellow leaves and acorns.

Of equal skill and perhaps even more ancient descent are the Gaggioli

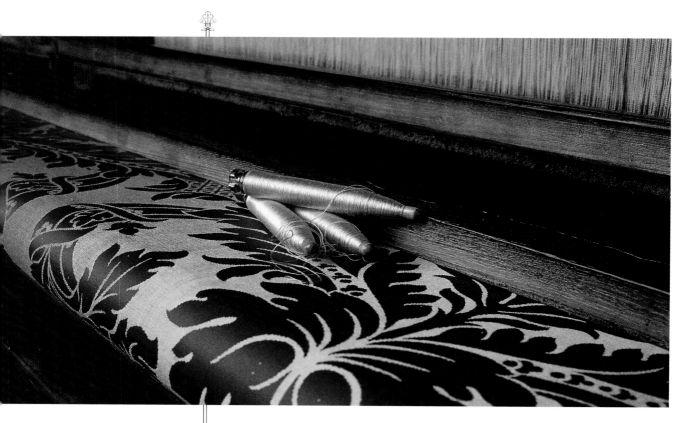

Top: Handwoven silk damask by the De Martinis of Lorsica. *Above:* Damask on a loom in the Gaggioli workshop in Zoagli.

family of weavers of Zoagli, near Rapallo, where velvet-making was introduced to Italy from Asia in the 12th century. It was from the workshops of this small Riviera village that the technique was taken by Ligurian weavers to Lyons, in France, where it thrives to this day on an industrial scale. The Gaggioli still use an antique hand-operated loom, one of the few remaining in Italy, that enables them to produce dense, luminescent damasks, velvet and other fabrics indistinguishable from those of hundreds of years ago, fabrics that you find in the many museums, mansions and patrician homes of the region. It takes Giuseppe Gaggioli some two hundred hand and foot movements on this loom to make about half an inch of exquisite velvet. Working eight hours a day, he produces less than a yard, which accounts for a large part of the cost of his wares: $200 to $600 per square yard. Given the skill, hard work and time needed to produce such fabrics it is understandable that only a handful of artisans are still willing and able to carry on this particular Ligurian tradition.

Other related crafts still practiced near Zoagli are lace-making and macramé, a knotting technique used to make fringes for a wide variety of fabrics, as well as complete decorative pieces. For hundreds of years, Portofino, Santa Margherita and Rapallo have been sources of excellent *pizzi al tombolo*, made at

home by dozens of women artisans who sell their wares to shopkeepers in these fashionable seaside villages. One highly regarded lace-maker I met lives on a footpath in the middle of the Monte di Portofino wilderness. She has no telephone, wishes only to be known as Signora Carla and sells most of her world-class work to passing hikers (near Portofino even the hikers are well-heeled). Macramé is a specialty of Chiavari, a small city about fifteen miles south of the Portofino peninsula. This is not the macramé of the hanging-plant-holder variety made popular in the sixties by flower children. The authentic Ligurian version derives from Middle Eastern influences picked up during the Crusades; it was originally practiced by sailors on long sea journeys, an alternative diversion, perhaps, to untangling fishing lines. The reason is simple: no tools are needed, only the ability to carefully tie knots. By the late Middle Ages macramé had found its way as a decorative fringe onto everything from bedspreads and towels to clothing and cupboard liners, and it is still used for these purposes today. Ever since Andrea Doria forbade the importation of the fashionable material from Valenciennes in the 16th century the macramé makers of Chiavari, always women, have been producing it in their tiny workshops. The uncontested master of traditional Chiavari macramé today is Elena Venzi. A single piece of her extraordinarily complex work can require hundreds of thousands of knots and take months, even years, to complete.

For a variety of historical reasons the Chiavari area has been an authentic crafts center for centuries. Slate and wood come from the Val Fontanabuona valley behind town; the Entella River separating Chiavari from Lavagna powered the area's early ironworks and foundries. The result was a disproportionately large number of woodworkers, boat builders, ironworkers, sculptors, sail makers and other artisans who banded together to form guilds in competition with Genoa, whose policy was to keep Riviera cities in check. The tables have turned, however, and now there are more crafts workers left in Chiavari, Lavagna and the Val Fontanabuona than in Genoa or anywhere else in the

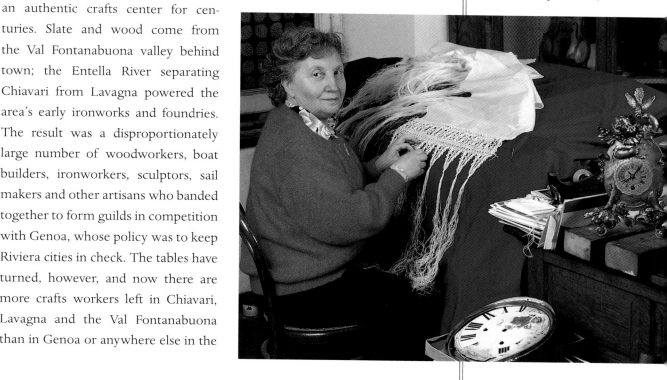

Elena Venzi, of Chiavari, makes macramé (her husband restores antique clocks).

region. Cabinetmakers like Franco Casoni produce everything from figure-heads for yachts and 17th-century-style *bamboccio* chests, to wooden stamps used to make *corzetti* pasta. Casoni's true passion, however, is carving figurines for Liguria's celebrated *Presepi* Nativity scenes.

A dozen Chiavari-area blacksmiths, among them Mario Màttoli, still make the wrought-iron bedsteads, pergolas, plant stands, gates and railings that have been a hallmark of the region since the 16th century. Màttoli, an artisan whose work is on a par with the best of past masters, also learned to smith copper from itinerant gypsies, and makes the best copper baking dishes in Liguria, a must for the perfect chick-pea *farinata* or focaccia.

But there is one craft in particular that has made Chiavari famous throughout Italy (and at one time all over Europe). Say the name of this small but prosperous city and any Ligurian will think "Chiavari chairs." Elegant, simple and extraordinarily light—some weigh as little as two pounds—these chairs are crafted exclusively from local beech, maple, ash, walnut and cherry. Following Ligurian tradition, the trees are felled only during a waning moon in deepest winter. The wood is seasoned for up to a decade, then sawed, bent, carved and assembled under tension, like a stringed instrument. So precise are the joints and engineering that no nails are needed, only a drop or two of organic fish-based glue. The finished chairs are lacquered or painted, then caned by other specialized artisans. No one seems to know why, but men have always built the chairs and women have always made their seats. Local hero Giuseppe Gaetano Descalzi, a master cabinetmaker widely considered the Ligurian Chippendale or Sheraton, is credited with the invention of the Chiavari chair in the late 18th century. Descalzi's chairs, tables and divans are found in many private collections, as well as decorative arts museums and mansions, including

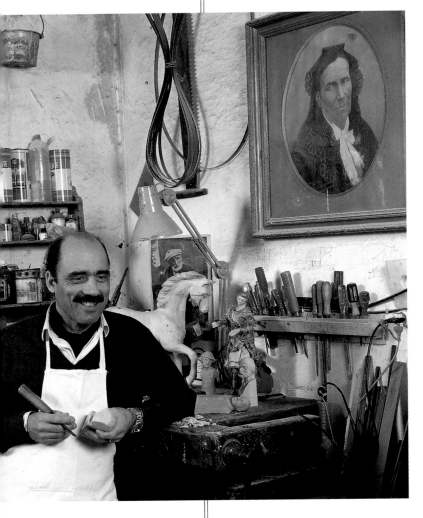

Cabinetmaker Franco Casoni of Chiavari. *Opposite:* A 17th-century *bamboccio* chest of drawers, flanked by an antique Albissola vase and a porcelain figurine, topped by a richly sculpted Renaissance cabinet.

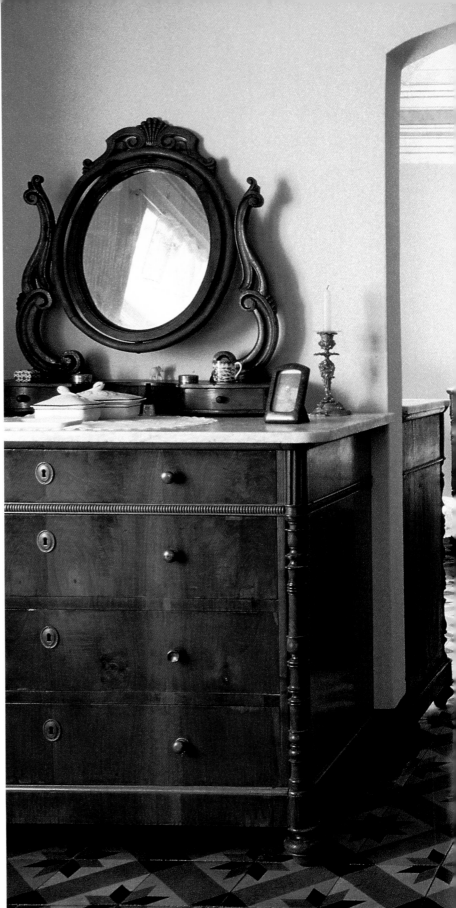

Ironsmith Mario Mattoli with an antique Ligurian bedstead at his workshop in Chiavari. *Right:* The master bedroom of an 18th-century Ligurian country house, with a wrought-iron canopy bed and typical Genoese tiled floors.

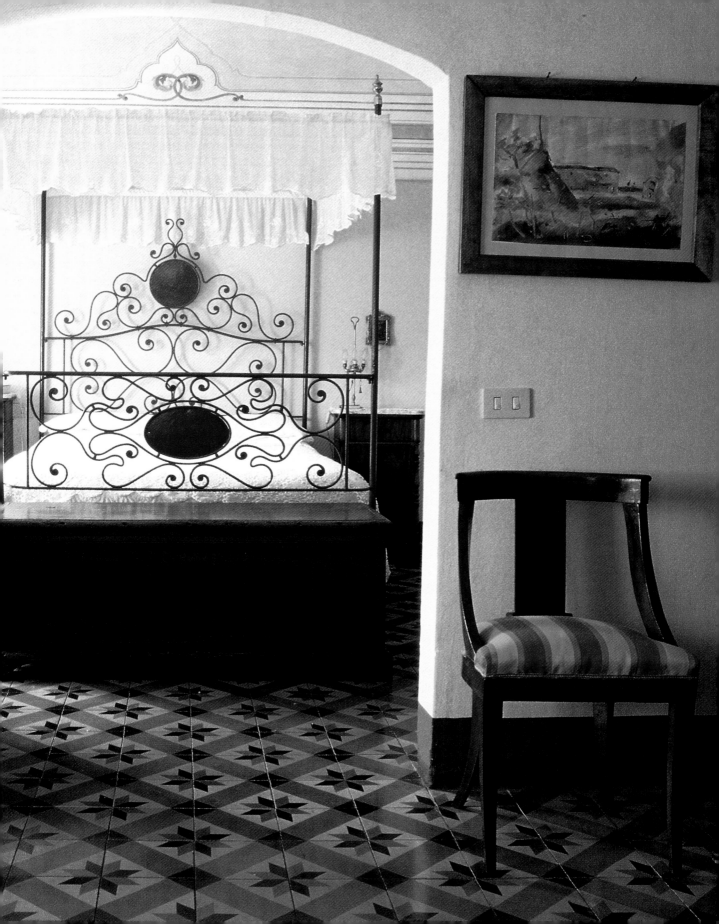

Genoa's Palazzo Rosso, Chiavari's Palazzo Rocca and Turin's Palazzo Reale. The popularity of Chiavari chairs reached its height in the mid-1800s, when Charles Louis Napoleon fell in love with them and ordered hundreds for his imperial residences. Some of Descalzi's original models are still made today, the most popular of which is the celebrated Campanino, a handsome chair with a slightly curving backrest. But lifelong craftsmen like the Rocca and Strucchi brothers of Sedie Artistiche Chiavaresi, or the Levaggi brothers, now produce dozens of other models, from elaborate (sometimes kitsch) 19th-century styles to sleek contemporary designs commissioned by architects from around the world. I would wager that nearly every family in Liguria has Chiavari chairs, for this peculiar piece of furniture is to the Ligurian interior what pesto is to Ligurian cooking.

The region's signature craft remains trompe-l'oeil and fresco painting for several reasons. The first and most prosaic is that tens of thousands of historic buildings are protected by heritage laws that require them to be decorated in this manner. The second is more romantic: most Ligurians love the cheerful colors and detailing of their pink, red and peach homes, colors that fade with the sun to delicate rose, russet and apricot tones. After a lifetime or two, just when they have reached their peak of weathered complexity, they are stripped of their mortar and re-frescoed, much to the chagrin of those who prefer a sun-washed patina. Some historians contend that this mortaring and painting tradition is a result of the need to color-code the properties of a clan: all the houses, towers and loggias of a medieval *borghetto* would have been painted in an easily identifiable color scheme. In the countryside, the farmhouses, barns, wineries and olive oil works of an extended family would have received similar treatment. There are some who argue that Liguria's kaleidoscope of colored buildings is instead a response to the desire of fishermen and sailors to be able to spot their homes from the sea. Fanciful as that might sound, it is entirely plausible, since churches, homes, palaces and villas were nearly always designed to face out to sea, toward the southern light, and many were built with widow's walks or observation towers. If those at home wished so strongly to look out to sea to spot their loved ones it seems only natural that the reverse should also be true. At any rate, dozens of skilled masons and decorators carry on the tradition today, with varying degrees of success. Ignorance and cost-cutting sometimes lead builders to mix cheap cement into the inert, long-lasting, lime-and-sand mortar that has been used here since Roman times. Authentic Ligurian trompe-l'oeil is an art that takes years to master and is often best practiced by fine artists with classical academic training. As a result of the ongoing renaissance in the

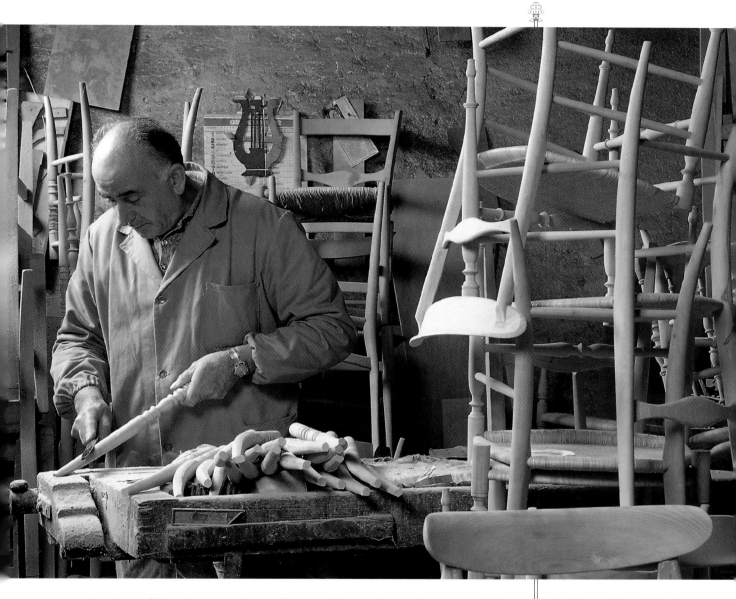

restoration of historic properties under way all over the region, more of these artists are working now than have been for decades. Of course trompe-l'oeil and eye-catching colors are not to everyone's taste and never have been. "The painted houses are ugly indeed," scoffed French novelist George Sand during a visit to Liguria in 1855. "Happily the fashion is changing." This is proof that Sand may have been a talented writer but she was neither an arbiter of taste nor prescient. Ligurian trompe-l'oeil, like many other regional crafts and customs, lives on.

Crafting a Chiavari chair in the S.A.C. workshop.

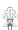

The Palazzo Doria

From a historical standpoint, the most important villa in Liguria is the Palazzo Doria del Principe at Fassolo, now in the center of Genoa but outside the city walls when it was built in the 1400s. It is still occupied by members of the Doria family. The villa essentially launched the mannerist style in Liguria and the fashion for building ever bigger, more sumptuous estates around Genoa and on the Riviera. Being first a Commune and then a Republic, Genoa had no royal palace in which to entertain visiting monarchs. In 1528 Andrea Doria, having been given the title of Prince by Charles V of Spain, decided to transform an existing villa into just such a palace and invite the emperor to stay. Apparently the Doge's Palace near today's Piazza de Ferrari was not up to scratch. Doria summoned the mannerist painter Perino del Vaga, Raphael's favorite pupil, who had fled the Sack of Rome and was keen to find a patron. Del Vaga not only frescoed most of the palazzo's interior, including the celebrated Hall of the Giants, with its outsized allegories representing Doria and Charles V, but also designed elements of the building itself and its theatrical gardens. Thanks to del Vaga the first of Genoa's monumental sculpted *pietra di promontorio* sandstone portals soon framed an entrance hall looking out onto terraces that swept several hundred yards to a white marble seaside loggia and private harbor. An elegant colonnade surmounted by a panoramic terrace ran the length of the palace, just as it does today, and since Andrea Doria is known to have loved cats it was probably as heavily populated with felines then as it is now. In 1841 Alexandre Dumas described the already decrepit palace as "the king of the gulf; to look upon it it seems that Genoa was built like an amphitheater around it to please the eyes of those who lived there."

Indeed, even an untrained eye can see that the palace's seafront position was strategic, affording the admiral direct access to his fleet via his private pier. It was also located outside the city walls which meant it was not subject to the Draconian sumptuary laws passed in 1484 by Cardinal Paolo Fregoso. These laws forbade in Genoa proper the wearing of diamonds and clothing made of luxurious velvet fabrics, and the eating of sinfully rich foods, especially sugar combined with meat— the sort of indigestible fare that was giving ulcers to bluebloods all over Europe. The existence of these laws seems to have captured Dumas' imagination, for in his *Impressions de Voyage* he refers to them repeatedly and tells the tale of Doria's famous feasts. They were served, we learn, on "silverware and silver dishes [which were] changed three times and, after each service, thrown into the sea; it is highly probable that hidden underwater were nets, with which the plates and pitchers were fished out the next day, but this is a jealously guarded secret of the Doge's that has never been revealed."

The palace was modified and enlarged by ensuing generations, but it has always remained in the Doria family. When Giovanni Andrea Doria III married Roman heiress Anna Pamphilj in 1671 and shifted the family's main residence to the Palazzo Pamphilj in Rome, Andrea Doria's by then rather

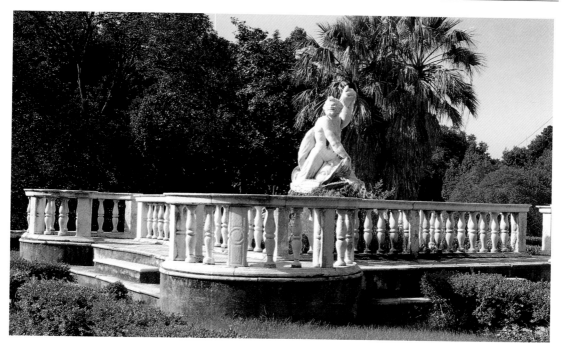

The garden and fountain of the Palazzo del Principe Doria at Fassolo.

shabby architectural showcase became a summer house filled with cobwebs and was gradually abandoned by the family. Parts of its gardens were expropriated over a century ago by Italian State Railways; the seafront highway and ferry building—the Stazione Marittima—cut off access to the loggia and the sea. For most of this century the palace was rented out to a variety of tenants. Some years ago, when I first visited it, what had been a grand salon was a warehouse stuffed with crates, from inlaid marble floor to frescoed ceiling. Luckily for Genoa and the palace, in 1995 the current heirs to the Doria estate, Princess Gesine Doria-Pamphilj, her husband Massimiliano Floridi and her brother Prince Jonathan, decided to move back to Andrea Doria's mansion to restore it and the seaside gardens to their former glory, a courageous undertaking sure to keep them busy for several generations.

Overleaf: The celebrated Serafina delicatessan in old Genoa specializes in vegetables preserved in olive oil—*sott'oli*—and pesto.

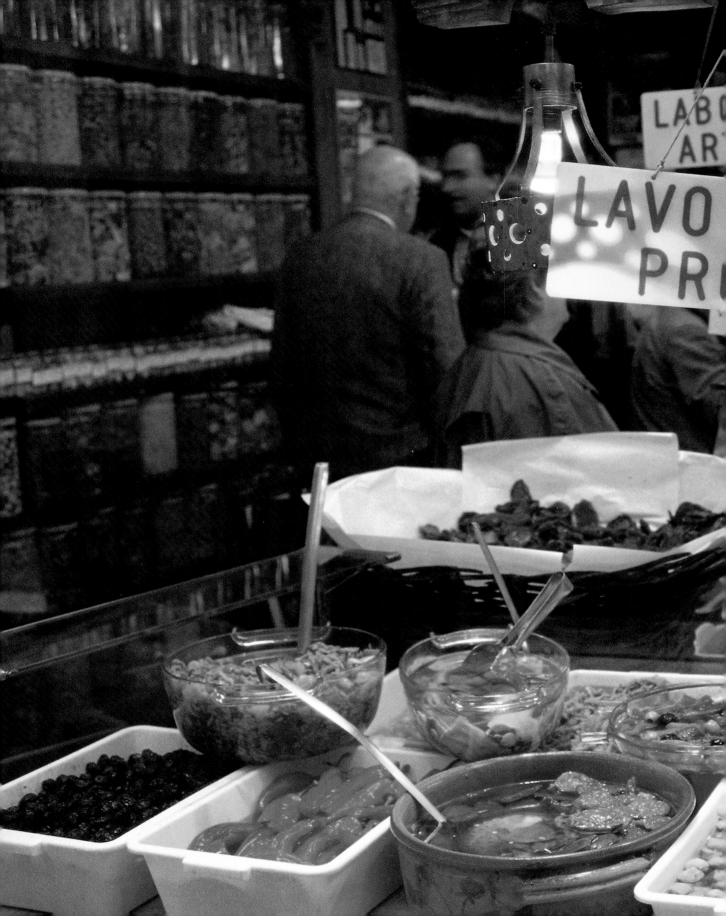

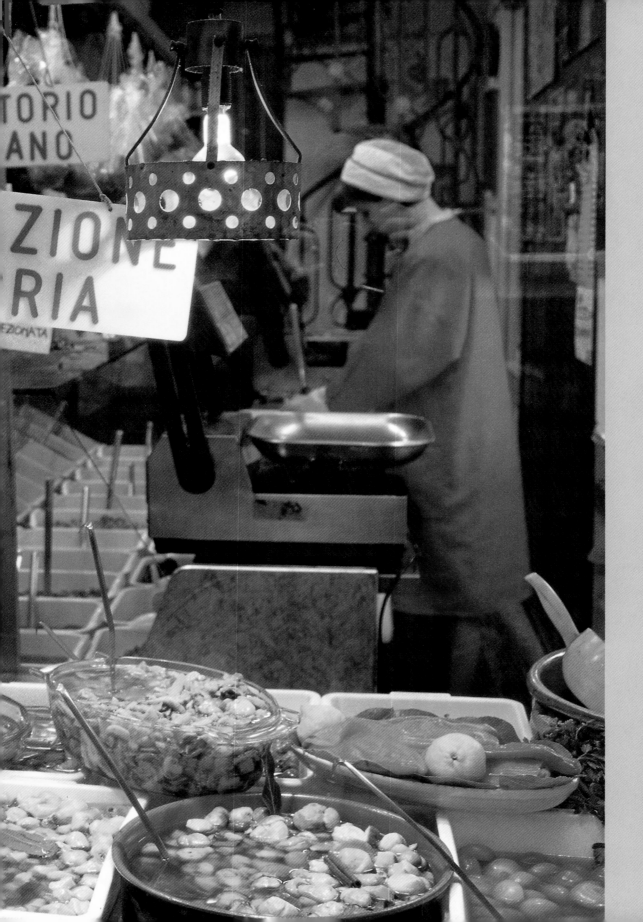

\mathcal{T}he Genoese flag, a field of white emblazoned with the red cross of Saint George, lacks something fundamental: the trinity of basil leaf, mortar and pestle. Nowhere is the identity of Ligurians more clearly seen than in the culture of food and nothing is more distinctly Ligurian than pesto. Dockworkers and bluebloods are as deft at making it as famous chefs and even more inclined to discourse on the poetry, politics and history of the luscious green sauce. Stroll down a bustling street in old Genoa and ask anyone you meet how to concoct it and soon you will be engulfed by a crowd of impassioned pesto experts. "What is that scent of alpine herbs mixing so strangely with the sea spray on the Riviera's cliffs," asked writer Paolo Monelli in a florid, 1934 essay on the region. "It is the odor of pesto: that condiment made of basil, Pecorino, garlic, pine nuts, crushed in the mortar and diluted with olive oil. . . . [It] is purely Ligurian; it speaks Ligurian; the mere smell of it makes your ears ring with a dialect at once sharp and soft, full of sliding sounds, of whispered syllables, of dark vowels."

Monelli could have been writing today. An apocryphal tale has it that when Pope John Paul II visited Genoa in 1990 basil and olive oil were slipped by a local priest into the Holy Water with which the city was blessed. Pesto remains the touchstone of Ligurians, a bastion as solid as the Apennines that protect the region's gastronomy from the perceived onslaught of barbarian influences. Manning the defenses are members of the Confraternità del Pesto (Brotherhood of Pesto), an association created in 1992 to uphold the authenticity of the sauce. Its militants include distinguished poets, writers, gourmets from all walks of life and basil-growers based in the western

Small, tender basil leaves, the most important ingredient in pesto.
Above: Purists, like the members of the *anti-frullatoristi* (anti-blender) faction, claim that pesto can be made only with a stone mortar and olive wood pestle.

\mathcal{T}he arcana of pesto-making extends to the origin of the basil and the color and texture of its leaves.

suburbs of Genoa, where the plant is said to excel thanks to the soil, sun and air. However, despite the admonitions of well-meaning Pesto Brothers, no two Ligurians will agree on the origins of the condiment, how old it is and how it is best made. Are pine nuts necessary? Not if pesto goes into *minestrone alla genovese*, the city's celebrated thick vegetable soup. What about garlic? It should be measured in cloves, say those who like pesto strong; others blanch their garlic or avoid it altogether. Can authentic pesto be made with anything but a mortar and pestle? The word *pesto* means "crushed" and the *anti-frullatoristi*, a faction dead-set against food processors and blenders (*frullatori*), would rather die than eat a mechanically blended sauce. The arcana of pesto-making extends to the origin of the basil and the color and texture of its leaves, the ratio of Parmigiano to Pecorino and the suitability of incorporating other herbs like parsley and marjoram—heresy to purists. The trouble is, no one has yet defined purity in pesto's perfumed realm.

This obsession is more than pedantry or eccentricity. It is indicative of the passion and particularities of the Ligurians themselves and of their cooking, which changes, like their dialects, from village to village, from the Levante in the east to the Ponente in the west and from coast to interior. This culinary *campanilismo*—my village knows best—means that there is no unified Ligurian cuisine but rather a group of common ingredients and techniques used to make a core of dishes in similar ways throughout the region. Nowadays all Ligurians eat local variations of pesto; focaccia (a flatbread with olive oil); *farinata* (a chick-pea flour tart); rabbit with olives and herbs; rockfish and anchovies in soups, stews and tarts, or stuffed, fried or grilled; *stoccafisso* (dried cod); ravioli or other filled pasta; vegetable tarts and stuffed vegetables; pandolce (a coffee cake with candied fruit) and a score of other pan-regional dishes. In San Rocco di Camogli you can buy olive-pulp bread which until recently was found only in Levanto, where it was invented centuries ago, and La Spezia's *mesc-ciùa* (a soup of chick-peas, white beans and winter wheat) is now popular in Genoa.

Similarly, every serious kitchen from Sarzana on the edge of Tuscany to Ventimiglia bordering France will be stocked with local olives and oil, pine nuts, salt-preserved anchovies, fresh and pickled vegetables like zucchini, chard, tomatoes and eggplants, white beans, chick-peas and preserved mushrooms, and the region's ubiquitous herbs—basil, marjoram, parsley, thyme and rosemary. Herbs are the basis of nearly every dish and could be said to define Ligurian cooking, distinguishing it from other regional Italian cuisines. The

second defining trait is leanness; it approaches what local food writer Bruno Bini, echoing historian Jacques Le Goff, calls the diet of the Golden Age of Antiquity, which was based on vegetables, fruit, olive oil, wine, fish and grains.

Less poetically perhaps, modern dietitians consider the region's food as typical of the so-called Mediterranean diet. It is no coincidence that this term—it does not mean a weight-reducing regime but rather a way of eating—was apparently coined in the 1940s by Dr. Lorenzo Piroddi, a physician who studied the eating habits and health of American POWs during the Second World War and compared them unfavorably to those of his fellow Genoese.

A loosely codified Ligurian cuisine indeed exists in upscale restaurants, bakeries and delicatessens throughout the region, but local specialties remain firmly rooted to their villages. Ask a home cook or trattoria owner from Sarzana about the Ponente's *barbagiuai* (plump ravioli stuffed with pumpkin, puréed white beans and spicy, fermented brusso cheese, cooked on hot stones) or *sardenaira* (a kind of pizza topped with anchovies, tomatoes, onions and black olives) and you will be met by the same blank stare that you would receive in Ventimiglia if you inquired about the Levante's *testaroli* (a crêpe-like pasta usually dressed with oil and grated cheese) or *spongata* (a shortbread pie stuffed with jam, dried fruits and nuts). Many Genoese, living halfway between Sarzana and Ventimiglia, would not recognize any of the four, or dozens of other localized dishes for that matter.

What most people now think of as Ligurian is in fact Genoese cooking with a twist. The city has for centuries adopted and adapted the region's favorite foods, flanking them with made-in-Genoa creations. Most of the truly Genoese dishes can be traced back to the city's maritime past. To cite one well-known example, minestrone with pesto (the sauce's earliest recorded use) was reportedly first served to returning sailors desperate for vegetables and herbs after months at sea. Within living memory the soup was dispensed from "floating kitchens" in Genoa's port and is considered one of the city's unassailable inventions, though similar soups are popular all over Italy.

This is not the whole story, of course, since Genoa's food has always varied from one end of the city to the other and among social classes. In the past only wealthy Genoese, many of whom had country houses or farms in what is now Piedmont, regularly ate beef, for instance. Via Macelli di Soziglia in Genoa's historic district, where the wealthy once lived, has long been given over to

> "*It was a cuisine made of labor and patience and the love of aromatic herbs. It was a cuisine of lean folk who lived on lean land . . . and lean olive trees.*"
> —VITTORIO G. ROSSI

Pesto

Pesto is the most Ligurian of all sauces. Locals who have never peeled a potato flourish their pestles and bouquets of basil at the mere mention of the condiment. This accounts for the myriad and sometimes ludicrous theories about how and with what it should be made. Unfortunately for the Pesto Brothers and gastronomes who would like to trace the sauce to Genoa's Phoenician foundation, there is no sign of it before the publication of Ratto's *Cuciniera Genovese* in 1865, in which it is called *Battuto alla genovese* and only subtitled *Pèsto*. So far the register of everything that went on board the galleys of the Genoese Republic, *Il Magistrato delle Galee della Repubblica di Genova*, though it scrupulously lists centuries' worth of fava beans and sea biscuits (made with white flour, yeast, salt and malt), omits pesto or a comparable sauce. Horror of all horrors, Ratto's milestone recipe calls for butter, equal parts of Parmigiano and Pecorino, with no mention of *trenette* pasta.

One of the best pestos I have ever tasted was made by an octogenarian Genoese woman who used this buttery, mild recipe and a convenient blender. In fact there are very few Ligurians whose mortars are more than decorative kitchen knick-knacks. There is no question, though, that basil and garlic have a rougher texture and a more intense flavor when they are pounded, releasing essential oils, than when chopped mechanically. Supposedly only the combination of marble mortar and olive wood pestle produces the proper taste, but this seems excessive. In any case rock salt is essential when using a mortar and pestle and only an expert can gauge how much to put in. Blenders and food processors chop, not pound, and tend to heat the sauce, so the traditional method should be tried.

Technique is only half the story: fresh, tender, seasonal ingredients tell the rest. Only pale-green sweet basil (*ocimum basilicum*) with a few leaves per plant should be used for pesto—never bush basil (*ocimum minimum*) or high-yield hybrids. Contact with metal, especially iron, should be avoided. The herb's scientific name, taken from the classical Greek *ocymum basilikon*, means "kingly, fragrant herb." In ancient times it was forbidden to harvest it with anything but noble metals like gold or silver. The reason is obvious: iron oxidizes basil immediately, altering its taste. Hence the stone

Opposite: A Ligurian larder, lined with lace, is stocked with sea biscuits, garlic, maccheroni di Natale, pine nuts, zucchini in oil, mushrooms in oil, tomato sauce, polenta, beans, winter wheat and homemade grappa. *Below:* Fresh basil displayed at the Mercato Orientale in Genoa.

mortar and wooden pestle; non-oxidizing stainless steel is the modern solution to that problem.

The ancient Greeks and Romans cooked with basil, pine nuts, garlic, olive oil and cheese and it is not impossible that they made some early form of pesto, perhaps a variation on the theme of the potent, fish and herb sauce known as *garum* which fueled the Legions in their conquest of the known world. That conquest included Liguria, which to the Roman mind was overrun by primitive tribal peoples. It may sound impossibly atavistic but many contemporary Genoese, the descendants of those early Ligurian tribespeople, are not pleased when historians point out that Virgil in the *Bucolics* talks about a paste of garlic, herbs, olive oil and cheese, for they are convinced that pesto is purely Genoese and certainly not Roman. According to the current edition of Antonio Piccinardi's *Dizionario di Gastronomia*, basil probably came from India and was brought west via Asia by the Greeks. As anyone who has lived in Liguria soon discovers, the plant is not native to the region and despite having been cultivated centuries ago will not reseed itself. It must be carefully tended. This does not stop many locals from claiming that good basil can only be grown in Liguria, in a restricted territory reaching from Portofino to Arenzano in Genoa's western suburbs. On the contrary, it heightens their passion. At the mention of Ponente basil from Albenga I have heard distinguished professors shriek, "It's no good and they aren't Genoese!" Greengrocers at the cavernous Mercato Orientale—Genoa's best covered market—scoff at powerful garden-grown basil from the Levante, which develops large, tough leaves. More level-headed is chef Rudi Ciuffardi of Polpo Mario restaurant in Sestri Levante. "Anywhere Ligurians go," he has assured me, "from the North Pole to Los Angeles, they will manage to grow delicious basil." Curiously, the story of the shipwrecked crew of the *Italia*, a sailing ship from Camogli that washed ashore in 1892 on the volcanic island of Tristan da Cunha near South Africa, would seem to belie Ciuffardi's claim. The sailors risked their lives to save a mortar and pestle from the *Italia*. Unfortunately for them and their descendants, no one has so far been able to grow basil on the island's volcanic soil, and the mortar is now in the local museum.

As far as can be deduced, pesto's probable birthdate is around 1850, between the death of Genoese poet and gastronome Martin Piaggio in the 1840s and the 1865 publication of the *Cuciniera Genovese*. Local food writer Silvio Torre points out that the prolific Piaggio wrote extensively about Ligurian food but never mentioned pesto. Basil preserved in olive oil and added to various sauces was certainly known long before then. It was probably the advances in greenhouse technology in the mid-1800s that made the herb available year-round and led to the development of the sauce as we know it today. Connoisseurs insist that the most fragrant basil comes from greenhouses, specifically those located in Prà, Voltri, Coronata and other western Genoese suburbs, from which it is exported all over Europe, especially in winter. The best is supposedly grown in the shady streets of old Genoa. Basil grown in direct sun is felt to develop a disagreeable minty flavor, and should be blanched in boiling water before use. No one can say what the most authentic recipe for pesto is and the debate will continue for as long as Ligurians draw breath. The Parmigiano versus Pecorino controversy is

academic, since both cheeses have been popular in the area since the Middle Ages and the amount of either is simply a matter of taste. A 1911 recipe I found in *L'Antica Cuciniera Genovese* calls for aged gouda, three cloves of garlic and only a few leaves of basil. No one seems to object that in Recco and Camogli *prescinsêua* cheese is added to give a creamy texture and a touch of acidity. Pine nuts are consistently left out when pesto is made to be blended into minestrone. It also appears to be uncontroversial to add baby spinach leaves to deepen the sauce's green color. Parsley pesto, made for generations throughout the entroterra, remains popular especially in winter months when garden basil dies and the greenhouse variety becomes more expensive. Other herb pestos like *pisto kastarnoésa* from Castelnuovo Magra near Tuscany, combining everything from walnuts and parsley to marjoram, are interesting but should probably not be considered true pesto.

Arguably the only indispensable ingredients for Ligurian basil pesto are basil, olive oil, salt and garlic. Garlic must be stressed, for if the origin of the sauce is not *garum*, the most likely second possibility is the age-old mariner's condiment *aggiàda*, a palate-bucking blend of garlic, vinegar and salt, to which some clever sailor probably added basil preserved in oil. In his writings on Liguria, Vittorio G. Rossi, an unbending regionalist, snarled about "the tender mouths of the Milanese," who supposedly hate garlic but love strong basil and from the 1950s to the 1970s were bringing about the ruin of the genuine article. This is overstatement, since too much garlic kills the perfume of the basil.

butchers' shops. For centuries the diet of the upper classes closely resembled that of their European peers, a sort of early Continental cuisine. So lavish were Renaissance feasts that in 1484 Cardinal Paolo Fregoso established restrictive sumptuary laws regulating the use of sugar in cakes, candies and sauces, and codified what sorts of foods could be eaten at celebrations within the city limits; it was this law that prompted many rich Genoese patricians to build their villas outside the city in territory not covered by the cardinal's edict.

A favorite recipe of the meat-eating Genoese was, and still is, *involtini* (*tomaxelle*): thin, tender slices of veal filled with a delicate stuffing of ground veal, porcini, pine nuts, marjoram and garlic, then simmered slowly and topped with fresh tomato sauce. *Vitello all'uccelletto* (*vitella a l'öxelletto*), easier to prepare, is another perennial and exquisitely Ligurian dish made with shredded veal sautéed with fresh bay leaves and white wine. In his charming book *Cucina e Santi* (*Cooking and Saints*), Genoese poet Vito Elio Petrucci recalls how until recently the less well-to-do Genoese, able to eat meat only on special occasions,

A 19th-century tripe storefront in Genoa's historic district.

would regularly fry up onions to trick their neighbors into thinking they were preparing a sumptuous meal. In fact they were probably eating tripe, the organ meat of the working classes and for centuries a favorite of Genoa's city guards, *gli sbirri*, after whom the gutsy *trippe da sbira* stew takes its name.

Only in this century have Genoa's city limits extended beyond the old ramparts, encircling what used to be autonomous villages with their own specialties. Imagine a large American city in which the food and language changed every few miles, say from Battery Park to the Empire State Building in New York. Then imagine that most of that food was unavailable in the Bronx or Brooklyn, let alone Boston or Philadelphia, and you begin to get an idea of the Ligurian culinary universe. This is not to suggest a comparison with the United States and its innumerable ethnic cuisines but to underscore the mind-boggling complexity of this ethnically homogenous region's culinary culture.

Most of Italy is mountainous and surrounded by seas. What applies to the peninsula as a whole is doubly true of Liguria. The region's spectacular topography and myriad micro-climates account for most of its culinary fragmentation; history and the celebrated reticence of the Ligurians explain the rest. Faced by a threatening Mediterranean and entirely hemmed in by the steep, arid Alps and Apennines, the region lacks the land resources of its neighbors. Their plains and rolling hills produce abundant grain and pasturage for

A plaque on the doors of the headquarters of the Order of the Knights of Ravioli, in Gavi-Ligure.

cattle and therefore milk, cheese and meat. Ligurian Riviera cities have always had easy contacts with other seaboard regions, but the interior—called the *entroterra*, as if it were something distant and vaguely threatening—was poor and isolated until the postwar economic boom. "It was a cuisine made of labor and patience and the love of aromatic herbs," wrote the nostalgic regional writer Vittorio G. Rossi a few decades ago. "It was a cuisine of lean folk who lived on lean land—sea cliffs and terraces hewn by hand from solid stone—and lean olive trees." Rossi beautifully echoes Diodorus, who in the 5th century B.C. spoke of Liguria as "a hard, sterile land" where men and women "live a hard, uncomfortable existence full of hardships and toil. Their physical efforts and the sobriety of the foods they eat have made them wiry and tough."

*P*aradoxically it is this leanness and sobriety that led to the extreme inventiveness of Ligurian cooks, particularly those from the *entroterra*. Narrow mountain valleys linked only by footpaths, mule tracks and winding roads forced those living there to depend almost exclusively on local foodstuffs. Where chestnuts grew in the

mountains of the Levante, for instance, the so-called Chestnut Civilization developed, in which the trees provided shelter, fuel and food for animals and people. Any number of chestnut-flour dishes were invented, from fresh *picagge matte* pasta, originally dressed only with vegetables and lard (pressed between slabs of marble), to naturally sweet *castagnaccio* cake with pine nuts and fennel seeds. While most of Liguria produces no cheese, high pastures where goats and sheep could be raised allowed shepherds in the Ponente, and in areas in the Levante behind the seaside town of Recco, to produce limited amounts of it. This led in turn to recipes for *barbagiuai* ravioli or *focaccia al formaggio*, a succulent flatbread with fresh cheese sandwiched between paper-thin crusts. Cheese focaccia is now Recco's flagship dish, the object of gastronomic pilgrimages from far and wide; the local ducks have become fat and unable to fly from feeding on it and are a tourist attraction themselves. Another highly localized specialty comes from Dolceacqua, near the French border: *crava e faxeu*. It is made with tough but tasty milk goat which, at the end of its productive life, is sautéed with onions and white beans and spiced with hot peppers.

The mountainous land imposes severe limits on farming and ranching. Though for centuries returning sailors hauled sacks of prized manure and compost back from Tuscany not much of it made it inland and the soil there is uniformly rocky. The climate on the coast is mild year-round, but in the *entroterra* it becomes progressively colder the deeper the valley and the higher the elevation. Vegetables that grow well in the lowlands do not necessarily thrive on the mountains. Ligurian valleys, inhabited for millennia from sea-level to three or four thousand feet, yield a number of different kitchen-garden crops in a single growing season. This means that for every micro-climate there is a micro-cuisine.

It is easy to see why fresh seafood was unavailable in remote areas only miles from the sea. Elderly fishmongers I know recall how they once met boats on the shore and carried basketfuls of fish on their heads up thousands of steps to coastal hamlets, some of which remain accessible only on foot. Those living in the *entroterra* had to make do with salted anchovies, dried or salted cod and other easily transportable preserved fish. Because of these long-standing traditions, even today you will not find fresh fish on an authentic *entroterra* menu, though you may drive on a good road to a comfortable restaurant and be served on a panoramic terrace with sailboats on the horizon and the smell of the sea in the air. Similarly you will rarely find wild mushrooms or game on seaside tables, though wild boar, hare and porcini are seasonably plentiful only minutes away in the interior.

Liguria's first comprehensive regional cookbook, La Cuciniera Genovese, was written by Giovanni Battista Ratto in 1865. Largely unaltered since, it is the bible of Genoese cooks and is in its eighteenth edition.

Olive Oil

If aromatic herbs define Ligurian cooking, olive oil underlines it. The single ingredient in almost every Ligurian recipe is olive oil. Not just any oil, for Ligurian olives produce a light, fragrant oil pressed from a handful of olive tree varieties that have thrived exclusively on the Riviera and in some inland areas for two millennia. There is barely a terraced mountainside not shagged with the silvery green trees shimmering in the breeze, painting the landscape in all seasons. In winter and fall, orange, green and yellow nets hang like hammocks under the groves, tied to the old, gnarled trunks to catch ripe olives. Look carefully as you travel along the coastal strip during the harvest season—from November to January—and you will discover dozens of small olive oil presses called *frantoi* buzzing with activity. Olive growers and *contadini* band together to operate the mills, turning heavy work into a festive social occasion. The intoxicating scent of freshly crushed olives wafts up with the sound of the huge, hurtling mill stones used to reduce the unpitted fruit to a glistening pulp which is spread on mats that are stacked, then pressed until a thick green oil with yellow highlights runs free.

Today the Ligurian olive oil industry is enjoying a renaissance in quality not seen since the 1700s. The ancient Greeks probably first brought the trees to the region but they were not planted extensively until the Romans arrived. Like basil, olive trees do not grow wild and must be tended to survive. It was in the medieval monasteries and convents that their cultivation continued after the fall of the Roman Empire. A thousand years ago monks near Lavagna, on the Riviera di Levante, hybridized the Lavagnina variety; others near Taggia on the opposite shore developed the Taggiasca. Taken together they account for nearly all the region's olive trees (other sub-species include *leccino*, *moraiolo*, *razzola* and cross-breeds collectively called *frantoio*). In the 1300s Petrarch marveled at the forests of olive trees near Genoa and two centuries later the German Joseph Furttenbach noted that many houses were equipped with olive oil storage tanks, like bathtubs hidden under the floor. "Ever since the Genoese began losing their assets in Vienna, Venice and Spain they have been investing in the deforestation of mountainsides in order to plant olive trees," wrote Montesquieu in a letter from Genoa dated 1728. "In the last twenty years the number of groves has much increased." By the end of the 18th century Liguria had become Italy's number-one producer, a position it maintained until well into this century. After a decline in quality in the 1950s, when thousands of trees were uprooted and replaced with flower fields and greenhouses along the Riviera dei Fiori, the region's oil is again considered among the world's best. (Antonio Mela's family-run Frantoio Sant'Agata near Oneglia won the coveted 1996 Ercole Olivaro award in Spoleto for Italy's best "light and fruity" oil.) It is also among Italy's most expensive because of high production costs and low yields. A ton of top-quality Ligurian olives costs at least twice as much as their Tuscan equivalents and ten times as much as the

bulk blending olives that are imported from Morocco and make up about half the contents of most factory-produced European oils.

Drizzle a teaspoonful of top-quality raw Ligurian *olio extra vergine d'oliva* on your tongue and you will taste wild flowers, chamomile, almonds and pine nuts. When used as a cooking fat the best Ligurian varieties do not overwhelm the ingredients the way a powerful Tuscan oil or southern Italian, Spanish, French or Greek oils may. Those can be excellent but are rarely subtle and are not suited to the light, mostly vegetarian Ligurian register where the unmediated, pure flavors of the ingredients are essential. The best Ligurian oils come from mountain terraces at the limit of the olive tree line: 1,600 feet above sea level in the Levante and 2,400 feet in the Ponente. Above this altitude the trees cannot survive the winter. The higher the grove, the more delicate the oil. These trees are also free of the Mediterranean olive fly, *dacus oleae*, whose larvae feed off the fruit and—by causing rot—indirectly cause an increase in acidity. One of the better small-scale producers I know is the Frantoio Portofino. Their old-fashioned oil works is located high on the hills behind Rapallo among some of the finest groves in the Levante. Like other top producers, Frantoio Portofino sells a special extra virgin reserve oil, made with hand-picked, slightly premature olives that are crushed with stone wheels, cold pressed, then centrifuged to remove suspended impurities and decanted. The olives are not heated, which would extract more oil, nor is the oil filtered, two processes that lower the quality. Another small, world-class producer is the Azienda Agricola Noceti near Sestri Levante: Noceti allows its olive groves to lay fallow during alternate seasons, to rotate production and ensure uniform quality year-to-year. All the best oil makers on both ends of the Riviera allow their products to settle and mature in the dark until the following spring, when they are ready to be used.

Like winemakers, local oil experts hold tastings and rate the bitterness, spice, sweetness, nose and aftertaste, then write enthusiastically about the taste of fresh-cut grass, the heady forest smells, the undertones of oregano and sweet peppers. By the taste and smell they can tell the olive tree varietal, the location of the grove and the way the oil was made. This can become excessive: I have never encountered more olive oils on a menu than at the Ristorante Il Frantoio in Santa Margherita, an upscale operation in a former olive oil factory where dozens of bottles are wheeled towards you on a dessert cart. Unlike wine it is difficult to taste and spit out olive oil.

Opposite: Taggiasca olives and oil, and a basket of olive pulp bread baked at Panificio Maccarini.

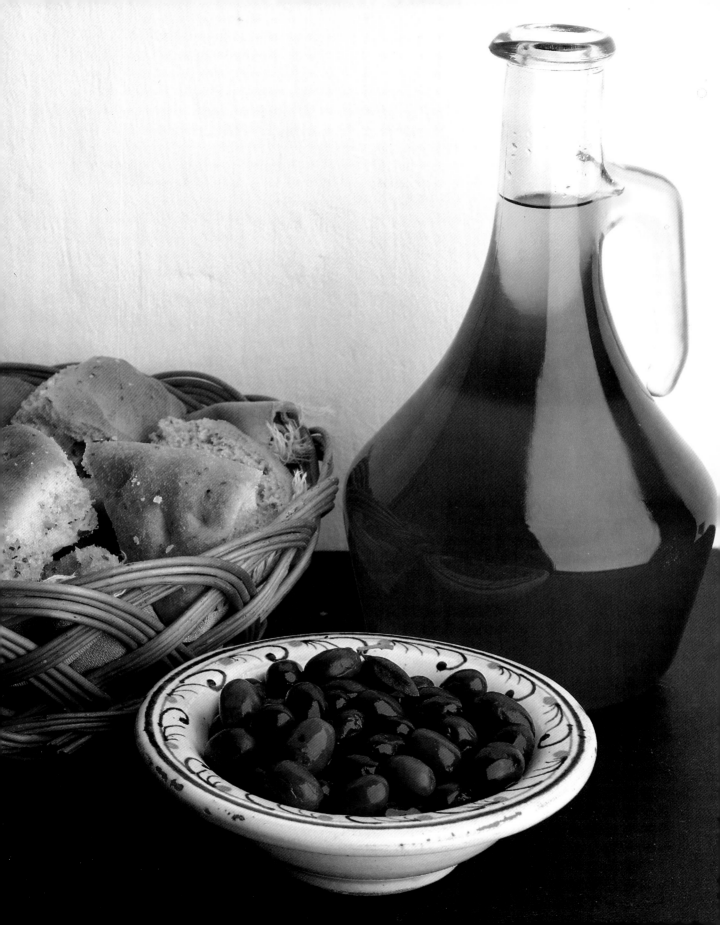

Inevitably the region's intricate history has shaped the cooking too, though it would be fanciful to trace most of today's particularities to ancient roots. Except for generalized references to leanness, no documents relating to local food exist before the Middle Ages. Yet the Ligurian tribes of antiquity almost certainly had distinct eating habits, some of which may have left a mark. For example, cooking on hot slabs of slate—*ciappe* in Ligurian dialect—was a common technique used until recently wherever the stone was available, particularly in the Val Fontanabuona behind Chiavari and Lavagna. A handful of restaurants still offer mutton, goat or tuna cooked in this way and seasoned with aromatic herbs. Similar stone-cooking techniques appear in parts of southern France, formerly within the territory of Ligurian nomadic tribes. In the Sarzana area, on the edge of Tuscany, locals have been using flat, earthenware disks to make a variety of grain and pasta dishes (*panigacci* or *testaroli*, for instance) since pre-Roman times. The disks, called *tèsti*, are still sold in specialty shops in the area. Utensils similar to contemporary *ciappe* and *tèsti* were employed in antiquity for making breads, focaccia and possibly chick-pea *farinata* in other parts of the Mediterranean basin. A thousand years later, in the 10th century, the Emperor Berengarius II divided Liguria into three units following ancient boundaries. That division corresponds roughly to the linguistic, administrative and culinary zones of Levante, Genoa and Ponente still evident today. Some contemporary Ligurian cookbook writers, including Bruno Bini, split the region's recipes into three distinct groupings following this tri-partite plan.

While scarce resources fostered inventiveness, it was neglect by the outside world that preserved the authenticity of Ligurian food down the centuries. Culinary historians point out that few Ligurian recipes appear in the world's first modern cookbooks, which were compiled and published in Italy in the late Middle Ages and the Renaissance. While anonymous chefs in Tuscany, Piedmont and Naples busily turned out their region's *libri di cucina* the Genoese remained aloof. Liguria's first comprehensive regional cookbook, *La Cuciniera Genovese*, was written by Giovanni Battista Ratto in 1865. Largely unaltered since, it is the bible of Genoese cooks and is currently available in its eighteenth edition at every Ligurian bookstore worth its salt and pepper, though Ratto's book remains relatively unknown outside the region. This is due in part to the fact that at the turn of the century much of Italy came under the sway of celebrity cookbook author Pellegrino Artusi (1820–1911), whose *La scienza in*

The last thing sailors returning from a long sea voyage want to eat is fish; Ligurian coast cooking was until the postwar period geared almost exclusively to satisfying waves of returning marinai.

cucina e l'arte di mangiar bene (*The Science of Cooking and the Art of Eating Well*), published in 1891, sanctified the cuisine of Artusi's native Emilia-Romagna and that of Tuscany, long considered Italy's aristocratic cuisines (along with that of the House of Savoy in Turin). Artusi essentially created an "Italian cuisine." Anyone who has experienced Italy more than superficially, however, knows that no such cuisine exists beyond the restaurants of famous chefs and international hotels. In any case Artusi did not approve of what he doubtless considered impoverished, meatless, creamless Ligurian food and gave only a few recipes from the region in his book. They include ravioli and rolled veal scallops (*tomaxelle* in Ligurian dialect). Not surprisingly these comforting dishes have long been popular throughout Italy, though no one thinks of them as Ligurian.

Neglect, poverty and reticence have been a blessing in disguise. You can count dynamic Milan's authentic regional restaurants on the fingers of one hand; legions of self-styled *trattorie Toscane* and *pizzerie Napoletane* have colonized the world with standardized Italian food. On the contrary Ligurian cooking remains distinctive and not always to everyone's taste. I recall dining with a group of well-traveled Americans, Canadians and Australians at a restaurant in Sestri Levante where we sampled numerous local specialties. None was recognized by my fellow diners and while most of them enjoyed their meal, several were dismayed by the heady aromatic herbs, the whole baby squid and octopus, and several spiny fish. "This isn't fish," exclaimed one, "it's bait."

*V*isitors are justly surprised by the Ligurians' peculiar relationship with fish. The sea has traditionally been this maritime region's main economic resource, but primarily as a means of trade and transport and only secondarily as a source of food. The last thing sailors returning from a long sea voyage want to eat is fish; Ligurian coast cooking was until the postwar period geared almost exclusively to satisfying waves of returning *marinai*. Like many seafaring nations the Ligurians long regarded the Mediterranean with suspicion. It was an unfathomable place in which ships sank and sailors drowned or were devoured by sharks—not very appetizing to diners. Lack of proper refrigeration meant fresh fish had to be consumed immediately, further limiting its popularity inland. Freshwater fish like trout, salmon and sturgeon once thrived in the region's many rivers and streams and the *piscina* hatcheries of aristocratic villas. They were generally preferred to ocean fish and were readily available in the *entroterra*. Unfortunately, in most of Europe today wild freshwater fish are scarce. Recipes calling for them have all but disappeared in Liguria with the

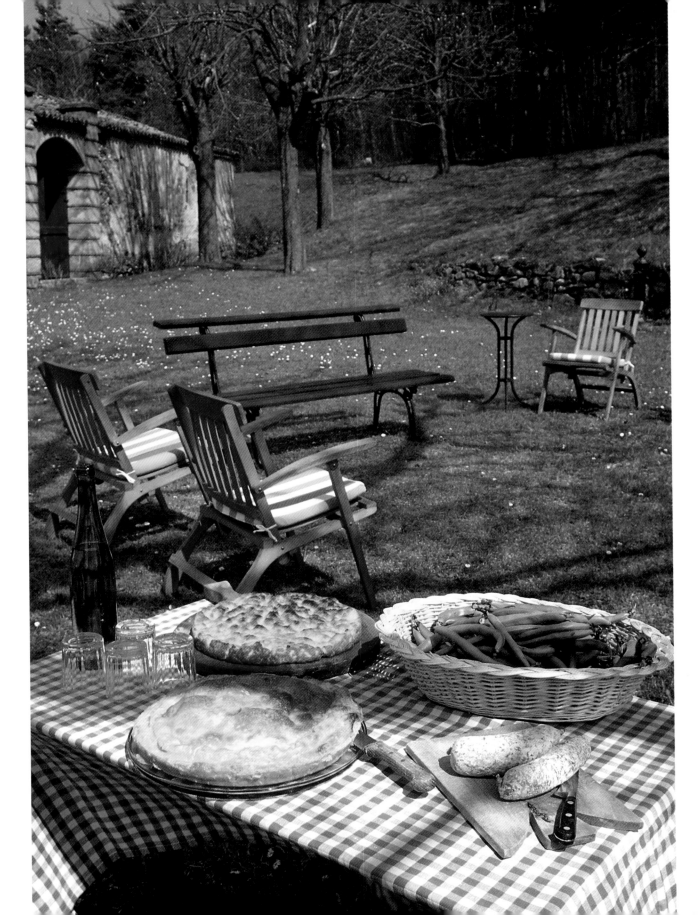

exception of one curious medieval sturgeon dish now made with turkey and described by local food writer Franco Accame in his cookbook *Mandilli de saea*. According to Accame, the turkey is boiled in water and white wine, seasoned with bay and nutmeg, and called *bibbin a-a storionn-a* (turkey sturgeon-style).

Certainly the dearth of dishes in the regional repertoire made with fleshy Mediterranean seabass, swordfish, bluefin tuna and flounder at first glance seems odd for a region with hundreds of miles of coastline. In fact the Gulf of Genoa does not abound in these fish and possibly never has. Prolonged over-fishing and pollution in modern times are partly to blame for fishery depletion worldwide but do not explain the centuries-old saying about Genoa's *mare senza pesci*, a sea without fish. The phrase is sometimes erroneously attributed to Dante but was more likely said by a resentful Pisan after that city's rout by the Genoese in the late 1200s. Self-deprecating Genoese seem to enjoy repeating the slur "fishless seas, barren mountains, shameless women." Of course it was not accurate then and is not accurate now, since the northern Tyrrhenian Sea still produces a respectable catch of mostly small but flavorful mackerel, garfish, mullet, piper, rockfish, tub-fish, spotted and greater weavers, scorpion fish, star gazers, as well as tuna and several kinds of squid. Anchovies and sardines (locally called *pesce azzurro* or blue fish, for their pronounced blue coloring) have been a specialty for centuries. When Thomas Jefferson put ashore at Noli during his 1787 voyage along the Ligurian coast he stayed in "a miserable tavern" that however served "good fish, namely sardines, fresh anchovies." Fifty years later Alphonse Karr noted that "the saying about Genoa's sea without fish isn't entirely wrong. However, the sardines are abundant and exquisite; so too are the mullet, which are the best fish of all. I'll mention mackerel too, which in the sea of Genoa reach a meter in length."

You need only look at the catch of the highly productive *tonnara* at Punta Chiappa just south of Camogli to judge whether there are fish in this sea today. The complex, hand-woven net several hundred yards long has been in use in the same spot from April to September since the 1600s. Suspended from floats, it forms a trap out of which tuna and other fish cannot escape. Go into Camogli's tiny port mid-morning or late afternoon and you will see the *tonnara*'s flipping-fresh catch being transferred from launches to nearby fish shops in time for lunch or dinner.

The Ligurian shoreline also yields octopus and a variety of particularly delicious *frutti di mare*—shellfish such as prawns, lobsters, mussels, sea truffles and sea dates—prepared in dozens of ways. Poet Vito Elio Petrucci recalls how

Opposite: An Easter Monday picnic of fresh fava beans, salame, potato focaccia and *torta pasqualina*.

Wine

Ligurian wines deserve a chapter to themselves, for there are more than a hundred different varieties, produced in every village of the region. Their history stretches back some 2,500 years to the Greeks, who taught local tribes to grow grapes and make wine. Boccaccio adored the wines; Renaissance writers called them nectars and the celebrated turn-of-the-century poet Gabrielle d'Annunzio sang their praises, yet they remain unknown in the rest of Italy, let alone in foreign markets. Only a handful are publicized, most notably Cinque Terre, a pleasant, dry white that goes well with fish, light pasta and vegetable dishes. There is good reason for this neglect: Ligurian wines are primarily white and light-bodied and therefore neither travel nor age well. Their price is the second limiting factor. Production costs are unusually high because of small yields and steep terrain that does not lend itself to mechanized harvesting. However, these factors also ensure high quality in the best vintages, and their unmistakable character makes them the perfect accompaniment to the region's food.

Starting with the Riviera di Ponente on the border of France are the sculpted vineyards where Rossese di Dolceacqua is grown. This light red with a flowery nose is drunk when about one year old and does not improve unless made during an exceptional year. Two of the top producers are Enzo Guglielmi and Pippo Viale, both in the medieval fortress town of Dolceacqua from which the DOC (controlled origin) wine gets its name. Other Rossese wines from the Riviera di Ponente come from a zone stretching from Savona to the French border. Ormeasco, a red made entirely from the Dolcetto grape, comes from the hills behind Imperia and San Remo and is a darker, deeper-bodied wine that can often have blackberry or violet overtones and can be kept for up to three years, though particularly good bottlings can last twice that long. Ormeasco red goes well with poultry, meat and robust pasta dishes. Ormeasco Sciactrà, in contrast, is a light-bodied rosé made from the same red grapes but quickly taken off the skins; it should be served chilled and drunk young, with fish and pasta.

Several of the Ponente's DOC whites are highly distinguished, including my personal favorite, Pigato, also grown from the Savona area to the French border. Drunk very young, it has an intense straw color and a fruity, flowery nose, making it an excellent accompaniment to fish, vegetable tarts, pasta with butter and herbs and *pansòuti*; the best Pigatos I have tasted are bottled by Tommaso and Angelo Lupi at Pieve di Teco, Luigi Anfossi at Bastia di Albenga and Laura Aschero at Pontedassio. Vermentino is another varietal protected by the DOC quality label and produced in the Ponente, often alongside Pigato, but also from the immediate Genoa area. It also should be drunk very young.

The Riviera di Levante's most famous wine is Cinque Terre, which comes from Riomaggiore, Manarola, Vernazza, Corniglia and Monterosso. In the sixties and seventies Waverley Root pointed out that perhaps only a fifth of the grapes that went into Cinque Terre were actually grown there on terraces

perched over the sea. That situation has changed, thanks both to the DOC appellation and the construction of several monorails that have made it easier to harvest the precious Bosco, Albarola and Vermentino grapes. Blended together they produce a straw-colored dry white that finishes with a pleasant bitter flourish on the tongue. The Cinque Terre also yield the superb, potent dessert wine Sciacchetrà, made entirely from sun-dried Bosco grapes. It takes nearly twenty-two pounds of dried grapes—which begin as three times that amount of fresh ones—to produce one liter of this nectar, which should age for at least six years. Good vintages can be kept for decades. (W. De Batté, a vintner in Riomaggiore, makes some of the area's most highly regarded Sciacchetrà and Cinque Terre wines.) Ligurians drink Sciacchetrà chilled with almond cookies, pandolce and castagnaccio.

A relative newcomer to wine shops is Colli di Luni Bianco from the hills behind La Spezia and Sarzana, near the Tuscan border, though excellent wines have been made there since antiquity. This little-known dry white with a fresh, flowery nose is made from a blend of Vermentino, Trebbiano Toscano and a handful of other local white varietals, and is a good match for salads, fish and light pasta and vegetable dishes. Colli di Luni Vermentino, from the same area, is almost entirely of the Vermentino varietal and often has a more intense nose and flavor. Ottaviano Lambruschi, a winemaker in Castelnuovo Magra, produces some of the best Colli di Luni whites I have tasted; another good cellar in the same town is La Colombiera, and Fattoria Casano in nearby Ortonuovo is also noteworthy. Some Colli di Luni reds are surprisingly complex and are sure to be recognized abroad soon as remarkable wines. DOC Colli di Luni Rosso, a blend of Sangiovese, Canaiolo, Pollera, Cabernet and Ciliegiolo varietals, is a fruity, peppery red with pronounced overtones of cherry, cloves and berries. A good bottle can be kept for several years, though most of it should be drunk young as an accompaniment to pasta, meat, poultry and rich fish dishes.

Of the dozens of non-DOC local wines you are sure to encounter in Ligurian *trattorie* I must mention summery whites like Bianchetta from the Golfo del Tigullio, Valpolcevera Bianco (made mostly of Vermentino and Bianchetta grapes, with other varietals), Moscato, Albarola and Lumassina (also called Buzzetto di Quiliano and Mataosso, and reputed to be the perfect accompaniment to pesto). Once famous Coronata white from the hills behind Genoa has all but disappeared, sold now under the label Vino da Tavola Valpocevera. It is missed by a nostalgic few more concerned with memories of youth than taste, for it is not a particularly distinguished wine, though its slight sulfur undertones give it an original nose and flavor. Vermentino di Verici, from behind Chiavari, is as good as any DOC Vermentino I have tried, and the best producer I know is Bisson. Terizzo red, made with Sangiovese and Cabernet, comes from Castelnuovo Magra, near Sarzana, and can be a rich, full-bodied wine excellent with game. The extraordinarily light, slightly effervescent red Ciliegiolo is among my favorites for its distinctive cherry taste. Like the scores of unsung Ligurian whites, rosés and red wines referred to as *nostralino* or *nostrano* and made all over the region, a good bottle of Ciliegiolo served chilled with a light meal on a hot summer day is the distilled essence of Liguria's flower-filled, sculpted landscape washed by the Mediterranean sea.

in his pre-war youth a favorite pastime of the Genoese was to scour the rocky shore for edible mollusks and small crabs. Hard-core combers would gobble them down raw on the spot; others would cook them on hot stone *ciappe* over camp-fires on the beach. Seaside stands on the Riviera sold them freshly opened with a squirt of lemon juice, as oysters are sold in France. Those days are mostly over, though in La Spezia you will still be able to find excellent small mussels and sea truffles (*tartufi di mare* or *venere tartufo*), a rare variety of clam and *datteri di mare*, a related bivalve. La Spezia mussels stuffed with breadcrumbs, grated Parmigiano, parsley and marjoram, and simmered with tomato sauce, a perfect meal in themselves on a warm summer day, remain a specialty of the nearby Cinque Terre.

The truth is most Ligurians prefer their "poor" seafood to the "noble fish" eaten elsewhere in Italy. As soon as they land their catch they ship the market fish to Milan, keeping the flavorful, difficult-to-eat ones for themselves. Only in the extreme Ponente near France, where swordfish and tuna are more common, do locals regularly eat these fish, usually grilled or pan-fried with white wine and parsley or bay leaves. As you settle into a seaside restaurant with a glass of chilled Cinque Terre or Pigato wine you will rarely hear Ligurians from either end of the Riviera ordering dishes made to cater to the tastes of tourists, especially non-Ligurian Italians generically scorned as *Milanesi*. A member of the prestigious Accademia Italiana della Cucina, the Italian Culinary Academy, once complained to me about the proverbial Milanese predilection for *branzino* (seabass), most of which comes from fish farms. "It is flaccid and tasteless," said the cultivated gastronome with a wicked wink as he prepared to sing the praises of local *torta di acciughe* (baked anchovy pie) and *ciuppin*, as fish soup is known primarily in the Levante, where it is the object of a cult.

Arguably the region's greatest *ciuppin* expert is flamboyant restaurateur Rudi Ciuffardi of Sestri Levante. He claims that he and many other families in this seaside

Traditional fish fry.

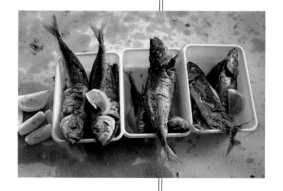

resort used to eat the soup not only at lunch and dinner but for breakfast too (though it must be noted that the jocular Ciuffardi also claims to be the son of an octopus known as Polpo Mario, the name of his restaurant). Recalling his youth in the 1950s Ciuffardi told me how fishermen's wives like his mother would rush to the beach to unload and sell the "good" fish—tuna, octopus, squid, bass—to wealthy Sestri Levante families or vacationers. The fishermen would stay behind to pick the spiny rock fish, smallfry, shellfish and tiny crabs

Dried cod adorns the Bottega dello Stoccafisso in old Genoa.

northern Europe in 1477, brought *stocvisch* back to Genoa, an achievement some jokingly say is on a par with his voyage to the Americas. It is no coincidence that Iceland's consul in Genoa, Carlo Alberto Rizzi, is among Italy's biggest importers of dried cod. His family has been in the business since 1889. Nowadays dried cod is an expensive delicacy in Liguria, usually eaten in traditional Genoese restaurants or made at home. Specialized shops hung with hundreds of feather-light fish, which are either divided lengthwise or thickly sliced, sell it pre-soaked and ready to cook. Even passionate *stoccafisso* home cooks can no longer be bothered with the lengthy ritual necessary to soften the fish. To do so you first lay the fish on a marble slab, beat it with a wooden pestle or rolling pin without tearing or damaging the flesh, soak it in cold water for three to four days, changing the water regularly, wash it under cold running water and then dry it carefully. The classic Genoese rendition of the fish is the tender, mouthwatering *stoccafisso accomodato*, which is cooked on the stove-top in a terra-cotta saucepan.

*H*owever popular seafood may be on the Riviera, it cannot compete with the region's inland foods: pasta, grains, legumes and vegetables. Combined with local olive oil and aromatic herbs they produce light and flavorful dishes that are also healthful. Wild porcini (*boletus edulis*) deserve special mention, because they were once so abundant and cheap that they cropped up in many recipes from which they have now been dropped because of their cost. Until the postwar economic boom every *contadino* knew where to find them and had a private patch in the woods of the *entroterra*. In Voltaggio, just north of Genoa in

Below: A *fungaiolo* (mushroom hunter) at Montellegro.
Opposite: A basket of prized porcini.

what used to be Liguria but is now Piedmont, I have heard tales of mushroom hunters leaving at midnight on foot with a hundred pounds of fresh porcini on their backs and arriving at dawn to sell them at Genoa's outdoor markets. Travelers' accounts down the centuries speak of their incredible abundance. Huge quantities of mushrooms are still harvested all over Liguria today. If you take a hike in the hills in fall you are likely to come across *fungaioli* scurrying up and down the slopes with their wicker baskets and walking sticks, especially in the Varese Ligure area inland from Sestri Levante. Varese is famous for its shops redolent of pungent, earthy porcini sold fresh, dried or preserved in olive oil. Restaurants there typically serve them breaded and fried, grilled, raw in salad with shaved Parmigiano, in olive oil beside an herby green salad, with game or beef and in potent *salsa di funghi* tomato sauce.

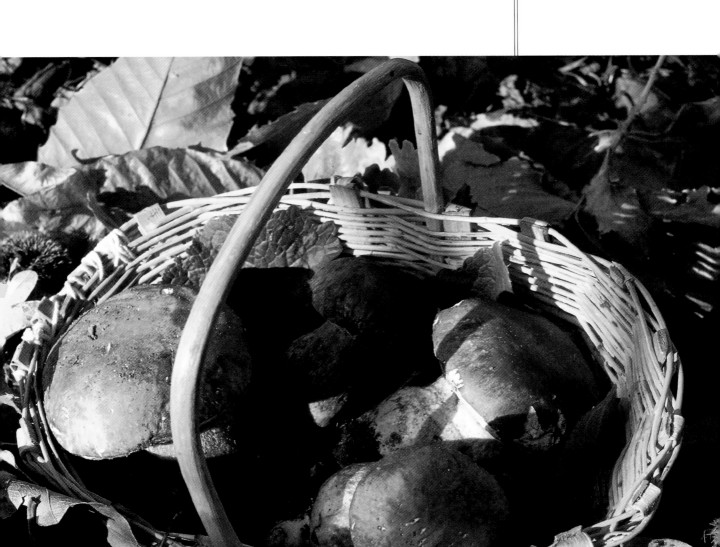

Liguria's other favorite mushroom is the now rare *ovulo*. Its scientific name is *amanita cesarea*, but only experts hunt it, because it is easily confused with the deadly *amanita phalloides*. In dialect the *ovulo* is always referred to in the plural as *funzi rosci* (red mushrooms). Food writer Silvio Torre reports an old Ligurian proverb about mushrooms: "il fungo vive d'acqua, muore nell'olio e annega nel vino"—they thrive off water, die in oil and drown in wine. It is not a bad way to go.

Seasonal, market-day cuisine has only recently been revived in France; here it has always been the rule. Almost all the produce and herbs eaten in Liguria are local and fresh from kitchen gardens or small-scale commercial greenhouses. Gathering wild herbs and greens is even more common than mushroom hunting, since nearly every Genoese family has a terraced *fascia* outside of town. On it are olive and fig trees, a vegetable patch and an overgrown area in which dozens of wild plants which would be considered weeds in America are allowed to grow. Collectively these herbs and greens are called *preboggion*. They are used in soups and stuffings, as well as in an exquisite vegetarian loaf. A retired chef from the celebrated restaurant Da ö Vittorio in Recco once showed me the ingredients of *preboggion* growing in the lawn under my window. I now regard dandelions and milkweed with respect, and gather them with half a dozen other unlikely yet edible plants to make my own *preboggion* (I would recommend extreme caution in trying to reproduce the mix anywhere outside the region). Ligurian *preboggion* includes tiny, tender, wild borage, chard, nettle tops, chicory and a handful of endemic untranslatable greens known only to locals. Ask a Ligurian about the mythical mixture and you will be told of its curative properties. It has long been eaten "to lighten heavy blood," perhaps an old-fashioned way of talking about cholesterol. One oft-repeated and particularly fanciful story traces its origin to crusader Godfrey of Bouillon (Goffedo di Buggione in Italian), who fell ill during the siege of Jerusalem and was supposedly revived with the concoction prepared by Genoese crusaders, who promptly named it "pro-Buggione." Since the greens are nearly always boiled before eating, the word far more likely derives from the Latin verb *bullire*, to boil, which in Ligurian dialect is *boggiô*.

Borage is one of the region's unsung culinary heroes: it grows in profusion, dotting seaside terraces with its tiny blue blooms in spring, and is substituted for spinach in stuffings, soups and salads. Nettles, too, have many uses other than as a component of *preboggion*, including as a flavoring; they are often boiled and minced, then mixed with white flour to produce green taglierini and

other fresh ribbon pastas. In Noli, on the Riviera di Ponente at an old-fashioned restaurant called Da Inès, I once ate an exquisitely fresh nettle pasta dressed with tender octopus and fresh tomato sauce. Nonna Nina, in San Rocco di Camogli on the opposite Riviera, uses nettles to make aromatic fresh *trofiette*—delicate pasta twists about an inch long—topped with pesto. Arugula, locally called *rucola* or *ruca*, has been used in salads and sauces for centuries, but only in the last decade has the peppery *salsa di rucola* become popular as a dressing for pasta, to the alarm of basil pesto purists. Marjoram holds a special place in the hearts of locals; it grows wild, as do thyme and rosemary, all up and down the coast and brings its sweet perfume of oregano and mint to dozens of dishes.

This emphasis on herbs and greens has a twofold origin. Because they grow wild they are an extremely economical seasoning. Equally important, though, they are the opposite of the sea: they smell of land, of home, of everything a maritime nation misses on ocean voyages. The extensive use of herbs also explains the lack of spices in Ligurian cooking. Along with Venice, Genoa was for centuries one of the world's greatest traders of spices—saffron, cinnamon, cloves, ginger, nutmeg, pepper and dozens of others. Spend several months on a spice galleon and you are unlikely to crave them on dry land. The Genoese of old did not like spices, nor do their descendants. Spices were viewed as a commodity to be shipped to the rest of Europe. Practically the only recipes in which they feature today are game dishes from the *entroterra*.

Three homegrown seasonal Ligurian vegetables of particular excellence are artichokes, peas and fava beans. The region is the world's biggest producer of artichokes and may have been responsible centuries ago for first hybridizing them from wild cardoons. The hills and fields around Albenga—the artichoke capital—are a sea of *spinoso di Liguria*, a dangerously spiky, small variety with a mild taste. Two hundred years ago Ligurian artichokes were sent to Paris at the behest of Auguste Parmentier, the doctor and botanist who is a national hero in France for his pioneering work with potatoes, which virtually put an end to famine in France and much of Europe. Today *spinoso* artichokes are eaten raw or cooked, either whole or sliced in stews, tarts and sauces. As Waverley Root points out in his classic *The Food of Italy*, a century and a half before Parmentier got his Ligurian artichokes, Louis XIV had developed an addiction to sweet baby peas from Genoa and had them planted at Versailles.

Two hundred years ago Ligurian artichokes were sent to Paris at the behest of Auguste Parmentier. A century and a half before, Louis XIV had developed an addiction to sweet baby peas from Genoa and had them planted at Versailles.

They are now famous worldwide as *petit pois*, but should be known by their Genoese name, *poisci*. In spring the tables of the region overflow with raw peas eaten with salami, usually the local pork and veal variety from Sant'Olcese behind Genoa. They also add sweetness and a touch of color to some stuffings. Otherwise they are cooked in the simplest manner possible—briefly blanched— and served as an accompaniment to other dishes.

No Ligurian kitchen garden is complete, however, without row upon row of fava beans. They are planted in December and mature in time for Easter, when they are shelled and devoured by the handful with Sant'Olcese salami or fresh Pecorino from Sardinia, with sips of dry white wine. Connoisseurs remove the so-called second skin of mature favas, revealing a heart as small and sweet as a pea, a ritual that takes on Proustian dimensions. The fava plant also produces lovely, orchidlike blooms and its tender leaves are delicious in salads. Favas are now fashionable, but for centuries they were the meager staple of the poor, who ate them fresh, dried, in soups or ground into a flour for bread. The gruel of the

Fresh fava beans, ready to be shelled and eaten raw.

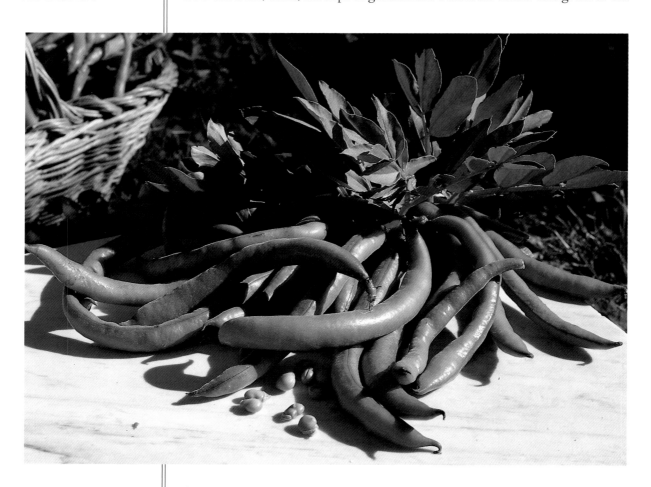

galley slaves of the Genoese Republic was made with favas; apparently they did not know how lucky they were.

While tomatoes are indeed grown here and widely used in salads and sauces, they are not the object of obsessive attention as in southern Italy, perhaps because they were introduced to Liguria relatively late, and the Ligurians had already developed their fondness for delicate greens and herbs that can easily be overwhelmed. Found in Central and South America shortly after colonization, tomatoes were brought to Europe by the Spanish as an ornamental plant and not eaten until the late 1700s or early 1800s. But no Genoese *tôcco* meat sauce would be possible without them, and in concentrated form they are a must in fish soup. The potato, another latecomer, finds its way into a variety of recipes but is by no means as popular here as in France and northern Europe.

Teresa Toneguzzi uses a mezzaluna to chop cooked greens for a classic Ligurian *torta*.

Only in Liguria could a vegetable tart elicit religious ecstasy among its devotees. *Torta pasqualina*, made exclusively at Easter (*Pasqua*), is in essence a puff pastry pie with layers of tender chard or artichoke hearts mixed with ricotta or *prescinsêua*. Each layer is separated by a leaf of pastry and whole eggs are nested into the filling. In a 1930 article in the daily newspaper *Il Lavoro*, the scion of an old Genoese family, Giovanni Ansaldo, called the Genoese an endangered species, noting that it was a shame since they had given the world two great things: America, thanks to Columbus, and *torta pasqualina*. He was only half-joking. Ansaldo's classic piece, now reproduced in cookbooks and essay collections, set forth what are known as the Twenty-Four Beatitudes of Torta Pasqualina. The pious and the patient make the tart with either twenty-four angelic layers of dough, or thirty-three, symbolic of the age of the crucified Christ. Those willing to apply Jesuit logic save work by counting three layers below and three on top (three and three side-by-side spell the numeral thirty-three). The essential thing is that the tart be made with sheets of oiled dough as transparent as a veil and that the ingredients be layered, not mixed together. Mixed, the tart is called a *torta cappuccina*. Ligurians will argue until kingdom come about whether chard or artichokes are the more authentic ingredient but I find them equally sublime.

A similar technique is used to make the myriad vegetable tarts—of pumpkin, chard, artichokes, spinach, onions and zucchini—that have been

popular since at least the time of Columbus (a recipe for chard *gattafura* or *torta alla genovese* is included in a Neapolitan cookbook of the period). What sets Ligurian vegetable tarts apart from those of other parts of Italy or France is the use of *prescinsêua* cheese—fresh milk curdled with rennet. It has the consistency of ricotta and the acidity of yogurt. For millennia it was made by shepherds in the *entroterra*, particularly in the area behind Recco, and sold from pails in the streets of seaside cities. In the industrial explosion of the 1950s and 1960s it almost died out but has made a comeback lately and is now produced by a large-scale operation in Genoa.

Of all the vegetarian foods of Liguria, probably the oldest and still the most popular are focaccia and *farinata*. Focaccia comes in many forms including Recco's cheese variety and doughy potato *focaccia alle patate*. But in its classic *focaccia all'olio* rendition it is a low leavened bread with depressions made by the fingers, drizzled with olive oil and, sometimes, sprinkled with rock salt. Some bakers season *focaccia all'olio* with fresh rosemary, sage, onions or olives. This ancient food was known throughout the Mediterranean in pre-Roman times. Bruno Bini, in his indispensable *Codice della Cucina Ligure*, claims that focaccia is mentioned in the *Book of Kings*, written around 350 B.C. The name derives from the Latin *focacius*, meaning cooked under ashes, or *focus*, fire. It has long been associated with the hearth, a symbol of family, food and life, and was used in the propitiatory rites of ancient Rome (in Christian times the Host has replaced it in ritual). Early forms of focaccia were baked on hot stones and made from a variety of grains. Now only standard wheat flour is used (with the exception of *focaccia castelnovese* from the Tuscan border area, a sort of dessert cake made with cornmeal, olive oil, butter and pine nuts). Publius Paquius Proculus, a wealthy baker in ancient Pompeii, was making something resembling focaccia—the Neapolitans insist it was pizza—when Vesuvius blew its top in A.D. 79. In Lombardy a close relative to *focaccia* is called *fitascetta*; in Tuscany *stacciata*; in Emilia *schiacciata*. It can resemble pizza or bread and is generally rather doughy and unexciting. Only in Liguria has it been transformed into a scrumptious finger food eaten as an accompaniment to meals or on its own. The making of focaccia in Liguria is considered an art and has been since the Middle Ages: a 1312 document from Genoa laid down rules for its ingredients and describes the stone on which focaccia was cooked at the time. Nowadays you can easily pick out the Ligurians at crowded Riviera cafés: they are the ones starting their day with a foamy cappuccino and a slice of warm, fragrant onion focaccia.

Historians for many years claimed—erroneously—that Marco Polo, a Venetian, brought pasta back to Italy from China in 1292.

Another culinary identity card is chick-pea *farinata*. In the pantheon of regional foods it rivals pesto in stature. There are associations to promote and protect it (since 1984 Genoa's chamber of commerce has awarded the honorary title of Maestro to traditional *farinata* makers). Festivals in various villages and towns scattered across the region celebrate it. It has become a cause célèbre: militants fear that *farinata* is losing the battle against pizza in the same way that Genoese dialect has been swamped by Italian. Professor David Bixio, a regional delegate of the Accademia Italiana della Cucina and a founding member of the Tigullio area's Association for the Protection and Promotion of Farinata, claims that the dish is mentioned in *The Odyssey*. It is surely a very ancient food. Like focaccia, it is not unique to Liguria, but *farinata* reaches the state-of-the-art only here. Pisans call it *cecìna*, Piedmontese *calda-calda* or *bella-calda*, and Tuscans *farinata* or *torta di ceci*. An edict from the 1400s regulating the sale of *scripilita*, an old name for *farinata*, is proudly displayed like a diploma by the Genoese and regularly invoked by cookbook writers and culinary historians. Three hundred years after the edict an anonymous Genoese drinking song dedicated to the delicacy declaimed its virtues with the catchy refrain "viva, viva, viva, viva, viva pur la farinata"—the same sort of roistering chant you might hear today at a *farinata* shop on Genoa's port, or in a century-old trattoria like Sà Pesta in the *carruggi* nearby.

For purists like Professor Bixio *farinata* is a seasonal dish, eaten from fall to spring in cool weather, and must be cooked in a wrought iron *tian* baking dish in an oven built with fire bricks and fueled with hot-burning olive logs. Bixio also insists that it must be served on pre-heated dishes and be no thicker than five millimeters, soft inside and crisp outside. Poet Vito Elio Petrucci, another perfectionist, has gone so far as to invent the so-called Seven Sacraments of Farinata, one of which says that it should only be made with freshly ground chick-pea flour. *Farinata* can be flavored with rosemary (but not other herbs) and is sometimes enriched with fresh whitebait, an unusual but surprisingly delicious combination.

*G*iven the region's vegetarian bent, it is not surprising that pasta is immensely popular and has been since time immemorial. Its origins are of vital interest to the Genoese for reasons that will become obvious: historians for many years claimed—erroneously—that Marco Polo, a Venetian, brought pasta back to Italy from China in 1292. In his chronicles, Polo describes the dish nonchalantly. As Bruno Bini points out, "How else would he have known what the Khan of the Tatars was eating if he wasn't already familiar with it?" Presumably Polo was

Focaccias at the Maccarini Bakery: onion focaccia on the left, flanked by simple olive oil focaccias.

eating it as he sat in a dungeon in Genoa, where he wrote *Il Milione*. Francesco Enrico Rappini of the University of Genoa assures me that documents prove that Genoese traders belonging to the Usodimare clan had been active in Asia at least fifty years before Marco Polo and that a Genoese graveyard from the early 1200s has been discovered near Beijing. In any case Marco Polo's return comes thirteen years after an oft-cited will of 1279 in which the Genoese gentleman Ponzio Bastone left a quantity of *maccarons* (macaroni) to his heirs. An even earlier inventory document of 1244 describes "smooth, dry pasta." The Spaghetti Historical Museum in Pontedassio, near Imperia, claims that pasta was produced on the peninsula from at least the 5th century B.C. Vincenzo Agnesi, of the pastamaking dynasty, has written extensively on the subject and argues that in the Etruscan Grotta Bella tomb in Cerveteri relief sculptures show pasta-making equipment. However, as with many foods lost after the fall of the Roman Empire, it is possible that the Tatars reintroduced pasta, via the Saracens, into medieval Europe. You do not have to look far for a concrete example: among Liguria's favorite homemade fresh pastas is *mandilli de saea*, which literally means silk handkerchiefs and is clearly taken from the Arabic word for handkerchief, *mandil*. The Genoese had a virtual monopoly on grain shipping from Sicily and the Middle East some eight hundred years ago and the world's earliest pasta factories subsequently sprang up on the Riviera; according to Silvio Torre, by 1351 there was a professional order of *lasagnari*—lasagna-makers. Torre gives the country's oldest statute for pasta-makers as a Genoese document dating to 1574. By the 1700s each *entroterra* village had its own flour mills to grind everything from homegrown fava beans and chick-peas (for *farinata* and the related dish *panissa*) to chestnuts (for *picagge* and *castagnaccio*), as well as prized imported wheat, for fresh pasta—*fresca*, and dry—*pastasciutta*.

As in the rest of Italy, there are hundreds of kinds of pasta available now in Liguria, though only a score are considered regional specialties. They include the ribbonlike *trenette* (also called *bavette*), the perfect match for pesto, often combined with green beans and potatoes; *mandilli de saea* and *trofie*, also eaten almost exclusively with pesto; *maccaroin*, macaroni sold in bundles and stuffed like cannelloni or used in a special Christmas soup; decoratively stamped, round *corzetti*, fresh pasta that go with a variety of sauces; and *pansòuti,* plump purses bursting with *preboggion* and Parmigiano and dressed with walnut and cream sauce or fresh sage, thyme, rosemary and melted butter.

The king of Ligurian pasta is ravioli. It might conceivably have been invented in Genoa and in any case is unsurpassed when made by a skilled Ligurian cook. Naturally there is an old tale to justify a Genoese genealogy. Raviolus was supposedly the name of a family of cooks in the town of Gavi Ligure in the 12th century, which at the time was a part of Liguria. Gavi shifted to Piedmont after the 1815 Congress of Vienna and the Raviolus tale sounds to me like a 19th-century compromise between the two regions, each of which lays claim to the genial invention. The Genoese turn a deaf ear to culinary historians who claim that similar food was made by the Babylonians and ancient Egyptians, and those who point out that Apicius, in his 1st-century B.C. *De re conquinaria*, describes fried envelopes of pasta stuffed with meat.

The most imaginative etymology for the word *raviolo* comes from the 1841 Casaccia dictionary, quoted by Vito Elio Petrucci. According to Casaccia ravioli is a wondrous food derived from the Greek *rabioles* in which "rha" means healthful herb, "bios" life and "leos" people. Hence, "herbs that give life to

A mixture of *preboggion* wild greens.
Below: Ravioli di magro "lean" ravioli with a filling of *preboggion*, in Ida Mortola's kitchen.

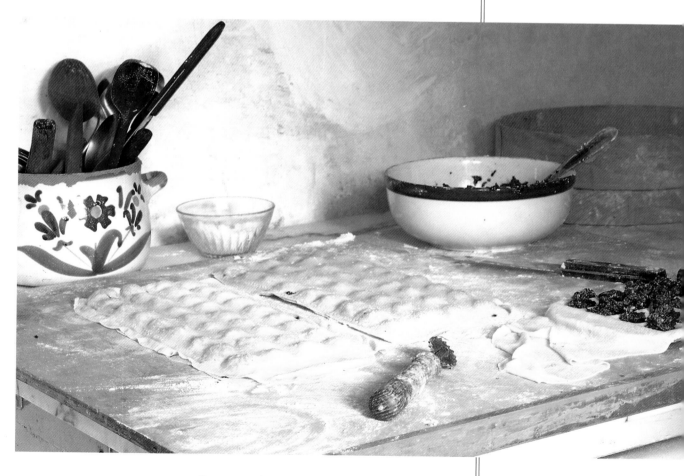

people." That might actually make sense for the popular *ravioli di magro* stuffed with herbs, wild greens and cheese, but it does not account for the more common type of Genoese ravioli stuffed with meat, or the delicate fish ravioli that have been eaten in Liguria since the Renaissance. Waverley Root claimed that *rabiole* is Genoese for "leftovers" and thought ravioli had once been common fare on galleys, made of leftovers chopped together and stuffed into pasta. But this draws blanks among the Genoese historians I know and it is unlikely that something as difficult to make as ravioli would be served on bucking galleys, where fresh pasta of any kind was extremely uncommon.

However, ravioli are traditionally eaten on December 26, the feast of Santo Stefano, and once upon a time were made from the leftovers of the Christmas meal. No self-respecting Genoese would now use leftovers to make ravioli, though, since they are considered the archetypal food of feast days and special occasions. Originally the meat stuffing was a ground mixture of beef and offal from milk cows that had reached the end of their productive life. The sauce to dress them—a classic Ligurian *tôcco*—was made with the juices of the beef stewed for five hours with carrots, celery and a touch of tomato concentrate. The beef was then served as the main course. A similar meat sauce is still the favorite dressing for ravioli, though few cooks have the time to simmer it for that long. Fish ravioli, once dressed with leftover *ciuppin* or herbs and olive oil, are now usually served with fresh tomato sauce with shellfish, while *ravioli di magro* are dressed with meat or tomato sauce, herbs and butter or even pesto.

To some urbane Genoese, humble *pansòuti* stuffed with *preboggion* and dressed with creamy walnut sauce are still considered the peasant's imitation of real ravioli. Walnut trees used to abound in the *entroterra* and the sauce was cheap and easy to make, a simple amalgam of minced nuts and herbs. Cream is a recent addition; the 1865 *Cuciniera Genovese* gives a recipe for a much more practical (and tastier) dish calling for walnuts, pine nuts, parsley and garlic crushed in a mortar and diluted with olive oil.

\mathcal{B}esides ravioli with *tôcco*, other of the region's most intricate dishes also still revolve around holidays and special occasions: *maccaroin di Natale* is a Christmas tradition and *torta pasqualina* is made around Easter. One of my favorites is *fratti*, an Easter treat of lettuce hearts stuffed with breadcrumbs, parsley, marjoram, pine nuts, Parmigiano and garlic. Easter's other celebrated dish is *cima di vitello*—*çimma pinn-a* in Genoese. It is a shoulder or breast of veal stuffed with a rich mixture of ground veal, offal, brains and parts of the animal never

described let alone eaten in America, with fresh peas and artichokes, pine nuts, herbs, eggs and grated cheese. Tied up carefully, *cima* is boiled then pressed and chilled, a process requiring several hours. Almost no one makes the dish at home, leaving the task to specialists who sell it thin-sliced to be eaten cold, the perfect picnic food for trips to the countryside on Easter Monday.

Capponmagro, probably the world's most complicated fish and vegetable salad, makes *cima* look like fast-food. It descends from the simple mariner's salad *capponadda* but is breathtaking in its complexity. Some recipes for *capponmagro* are several pages long and require the simultaneous, separate preparation of several dozen different ingredients. The classic Ratto recipe from *capponmagro*'s heyday in the 19th century includes one large lobster, a whole fish, twenty-four each of prawns, shrimp and oysters, eight boiled eggs, six salted anchovies, plenty of olives and mushrooms in oil, capers, garlic, parsley, pine nuts, breadcrumbs, beets, green beans, goat's beard salsify, artichokes and sea biscuits, plus an infinity of vegetables as garnishes. A green parsley sauce goes on top. Ratto's opus ends with the almost farcical note, "The above can be enriched with various other articles" The most popular *capponmagro* additions are tuna *mosciamme* and *bottarga*—pressed and dried tuna eggs exploding with seafood flavor. These ingredients are variously boiled, beaten, soaked and otherwise rendered aesthetic and edible, then carefully arranged in a spectacular small mountain that is as daunting to serve and eat as it is to make. As with *cima*, only specialists make *capponmagro* nowadays, almost exclusively for banquets.

A much less challenging feast-day dish to prepare is *frisceu*, delicately battered and fried vegetables, herbs and codfish, which appear on dinner tables and restaurant menus around March 19 in honor of San Giuseppe, though they are available at some traditional Genoese *trattorie* most of the year. They are the Genoese equivalent of Japanese tempura and just as delicious.

The Milanese may have airy *panettone*, but the best-known Ligurian holiday dessert is pandolce (*pandöçe* in dialect), a Christmas cake which comes in two basic forms, the flat, dense *pandolce all'antica* and the familiar leavened variety. Both are buttery, studded with candied fruit and perfumed with orange-flower water. It is unclear which is the older of the two; the *all'antica* kind lasts longer and is considerably richer, while leavened pandolce is best when freshly baked. In the old days it was always made at home and crowned with laurel leaves; a ritual of kissing it, then cutting and serving it, was respected in many families, but as usual no two Ligurians can agree on the details. The making of

Capponmagro, probably the world's most complicated fish and vegetable salad, descends from capponadda but is breathtaking in its complexity.

Overleaf:
Lettuces displayed at a Chiavari market include mache (*bottom*) and Trevigiano radicchio.

the candied fruit that goes into pandolce has been a local specialty since the Middle Ages, because for centuries the Republic held a virtual monopoly on sugar shipping. Candying preserves fruit, especially vitamin-rich citrus fruit which cannot be dried, and was one means of combating scurvy on long sea journeys. The Genoese learned the technique from the Saracens and were soon candying everything from oranges to pumpkins and chestnuts. The gorgeously appointed confectioner's shop Romanengo, in Genoa's historic district, has been making marrons glacés with the same recipe for over two hundred years and some culinary historians think that candied chestnuts are yet another Ligurian invention appropriated and made famous by the French. A problem for confectioners throughout the Roman Catholic world was Lent, during which only sugarless and lean foods could be eaten; marzipan *quaresimali* and dozens of kinds of malted chocolates were allowed and traditionally eaten during the forty weekdays between Ash Wednesday and Easter. Like pandolce they are now sold at any time of year.

As in much of Europe until after the Second World War, most Ligurians indulged in meat, poultry and game only rarely, usually on Sundays, holidays and special occasions. Beef and veal were especially prized and had to be brought down from Piedmont. Since the abundance of newborn lamb and kid in spring coincided with Easter, the holiday became a pretext to prepare rich fricassees with the suckling animals and tender artichokes, or roasts perfumed with rosemary and thyme. No part of the lamb or kid was wasted, including the inner organs and lungs: when sautéed with white wine and parsley and baptized *giancu e neigro* (white and black, a reference to the colors of the meats) they make a hardy dish still popular among many older Ligurians. Fall specialties throughout the *entroterra* are jugged hare and wild boar stew—so thick, dark and redolent of cloves, wine and spices that they taste like a gamy pudding. The more urbane, subtle dish of rabbit with herbs and black or green olives, stewed with pine nuts and white wine, *coniggio à sanremasca*, is a year-round favorite all over Liguria; duck and chicken are prepared in much the same way.

For the first time since the disappearance of the Genoese Republic two centuries ago, the lean, fresh and herb-perfumed cooking of Liguria is no longer the poor relation of Italy's other regional cuisines. It is gratifying to see that many of the once-exotic foods I grew up eating in San Francisco—the pesto, focaccia and *farinata* of North Beach, the *cioppino* of Fisherman's Wharf—are now popular not only throughout Italy but across America, where the centuries-old traditions of the Mediterranean diet have finally come of age.

ECIPES

Where applicable the Ligurian dialect name of the dish is given first, followed by the Italian name. Because the spelling of dialect names changes from one part of Liguria to another, I have adopted the most common forms.

- MARJORAM: Marjoram is an aromatic, sweetly perfumed herb that imparts a special taste to Ligurian food. If fresh marjoram is unavailable use dried marjoram in slightly greater quantities. Fresh oregano, which has a stronger, mustier taste, can work as a substitute; use about half as much oregano as marjoram. Dry oregano is unsatisfactory.

- OIL: Use extra virgin olive oil, preferably a light, fruity oil from Liguria, rather than a heavy, spicy one, as Ligurian cooking is delicate and easily overwhelmed. Never heat olive oil until it smokes and avoid extreme temperatures with all cooking fats.

- OLIVES: Small, firm Ligurian Taggiasca olives have an inimitable flavor and should be used wherever black olives are called for. You may substitute Niçoise or picholine olives from the French Riviera, small black Greek (Gaeta) olives, provided they are not overly salty, or tiny black or green Saracena olives. Ligurians do not pit their olives—Taggiasca are small and often collapse when pitted.

- *PRESCINSÊUA*: You may substitute a mixture of 80 to 90 percent ricotta and 10 to 20 percent yogurt.

- SALT: Use only plain cooking salt, not iodized.

- U.S. and metric measures are provided, though U.S. and metric teaspoons and tablespoons are approximately equal and so have not been converted. See equivalents chart on page 177. *Note:* The metric cup is equal to 200 ml (2 dl).

- Unless otherwise stated, recipes serve 4 to 6.

Finally, Italian cooking—and especially Ligurian cooking—is an art, not a precise science, and should be approached with an open spirit. Bear in mind that the herbs, produce, fish, water and air of Liguria are found only there; cooks in California, New York, Quebec, England or Singapore will have to experiment with these recipes and tailor them to the realities of their own regions.

PASTAS AND SAUCES

Trenette or Trofie al pesto

DRY RIBBON PASTA OR
FRESH, HOMEMADE *TROFIE*
TWISTS, WITH GREEN BEANS
AND POTATOES, SAUCED
WITH CLASSIC BASIL PESTO

Trofie are a fresh peasant-style pasta made with flour, salt and water—no eggs. No precise recipe for pesto is possible, as everything depends on the strength of the garlic and basil that go into this simple sauce, so make adjustments according to your ingredients and personal preference. *This recipe serves 8 to 10.*

FOR THE PESTO

About 1½ cups tightly packed small basil leaves

½ to 1 clove garlic, peeled

3½ tablespoons pine nuts

¼ cup (50 ml) olive oil

2 tablespoons freshly grated Parmigiano-Reggiano or half Pecorino Sardo and half Parmigiano-Reggiano

Salt (rock salt if using a mortar and pestle)

1 heaping tablespoon prescinsêua (optional; see page 137)

FOR THE PASTA

4 cups (500 gr) flour

Salt

or

1 pound (500 gr) dried trenette, bavette or similar ribbon pasta (linguini)

20 to 30 fresh green beans

2 medium potatoes or 4 to 5 small new potatoes

Freshly grated Parmigiano-Reggiano

To make the pesto, wash the basil leaves and dry them thoroughly with paper towels. If the basil has a minty smell or the leaves are tough, blanch it briefly in boiling water, drain and pat it dry. Chop the garlic, removing any green shoots in the heart of the clove. Place the garlic and basil in a food processor or blender, add the pine nuts and pour in about one-third of the oil. Process or pulse, stopping occasionally to press the leaves down with a wooden spoon and to add oil, until the pesto has a slightly chunky texture with some whole pine nuts left. Do not overheat the pesto by excessive blending. Spoon the pesto into a ceramic or other non-metallic bowl. Stir the Parmigiano-Reggiano into the sauce and add salt to taste. Cover the pesto with a film of olive oil until ready to use. To make a milder *pesto alla camogliese*, add the *prescinsêua* just before serving.

NOTE: If you are planning to store pesto for any length of time, do not add the cheeses or garlic, since these ingredients slowly ferment; instead, add them just before using the sauce. To store pesto, place it in a glass jar or earthenware container—never use metal or plastic containers or utensils. Cover

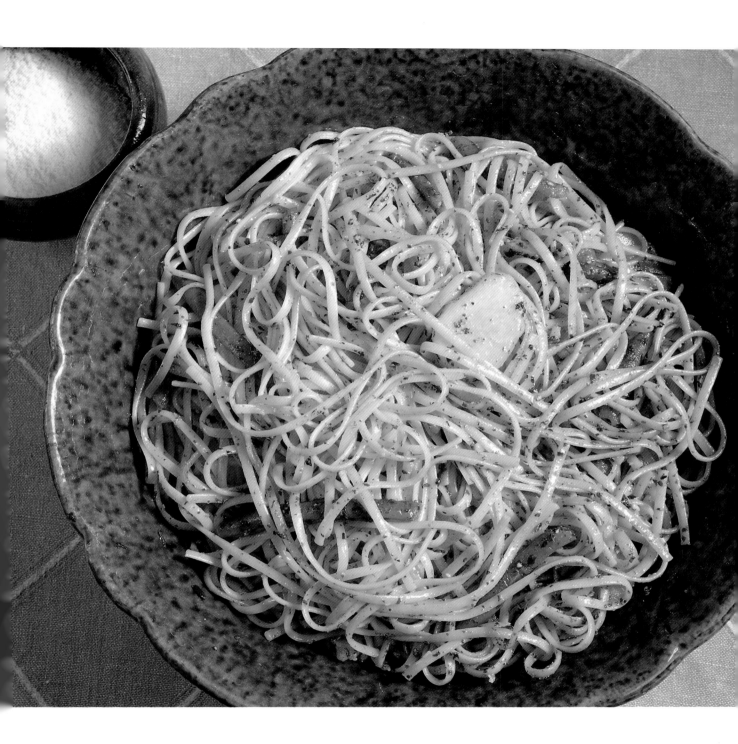

the surface of the pesto with a thin film of olive oil to prevent oxidation and discoloration and seal tightly. Pesto can be kept in the refrigerator for several weeks if the garlic and cheese have not been added, or it can be frozen for several months.

To make *trofie*, place the flour on a board or other work surface and make a well in the center. Sprinkle with salt and gradually add enough cold water to produce a dense, smooth dough that is not too sticky, kneading the dough as you incorporate the water. Pinch off thimble-sized bits of dough and roll them energetically with the palm of your hand clockwise on a large wooden cutting board to shape each piece into a compact twist. *Trofie* are rustic and should look like rough-cut tortiglioni or short fusilli twists, about 1 to 1½ inches long. Allow the *trofie* to sit at room temperature for several hours before cooking.

Wash and trim the green beans; peel and cut the potatoes into thick slices. Bring a large pot of water to a boil and add several large pinches of salt. If you are using dried pasta, add it with the potatoes and green beans to the boiling water. The ingredients should reach the al dente stage at the same time (8 to 10 minutes, depending on the brand of pasta). Alternatively, if you are unsure about the cooking times, boil the beans and potatoes separately until just tender, remove them, boil the pasta in the same water, and just before the pasta is al dente, return the beans and potatoes to the water to finish cooking.

If you are using fresh *trofie*, boil the beans and potatoes first, and, with a slotted spoon, remove them from the cooking water when they are nearly done. Boil the *trofie* in the same water, stirring occasionally, for 2 to 3 minutes, then return the potatoes and green beans to the water to finish cooking. When the *trofie* rise to the surface, after about 2 to 3 more minutes, they are done. Drain the pasta and vegetables in a colander, place them in a non-metallic bowl and toss with abundant pesto, adding about one tablespoon of the cooking water to thin the pesto if desired. Serve with the grated cheese on the side.

To make pesto with a mortar and pestle

A marble mortar and olive wood pestle are recommended. Place a handful of the basil leaves in the mortar with a pinch of rock salt and pound, then rotate pestle clockwise, crushing the basil against the side of the mortar. Drizzle in olive oil, add more leaves, a few pine nuts and minced garlic. Continue to add the ingredients slowly, pounding and crushing until you have produced a chunky paste. Dilute with olive oil and incorporate the cheese.

Corzetti

Stamped *corzetti* fresh pasta probably comes from La Spezia (where it is called *crosetti*), though it is now common all over the Levante. In the Valpolcevera valley behind Genoa the pasta is not stamped but rather shaped into figure-eights, which I find as unwieldy to make as they are to eat. *Corzetti* are a festive food: once upon a time the wooden stamps bore family crests or coats of arms, and were used on special occasions and holidays. Now the stamps are more likely to be decorated with the owner's favorite animal, a geometric pattern or the name and logo of a restaurant or pasta shop. *Corzetti* stamps have two pieces: the top part is used to press the dough into the bottom section, like a stamp and die for minting coins. Today some Ligurians use a single wooden form, gently pressed down and twisted on a sheet of fresh dough, but this impresses the *corzetti* on one side only and is considered an inferior method. "The goodness comes from the rough texture of the low-relief decorations," says Paolo Delpian of La Cucina di Nonna Nina. "The sauce clings to the raised parts of the *corzetti*."

The best source of custom-made *corzetti* stamps is woodworker Franco Casoni, whose shop is under the arcades of Chiavari's medieval center. Off-the-rack stamps (with geometric designs, family crests, laurel wreaths, etc.) are made by woodworkers Granone & Monchieri, located in atmospheric Vico del Filo, a hundred yards south of Genoa's cathedral (see page 181). My favorite store-bought *corzetti* come from Pasta Fresca Dasso on Piazza Venezia in the center of Rapallo, and Pastificio Prato on Via Cittadella facing Chiavari's city hall.

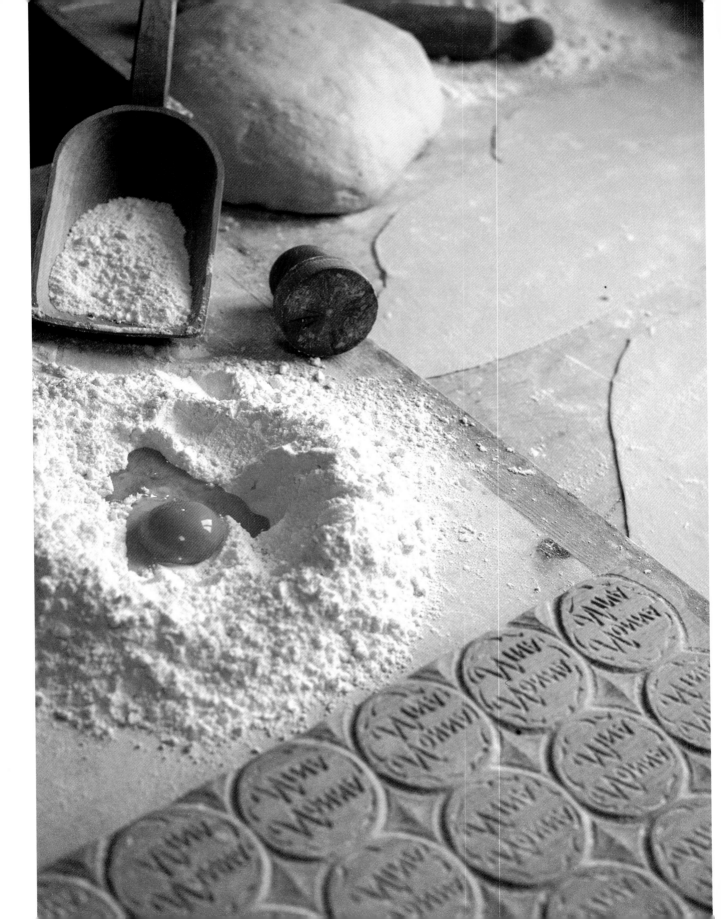

Corzetti

This recipe for old-fashioned *corzetti* made with mashed potato comes from Paolo Delpian and Rosalia Musumeci of La Cucina di Nonna Nina in San Rocco di Camogli. Serve them with mushroom and tomato sauce (page 153), pesto (page 138) or meat sauce (page 152), or toss *corzetti* with melted herb butter and sprinkle with fresh marjoram or thyme leaves and freshly grated Parmigiano-Reggiano.

Boil the potatoes in their jackets until they are soft. When the potatoes are cool enough to handle, peel them and mash with a fork. Place the flour on a board or other work surface and form a well in the center. Slowly add ¾ cup (1 cup UK) tepid water, a pinch of salt, the egg yolks, oil and mashed potatoes, gradually incorporating all the ingredients; knead the dough until it is smooth and elastic. Stretch or roll out a sheet of pasta to a thickness of about ¹⁄₁₆ inch. If you have one, use a wooden *corzetti* stamp to impress and with a round pasta-cutter or a drinking glass, cut out rounds of pasta; otherwise, use the palm of your hand to flatten and twist off silver-dollar-sized rounds. *Corzetti* can be cooked and eaten immediately or can be set aside, covered with a clean towel, for several hours—ideally an entire day—in the refrigerator. Boil the *corzetti* in abundant salted water until al dente, about 2 to 3 minutes if fresh or 4 to 5 minutes if dry, and drain.

NOTE: *Corzetti* can be kept refrigerated for up to 1 week in a sealed plastic container.

2 small potatoes (100 gr)

4 cups (500 gr) flour

Salt

4 egg yolks, beaten

1 tablespoon oil

Raviêu

(ravioli)

*T*here are two types of ravioli: lean and with meat. In either case, ravioli are considered urbane, not rustic. For lean ravioli, use the recipe for *pansòuti* filling (page 148), using mild greens such as baby spinach, tender chard leaves, borage, escarole, frisée or even pre-boiled nettles. Lean ravioli are usually served with a simple fresh tomato sauce with a pinch of marjoram and a single clove of garlic. The pasta for Ligurian ravioli should be made in the same way as for *pansòuti*, except that a metal form is recommended (to achieve perfectly square ravioli). Dress the ravioli with meat sauce (page 152), tomato and mushroom sauce (page 153) or melted butter and grated Parmigiano-Reggiano.

1 pound (500 gr) mixture of borage, escarole, spinach and chard leaves, washed, tough stems removed

Oil

3½ ounces (100 gr) finely ground lean veal

About 1 tablespoon dry white wine

3½ ounces (100 gr) sweetbreads and calves' brain (see Note)

1 tablespoon fresh marjoram leaves

1 clove garlic (optional), peeled

A pinch of salt

2 large eggs, beaten

3½ tablespoons freshly grated Parmigiano-Reggiano

1 recipe fresh pasta dough (page 148)

Most Ligurians—especially members of the Knights of Ravioli in Gavi-Ligure—think ravioli were invented in their region in the Middle Ages, although the ancient Babylonians, Egyptians and Romans probably ate a similar kind of filled pasta, and excellent ravioli have long been made all over Italy. In Giovanni Boccaccio's *Decameron*, written in Tuscany in 1348, delighted diners romp on a mountain of grated Parmigiano cheese scattered gleefully over ravioli boiled in capon broth. Nonetheless a Christmastide Ligurian meal would not be complete without a delicious plate of homemade *raviêu*, particularly on December 26, the feast day of Santo Stefano. While most Italian ravioli are made with fresh egg pasta, the Ligurians prefer to make theirs with light, eggless pasta that allows the flavors of the delicate, classic meat filling and *tôcco* sauce to shine through.

Boil, drain and finely chop the greens according to the method for *preboggion* in the recipe for *pansòuti* (page 148). Heat about 1 teaspoon oil in a sauté pan over low heat. Add the veal and sauté for 2 to 3 minutes, adding a splash of wine halfway through; do not overcook the veal. Bring a small pot of water to a boil, add the

sweetbreads and cook for about 7 minutes, then add the brain and cook until they are cooked through and tender, about 8 more minutes; drain. Mince the marjoram and garlic. Finely mince the veal, brains and sweetbreads. Combine the greens, meat, marjoram mixture, salt and eggs in a large mixing bowl. Gradually add the cheese and oil until the mixture is dense and moist but not wet. Add additional cheese, if necessary, to absorb any excess juices.

Roll out the pasta dough according to the recipe on page 148. Lightly dust a ravioli form with flour. Place one sheet of dough into the form, fill each depression with a teaspoon of filling, cover the form with the second sheet of dough and lightly but firmly press between the mounds to seal. Flip the form over onto a flat surface.

If you do not have a ravioli form, place the mounds of filling about 1½ inches apart on a sheet of dough and carefully cover with another sheet; press gently between the mounds to seal. With either method, use a serrated cutter to cut straight between the rows of filling. Check each raviolo to make sure it is properly sealed, pinching with your fingers where needed.

Bring a large pot of water to a boil, carefully drop in the ravioli and cook until they rise to the surface, about 5 minutes, and drain.

NOTES: Double the amount of veal if calves' brain and sweetbreads are not available.

The ravioli can be cooked and served immediately or allowed to sit for several hours. Lightly dust the ravioli with flour and separate layers of ravioli with sheets of plastic wrap to keep them from sticking together. They can be kept for up to 3 days, covered with a clean cloth, in the refrigerator.

Overleaf:
Ravioli with *tôcco*, served on antique Ginori porcelain and a Ligurian lace tablecloth.

Maccaroin in broddo

(maccheroni di Natale in brodo)

LARGE MACARONI
COOKED IN BROTH,
WITH SAUSAGE MEAT

*T*his is a simple, delicious pasta soup eaten all over Liguria at Christmas. Though the pasta—about six inches long and the thickness of a large pencil—is not readily available outside the region, large penne, rigatoni or ziti can be used instead. Purists do not add pepper to the soup, but I think it is needed. Traditionally, the broth was made with a boiled capon, the main course in many homes on Christmas day; leftover beef from other holiday meals was also used to make broth.

To make chicken broth, place a lean, free-range chicken in a large pot with enough water to cover it thoroughly, several peeled carrots, a peeled onion, black peppercorns, a few stalks of celery and a pinch of salt. Bring to a simmer and cook for 2½ to 3 hours. Remove the chicken when it is thoroughly cooked and reserve for another use. Skim the fat from the surface of the broth. Beef broth is made in the same way.

5 ounces (150 gr) lean pork sausage without fennel, casings removed

2 quarts (2 liters) chicken broth or an equal mixture of chicken and beef broth

Salt

1 pound (500 gr) dried maccheroni di Natale or similar tube pasta

3½ tablespoons freshly grated Parmigiano-Reggiano

Freshly ground black pepper (optional)

Shape the sausage meat into small, compact, quail-egg-sized balls. Bring the broth to a boil and add salt to taste. Add the pasta and stir for a few seconds. Carefully add the sausage balls while gently stirring the broth. Cook until the pasta is al dente, about 10 to 12 minutes, stirring occasionally to prevent the pasta and sausage balls from sticking to the bottom of the pot. Ladle the soup into deep serving bowls, sprinkle with the cheese and pepper and serve.

*T*his sauce, most popular in the Levante, varies widely throughout Liguria. It is usually used to dress *pansòuti* (page 148), but also goes well with chestnut flour *picagge matte* and fresh fettuccine. Cream is a recent addition: the 19th-century version is made exclusively with walnuts and herbs. Ideally, a mortar and pastle are used to make this sauce, though a good food processor will do the job.

Blanch the walnuts and remove the inner (papery) skins. Soak the breadcrumbs in the milk. Crush the walnuts and pine nuts using a mortar and pestle or in a food processor. Mince the garlic together with the marjoram and add to the nut mixture. Squeeze the milk from the breadcrumbs and add them to the mortar or processor. Crush or blend until the mixture is smooth and uniform. Force the mixture through a sieve into a mixing bowl and blend in a small amount of olive oil until the sauce is creamy and thick. Add the heavy cream, if using, and blend thoroughly. If the sauce is too thick to pour, add more oil or a few drops of hot water or milk.

10 ounces (300 gr) shelled walnuts

½ cup (25 gr) fresh breadcrumbs

About ½ cup milk

About 1 heaping tablespoon pine nuts

1 clove garlic, peeled

1 heaping teaspoon fresh marjoram leaves (optional)

About 1 tablespoon oil

½ cup (⅔ cup UK) heavy cream (optional)

Tôcco

*C*ooks once made this using the leftover beef of the holiday meal—tough cuts that had cooked for hours and hours at low heat. Everyone concurs that slow-simmering is necessary to make such meat tender, but many disagree about the inclusion of the tomatoes and mushrooms, given here as an option. This sauce is used to dress meat-filled ravioli (page 144), lasagna, *corzetti* (page 143), fettuccine and other fresh pastas.

1 medium onion

1 carrot

1 celery stalk

¾ cup (1 cup UK) oil

*1 pound (500 gr) shoulder, shank or other
 tough but tasty cut of beef*

Flour

¾ cup (1 cup UK) dry red wine

1 heaping tablespoon tomato paste

*1 pound (500 gr) canned plum tomatoes,
 drained*

*¾ cup (1 cup UK) unsalted beef broth,
 homemade or good-quality store-bought*

Salt

⅓ ounce (10 gr) dried porcini (optional)

Peel and finely dice the onion and carrot and dice the celery. Heat the oil in a large earthenware or heavy metal casserole. Cut the beef into 2-inch chunks, dredge them lightly in flour and add them to the casserole to brown over medium heat. Add the onion, carrot and celery to the casserole and cook, stirring, until browned slightly. Slowly pour in the wine and stir until evaporated. Add the tomato paste and the tomatoes. Add ¼ cup (⅓ cup UK) of the broth and a pinch of salt. Lower the heat to maintain a slow simmer. If you are using the mushrooms, soak them in tepid water for about 15 minutes, drain and rinse them, then chop them roughly. Add the mushrooms to the casserole after 1 hour. Continue to simmer the sauce for a total of at least 2 hours, adding small amounts of broth if needed (if the broth runs out add hot water a tablespoon at a time). When the meat has disintegrated and the vegetables are very soft the sauce is done. The sauce may be pushed through a sieve, food mill or potato ricer to remove or crush tomato seeds, stringy beef fibers and lumps if this seems necessary.

Tôcco de funzi

(salsa di funghi)

PORCINI MUSHROOM
SAUCE WITH TOMATOES,
GARLIC, ONION AND
ROSEMARY

*F*resh porcini mushrooms make a world of difference in the preparation of this classic fall or winter sauce, used to dress ravioli, taglierini, fettuccine and other fresh pastas. The onion is optional because it is omitted by purists who think it adds too much sweetness to the sauce.

If using fresh porcini, cut off the bases of the stems, remove any blemished parts and wash thoroughly in cold water. If using dried porcini, soak them in a small amount of tepid water for about 15 minutes to allow sand and sediment to fall to the bottom of the bowl; remove the mushrooms and rinse. Cut away any still hard bits. Mince together the rosemary, garlic and onion. Heat the oil in a large non-reactive sauce pan, add the rosemary, garlic and onion and sauté over low heat until the onion is soft and translucent. Drain excess juices from the tomatoes, add them to the pan and bring the sauce to a simmer over very low heat. Mince the mushrooms and add them to the sauce. Cook the sauce for about 30 minutes, add salt to taste and serve.

½ pound (200 gr) fresh porcini or 1 ounce (30 gr) dried porcini

2 sprigs fresh rosemary leaves

1 clove garlic, peeled

1 medium onion (optional)

¾ cup (1 cup UK) oil

10 ounces (300 gr) fresh, ripe tomatoes, peeled and chopped (or drained canned plum tomatoes)

Salt

Articiocche a l'inferno
(carciofi all'inferno)

WHOLE TENDER YOUNG
ARTICHOKES SIMMERED
WITH GARLIC, PARSLEY,
ARTICHOKE STEMS AND
ANCHOVIES

This recipe probably originated in the Ponente, where artichokes are grown in huge numbers. Ideally, use spiny Albenga or other small, pointy artichokes, as opposed to large, round varieties. The name derives from the original earthenware or cast-iron cooking pot that had a thick lid with a special compartment for embers or coals; the pot was placed on embers or hot coals which heated the artichokes from below and above, as if they were suffering the fires of Hell (the *inferno*).

8 small artichokes

1 clove garlic, peeled

1 bunch flat-leaf parsley, washed, tough stems removed

2 small anchovy fillets, preferably preserved in olive oil

1 sprig fresh mint (optional)

About 1 heaping tablespoon dry breadcrumbs

¾ cup (1 cup UK) oil

1 pint (½ liter) chicken broth or water

Wash the artichokes, remove thorns and tough outer leaves, cut off the tips of the leaves and remove any fuzz from the centers. Cut off the stems and reserve the parts closest to the hearts. Mince the stems with the garlic, parsley, anchovies and mint. Place the mixture in a small bowl, add the breadcrumbs and combine. Force open the artichokes with your fingers and fill the centers with the mixture. Arrange the artichokes side by side in a deep earthenware pot or large Dutch oven. Combine the oil and broth and pour the mixture around the artichokes to a depth of about 1 inch (2½ cm). Cook, covered, over medium heat, until the artichokes are tender, 15 to 30 minutes, depending on the type and size of the artichokes. Carefully remove the artichokes to a platter and serve hot.

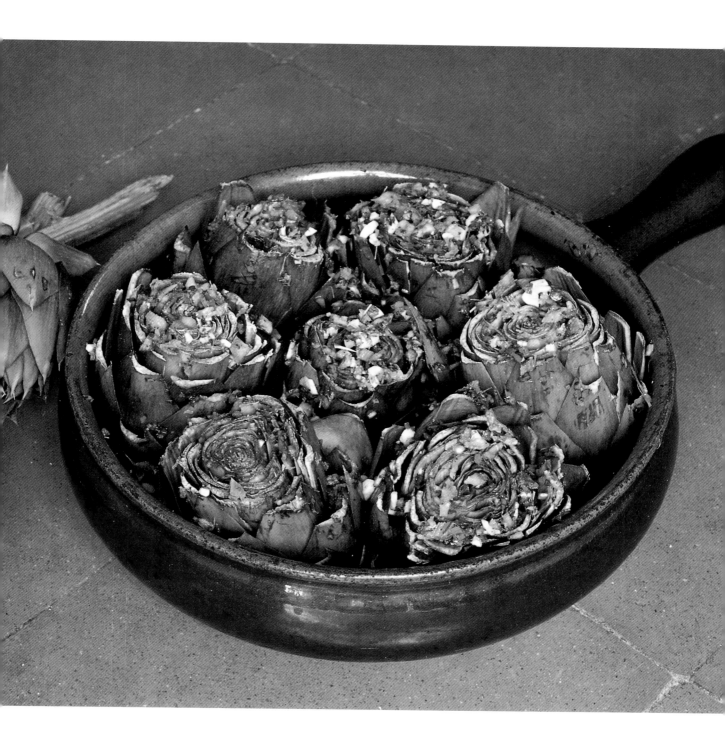

Torta pasquâlinn-a

(torta pasqualina)

TRADITIONAL EASTER
VEGETABLE PUFF-PASTRY
PIE WITH CHARD OR
ARTICHOKES, RICOTTA
OR *PRESCINSÊUA* CHEESE
AND CREAM

5 cups (600 gr) flour

About ¾ cup (1 cup UK) oil

Salt

2 pounds (1 kg) baby chard or 12 small arti-
 chokes or 1 pound (500 gr) baby chard
 and 6 small artichokes

Juice of 1 lemon

3 tablespoons butter

Freshly ground black pepper

3 sprigs fresh marjoram leaves, minced

6 to 8 tablespoons freshly grated Parmigiano-
 Reggiano

¾ pound (400 gr) prescinsêua (see page 137)

⅓ cup (½ cup UK) light cream

4 medium eggs

*T*here are many variations of *torta pasqualina*, some quite complex and requiring thirty-three layers of extremely thin pastry dough. If possible, use a flour made with hard wheat for the dough; this will result in a more elastic dough that is easier to roll out. The dish's origin is probably Middle Eastern. There are three common versions: pure chard, pure artichoke and mixed. Their preparations are almost identical and all three are delicious.

Place the flour on a board or other work surface, make a well in the center and add 2 tablespoons of the oil and a pinch of salt. Gradually add cold water until the dough holds together in a ball. Knead for 5 to 8 minutes, until the dough is smooth and elastic. Divide the dough into at least 6 equal parts (or more, if you are a skilled pastry chef), shape them into balls, dust with flour, wrap individually in cloths and set aside to rest for about 3 hours.

Place a small pot of water over medium heat and bring to a boil. Clean the chard, removing the stems. Cut the leaves into strips and boil, stirring often, until tender and wilted, about 5 minutes. Turn off the heat and allow to sit, covered, for about 5 minutes, then drain in a colander and press dry. Place the chard on a cutting board and sprinkle with salt; incorporate Parmigiano-Reggiano until the mixture is moist but not runny, and add marjoram.

If you are using artichokes, wash them, cut off the stems, remove the tough outer leaves, remove the fuzz from the centers and slice the artichokes vertically to the thickness of a coin. Submerge the artichokes in a bowl of water with the lemon juice. Place 3 table-spoons butter and 3 tablespoons oil in a medium-sized skillet over medium heat. Drain the artichokes, pat them dry and sauté them in the oil and butter for about 5 minutes. Set aside to cool to room temperature, then sprinkle with a pinch of salt, pepper, the marjoram and about 1 tablespoon Parmigiano.

Drain the *prescinsêua* in several layers of cheesecloth. Place the cheese in a small bowl, add the cream and combine. Dust the mixture with flour or up to 1 tablespoon of Parmigiano-Reggiano if it seems too runny.

Oil a standard round pie pan (11 to 14 inches in diameter). One at a time, knead then stretch each ball of dough, tossing it like a pizza maker, to create translucent sheets large enough to cover the pie pan and hang down to the work surface. Place the first sheet in the pan, brush it with oil and cover it gently with a second sheet. Brush again with oil and cover with a third sheet of dough. Carefully arrange the chard and/or artichokes over the dough, drizzle with oil and spoon on the cheese mixture. Use a spoon to form four indentations in the filling, each deep enough to accommodate a medium egg. Place a bit of butter in each indentation, then carefully crack an egg in. Drizzle with oil, sprinkle with salt, pepper and Parmigiano.

Preheat the oven to 400° F./200° C. Carefully place all the remaining sheets of dough over the filling, brushing each with oil and taking care that the egg yolks do not burst under the weight. Trim the excess dough from around the edge of the pan, roll all the layers together to the rim of the pan and crimp them all around the edge. Bake for about 45 minutes, until the pastry is golden and puffy.

NOTE: Master *pasqualina* makers use a straw to blow air between the top pastry layers to puff them up before sealing them.

\mathcal{P}inn-e

(ripieni)

STUFFED, BAKED
VEGETABLES

5 small eggplants, preferably round

10 small zucchini

3 medium onions, peeled

3 large round tomatoes

1 yellow bell pepper

1 tablespoon fresh or dried marjoram or
* oregano leaves*

1 clove garlic (optional), peeled

6 slices stale white bread

1 to 1½ cups milk

1¾ ounces (50 gr) chopped mortadella or
* thinly sliced prosciutto cotto (optional)*

4 medium eggs, lightly beaten

¾ cup (1 cup UK) freshly grated Parmigiano-
* Reggiano*

3½ ounces (100 gr) prescinsêua (see page 137)

Salt and freshly ground black pepper

2 tablespoons fine, dry breadcrumbs

1 tablespoon oil

\mathcal{S}tuffed vegetables are an obsession throughout Liguria, though the best seem to be made in the Levante. They are at their most flavorful in spring and early summer, when the vegetables are young and tender. This recipe comes from Emanuele Revello, former chef of Da ö Vittorio restaurant in Recco.

Wash, then blanch the eggplants, zucchini and onions in boiling water until they are slightly softened but still firm enough to cut without difficulty. Set aside to cool. Cut the vegetables in half: eggplants and zucchini (lengthwise), onions (vertically), tomatoes (horizontally), cut the pepper in half lengthwise or, if very large, separate into sections.

Preheat the oven to 475° F./250° C. Remove the pulp from the eggplants and zucchini with a small spoon and reserve; discard the seeds and membranes from the pepper and tomatoes; remove the centers of the onions, dice the pulp and reserve. If using fresh marjoram, mince it together with the garlic. Break the bread into pieces and soak it in the milk for 2 to 3 minutes, then squeeze dry. Place the bread, vegetable pulp, mortadella, marjoram and garlic, eggs, cheeses and salt and pepper to taste in a bowl and mix thoroughly.

Arrange the vegetables cut-side up in baking dishes, stuff with the mixture, sprinkle with breadcrumbs and drizzle with oil. Bake for about 30 minutes, until golden brown. Allow to sit ½ hour before serving.

NOTE: Once baked, stuffed vegetables can be kept for up to 2 days, covered, in the refrigerator.

Funzi e patatte into tiàn

(funghi ovuli o porcini con patate al forno)

SLOW-BAKED LAYERS OF
FRESH PORCINI MUSHROOMS
AND POTATOES WITH MINCED
PARSLEY AND GARLIC

Once made with russet-colored, rare, wild ovuli mushrooms, *amanita cesarea* (referred to in the plural as *funzi rosci*, red mushrooms in dialect), this exquisite yet simple dish is now almost always made with fresh porcini.

Wash the potatoes and remove any eyes or blemishes but do not peel. Place the potatoes in a large pot of cold water and set over medium heat. When the water comes to a boil remove the potatoes and slice them to the thickness of a silver dollar. Wash or wipe mushrooms thoroughly, removing any hard parts, dirt or sand. Slice the mushrooms vertically to half the thickness of the potatoes. Mince the garlic and parsley.

Preheat the oven to 350° F./180° C. Oil a 4-inch-deep (10 cm) earthenware or porcelain, oven-proof covered casserole and arrange in it a layer of potatoes, top with a layer of mushrooms, sprinkle with parsley and garlic, drizzle with oil, and continue to build layers until ingredients are used up. Drizzle with abundant oil and sprinkle with the salt. Cover the casserole and bake for 20 to 30 minutes, remove cover and continue to bake for 5 minutes more, or until the top is crisp; the center layers should be tender and melded together and the bottom layer of potatoes also crisp. Serve hot.

3 firm, medium potatoes (300 gr)

12 ounces (300 gr) fresh ovuli or porcini

1 clove garlic, peeled

1 bunch flat-leaf parsley, washed, tough stems removed

¾ cup (1 cup UK) oil

A pinch of salt

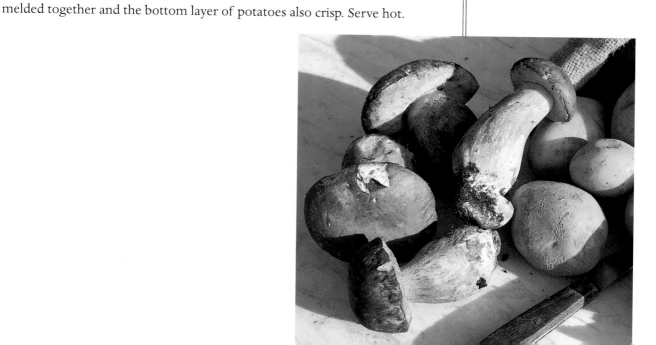

Fratti or leitughe pinn-e
(lattughe ripiene)

STUFFED LETTUCE
LEAVES SIMMERED WITH
WHITE WINE

*B*e warned, this is a time-consuming dish to prepare. The name *fratti*, as in friars, indicates that it was invented by (or at least popular with) monks who had plenty of time to tend gardens and cook. Stuffed lettuce, at least in one version, is also lean, making it ideal for religious orders. There are two basic versions, each delicious but with surprisingly different nuances. In both recipes, use butter lettuce or another large-leafed variety—do not use iceberg lettuce.

Anna Maccarini of Panificio Maccarini in San Rocco di Camogli makes them in the following, classic manner. *This recipe serves 6 as an appetizer or 2 as a main course.*

18 large lettuce leaves plus 1 lettuce heart (up to 3 heads may be needed to yield the necessary number of leaves)

1 heaping teaspoon fresh marjoram leaves

1 clove garlic, peeled

½ cup (50 gr) white bread, crusts removed, soaked in milk and squeezed

1 large egg

3½ tablespoons freshly grated Parmigiano-Reggiano

¾ cup (1 cup UK) dry white wine

Salt and freshly ground black pepper

Wash the lettuce leaves, taking care not to tear them. Bring a small pot of water to a boil, add the lettuce heart, boil for 2 minutes, allow it to cool, then mince it. Mince together the marjoram and garlic. Mince the soaked bread. Beat the egg in a large mixing bowl with salt and pepper to taste and mix in the lettuce heart, marjoram and garlic and the bread. Add the cheese and combine to form a thick, pasty mixture.

Place 3 lettuce leaves on a work surface, nested together and fanned out. Spoon about 1 tablespoon of the mixture (more or less, depending on the size of the leaves) into the center of the leaves; bring the leaves together to form a beggar's purse and tie carefully with kitchen string. Repeat with the remaining leaves and filling to make 6 purses. Place them side-by-side in a pan, pour the wine around them to the level of about ½ inch, cover and simmer over low heat for 15 to 20 minutes, adding water if necessary to maintain the wine level. Remove the stuffed leaves to a platter and serve hot.

Paolo Delpian's version from La Cucina di Nonna Nina, also in San Rocco, differs considerably. *This recipe serves 6 to 8 as an appetizer or 4 as a main course.*

Blanch the lettuce heart as in the previous recipe, then briefly blanch each lettuce leaf in boiling water, carefully remove from the water and pat dry. Finely mince the lettuce heart.

To make the stuffing, place the bread in a food processor with the marjoram and blend. Beat the eggs in a large mixing bowl and stir the bread and marjoram into the eggs. Mince the prosciutto and add it to the mixture. Stir in the ricotta, Parmigiano-Reggiano, nutmeg, lettuce heart and salt and pepper to taste. Place about 1 teaspoon of the stuffing on each leaf and roll up the leaf carefully from stem end to tip, tucking in the tip.

Heat the oil in a medium-sized skillet, add the onion and sauté until it is translucent. Add the wine, raise the heat and let the wine evaporate. Add the tomato sauce and about ½ cup water. Simmer, uncovered, for 5 minutes. Place the rolled-up leaves seam-side down in the pan with the sauce. Cover the pan and simmer gently over low heat for 20 minutes, adding water if needed. Serve hot.

18 large lettuce leaves and heart, cleaned

½ cup (50 gr) white bread, crusts removed, soaked in milk and squeezed

1 heaping teaspoon fresh marjoram leaves

3 medium eggs

2½ ounces (70 gr) prosciutto cotto

7 ounces (200 gr) ricotta

8 tablespoons freshly grated Parmigiano-Reggiano

A pinch of freshly grated nutmeg

Salt and freshly ground black pepper

1 tablespoon oil

1 medium onion, sliced

¾ cup (1 cup UK) dry white wine

2 tablespoons thick tomato sauce or 1 tablespoon tomato paste

Capponadda

(caponata)

SALAD OF PLUM
TOMATOES, GARLIC, BLACK
OLIVES, OLIVE OIL, AND
CRUMBLED SEA
BISCUITS, WITH ANCHOVY
FILLETS AND TUNA

One story of the origin of this dish has it that sailors, when weighing anchor with a wooden wheel-winch, a laborious process known as *capponare* in dialect, would snack on *capponadda* as they pushed past a bowl held out to them by their mates. The dish once contained dried dolphin meat but is now made with canned tuna. If you use scallions, be sure they are tender and sweet. There are many versions of this summertime salad; this is our favorite.

3 ripe plum tomatoes or 10 ripe cherry tomatoes

1 (5-ounce/140-gr) ball fresh mozzarella

1 anchovy fillet, preferably preserved in olive oil

1 small cucumber, diced (optional)

2 whole young scallions, trimmed and sliced (optional)

1 bell pepper, diced (optional)

2 sea biscuits or 2 slices very hard, stale toast (½ per person)

About 20 small black olives (preferably Taggiasca or another small, intensely flavored variety of black olive; see page 137)

About 10 large green olives

1 (16-ounce/450-gr) can solid white tuna, drained

3 tablespoons oil

2 tablespoons red wine vinegar or balsamic vinegar

Wash and dice the tomatoes (use cherry tomatoes whole), and place them in a serving bowl. Cut the mozzarella into ½-inch cubes and add it to the tomatoes. Dice the anchovy and add it to the bowl. Add the cucumber, scallions and pepper, if using. Dunk the sea biscuits into cold water until they develop hair-line cracks, then break them into quarter-dollar-sized pieces. If still extremely hard, dunk them again, but they must remain firm and not at all mushy. Add the biscuits, olives and tuna to the bowl, drizzle in the oil and vinegar and combine thoroughly. Let the salad stand about 5 to 10 minutes so that the sea biscuits can absorb the oil and vinegar. Serve cool.

Right: Ligurian sea biscuits.

FISH

Dried codfish is the object of a cult in Genoa. Every Ligurian cook has "the perfect recipe," but this one, supplied by Emanuele Revello, formerly of Da ö Vittorio in Recco, seems to work best. As Bruno Bini points out, the quality of the dried cod is the determining factor; given the effort involved, it is pointless to economize on cut-rate codfish. Use only the best olive oil, too. "Codfish live in water but must drown in oil," according to a centuries-old Genoese saying. Most Ligurians do not use anchovy or black pepper in the dish, but I think they are needed.

Clean the fish and cut it into strips about 1 to 2 inches wide. Bring a medium-sized pot of water to a boil, add the codfish and blanch for 1 to 3 minutes. Remove the skin and any bones. Thinly slice the carrot and onion, chop the celery and mince together the garlic and parsley. Pour ½ cup (¾ cup UK) of the oil into a large earthenware pot over medium heat, add the carrot, onion, celery and anchovy and brown lightly. Add the pine nuts and codfish; add the wine and let it evaporate while stirring. Add the salt and ½ cup hot water. Simmer, covered, for about 30 minutes, adding water to cover the fish; add the potatoes and tomato sauce and cook, covered, for another 20 minutes. Add the olives, parsley and garlic and simmer, uncovered, for about 10 more minutes or until the cod is tender and the sauce is thick. Pour in the remaining oil at the last minute, sprinkle with pepper and serve hot.

Stocchefisce accomodòu
(stoccafisso accomodato)

CLASSIC LIGURIAN DRIED CODFISH STEWED WITH VEGETABLES, PARSLEY, WHITE WINE, PINE NUTS, OLIVE OIL, OLIVES AND DRIED PORCINI

28 ounces (800 gr) pre-soaked dried codfish

1 carrot (optional), peeled

1 medium onion, peeled

1 celery stalk

1 clove garlic, peeled

1 bunch flat-leaf parsley, washed, tough stems removed

¾ cup (1 cup UK) oil

1 anchovy fillet, minced (optional)

1 tablespoon pine nuts

¾ cup (1 cup UK) dry white wine

A pinch of salt

3 small potatoes (300 gr), peeled and quartered

1 tablespoon tomato sauce or 1 teaspoon tomato paste

About 20 small black and green olives (see page 137)

Freshly ground black pepper (optional)

Ciuppin
(zuppa di pesce)

THICK ROCKFISH AND
SQUID SOUP WITH
MINCED ONION,
GARLIC, PARSLEY, HOT
PEPPERS AND WHITE
WINE

Fish soups and stews are eaten up and down the Ligurian coast. The name changes from *zuppa di pesce* near the Tuscan border to *ciuppin* closer to Genoa in the Levante, and *buridda* in the Ponente (*buridda* generally has larger pieces of fish in it). However, the names and recipes have been mixed and matched over the years. Most Ligurian versions of *ciuppin*—a genial Genoese dialect term meaning "nice little bowl of soup"—do not have tomatoes or tomato paste. This sets them apart from San Francisco's famous, ruinously rich fish and tomato soup, *cioppino*. It is the pride of Fisherman's Wharf (where the little old fishing boats—in fact Ligurian *gozzi*—are known as *feluccas* by the Genoese American immigrants, and rather less poetically as "dago boats" by their non-Italian colleagues). Most San Franciscans—even those of Italian descent—think *cioppino* was either invented in San Francisco or came from Livorno (Leghorn), on the northern Tuscan coast. The former is certainly wrong (*cioppino* is simply a corruption of the word *ciuppin*) and the latter improbable (the Tuscan name for this soup is *cacciucco*). As Waverly Root points out in *The Food of Italy*, Ferdinand I dei Medici, of Florence, bought the Province of Livorno from the Genoese in 1422; the Livornesi presumably learned how to make the soup from them. Wherever it originated, the essential thing to remember is that the fish you put into your *ciuppin* should be fresh and flavorful.

4 to 5 pounds (2 kg) mixture of baby squid, baby octopus, rockfish, small striped bass, grouper, red mullet, scorpion fish, greenling, or red snapper, cleaned; reserve fish heads

2 small carrots

1 celery stalk

1 medium onion, peeled

Whole black peppercorns

1 large onion

1 tablespoon oil

1 cup (1⅓ cup UK) dry white wine

2 anchovy fillets

1 bunch flat-leaf parsley, washed, tough stems removed

2 cloves garlic, peeled

2 dried hot peppers

1 medium squid, cleaned

1½ tablespoons tomato paste

Salt

6 sea biscuits or 6 thick slices very hard, dry toast

Place the fish heads, carrots, celery, medium onion and peppercorns in a stock pot or large pan, cover with water and bring to a simmer over medium-high heat; lower the heat and simmer for about 30 minutes. Do not let the broth boil.

Meanwhile, dice the large onion. Heat the oil in a deep earthenware pot or large stock pot over medium heat, add the onion and sauté until it is

translucent. Add the wine and let it partially evaporate for about 2 minutes, then reduce the heat. Mince the anchovies and add them to the pot. Mince the parsley and garlic and add them to the pot. Crumble the hot peppers into the pot and stir the mixture. Finely chop the medium squid, then add it, continuing to stir. Simmer for 3 minutes. Add one ladleful of the broth. Arrange the fish and whole baby squid and baby octopus carefully in the pot so that they will not break apart as they cook. Fill the ladle with broth and dissolve the tomato concentrate in the broth, stirring with a fork. Ladle in more broth until the fish are covered. Simmer very gently for 30 minutes or until the fish flakes easily off the bones at the flick of a fork (cooking times vary widely depending on the type of fish). Season to taste with salt and serve in wide—not deep—soup plates with the sea biscuits or toast.

Anciòe pinn-e
(acciughe ripiene)

STUFFED FRESH
ANCHOVIES WITH
BREADCRUMBS, HERBS
AND PARMIGIANO-
REGGIANO

1 pound (500 gr) fresh small anchovies

Crumb of 1 medium white bread roll

3 to 4 tablespoons milk

3 medium eggs

3½ tablespoons freshly grated Parmigiano-
Reggiano

A pinch of salt

1 sprig fresh marjoram or oregano leaves,
minced, or 1 teaspoon dried

¾ cup (1 cup UK) fine, dry breadcrumbs

Oil for frying

Fried or baked, stuffed fresh anchovies are a favorite finger food in Genoa and the Levante, especially in spring and summer when the fish are at their best. Ligurian anchovies are small—about four inches long—and less fatty than Atlantic or Pacific anchovies. When using non-Ligurian fish, try to remove as much of the fat and oil as possible by scraping gently under the skin and patting the fish dry with a paper towel. In any case, use only extremely fresh anchovies. This recipe comes from Genoese home cook Anna Bo, an anchovy expert.

Wash, scale and clean the fish, removing the spine bone from the tail end toward the head but leaving the tail attached. Cut 5 of the smallest anchovies into small pieces and pound them in a mortar. Soak the bread in the milk, squeeze dry, add it to the mortar and pound. Beat 2 of the eggs in a large mixing bowl, sprinkle in the cheese, salt and marjoram and add the anchovy and bread mixture. Combine thoroughly, adding cheese and more milk-soaked bread, if needed, to produce a thick paste. Stuff each anchovy with about 1 teaspoon of the mixture, taking care to keep the fish intact. Beat the remaining egg in a separate bowl, dip the stuffed anchovies into the egg one by one, then coat thoroughly with the breadcrumbs. Heat about 1½ inches of oil in a heavy skillet over medium heat and fry the anchovies until golden brown on both sides, about 5 minutes total.

Alternatively, the stuffed anchovies can be placed in an oiled baking dish and baked at medium heat (300° F./150° C.) for about 20 minutes, until golden brown.

Poultry and Meat

Rabbit is a favorite all over the region and many people raise their own, even in the suburbs of Genoa. This recipe can also be made with free-range chicken. The term *"a-a carlonn-a"* means, in essence, that even an idiot can make this simple dish successfully.

Mince together the onion, green olives, pine nuts, garlic and herbs. Pour the oil into a deep skillet or shallow, heat-proof casserole over medium-high heat. Add the rabbit and brown it on all sides. Remove the rabbit from the casserole and cover to keep it warm. Add the minced mixture to the casserole and brown, stirring. When the onion is golden, return the rabbit to the casserole, add the wine and let it evaporate, stirring. Reduce the heat to maintain a simmer and cook, covered, for 15 minutes. Add the black olives and enough broth to make a sauce. Season to taste with salt and pepper, sprinkle with whole pine nuts, simmer for 10 to 15 more minutes and serve.

Coniggio a-a carlonn-a
(coniglio alla ligure)

RABBIT OR CHICKEN FRICASSEED WITH HERBS, PINE NUTS, OLIVES AND WHITE WINE

1 medium onion, peeled

About 20 green olives, pitted

3 ½ tablespoons pine nuts

2 cloves garlic, peeled

6 sprigs fresh thyme or rosemary leaves

¼ cup (⅓ cup UK) oil

1 (2-pound / 1-kg) rabbit or free-range chicken, cut into 8 pieces

¾ cup (1 cup UK) dry white wine

20 black olives (see page 137)

Chicken broth or hot water

Salt and freshly ground black pepper

Pine nuts

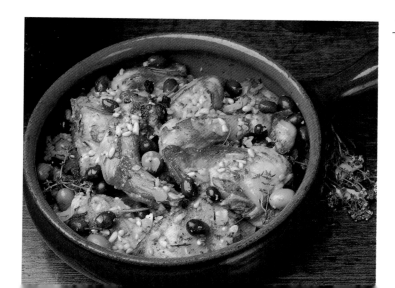

Carne a l'öxelletto
(carne all'uccelletto)

LEAN VEAL, THINLY SLICED THEN FINGER-SHREDDED, SAUTÉED WITH GARLIC, BAY LEAVES AND WHITE WINE

1 pound (500 gr) veal top round, thinly sliced into scallopine

Flour

3½ tablespoons butter or 2 tablespoons oil

1 clove garlic, peeled and minced

2 fresh bay leaves

⅓ cup (½ cup UK) dry white wine

Salt

Freshly ground black pepper (optional)

This simple dish requires skill in handling the sauté pan over high heat. Emanuele Revello, formerly of the Da ö Vittorio restaurant in Recco, makes it in the following manner.

Using a mallet or the flat side of a large cleaver, flatten the veal to the thickness of a coin, then tear the meat with your fingers into tatters about 1 inch wide. Toss the veal in a small amount of flour to coat lightly. Heat the butter in a sauté pan, add the garlic, bay leaves and meat, flipping and stirring until browned. Splash in the wine, season to taste with salt and pepper and continue to flip and stir for a few minutes, until the wine has evaporated. Serve immediately.

Breads, Focaccias and Desserts

Fainâ
(farinata)

BAKED CHICK-PEA MEAL

Pour 4 cups (1 liter) water and a pinch of salt into a large mixing bowl and slowly add the chick-pea flour, mixing clockwise with a wooden spoon to avoid the formation of lumps. The batter should fairly thickly coat the back of the spoon. Allow to sit for about 5 hours.

Preheat the oven to 500° F. / 260° C. Skim off any foam that has formed on the surface of the batter and gradually add 4 more cups (1 liter) water, mixing to avoid lumps, until the mixture has the consistency of runny pancake batter. Add the rosemary and ¼ cup (⅓ cup UK) oil and mix thoroughly. Use the remaining oil to coat a large, round, 1-inch-deep baking pan (the largest you can get into your oven). Pour in the batter to a depth of about ¾ inch and bake for about 30 minutes, or until the *farinata* is golden brown and firm but not dry. Remove from the oven, sprinkle with pepper and serve hot.

Salt

1 pound (500 gr) chick-pea flour

10 to 20 leaves fresh, tender rosemary (optional)

⅓ cup (½ cup UK) oil

Freshly ground black pepper

Fugassa
(focaccia)

CLASSIC LIGURIAN
OLIVE OIL FOCACCIA

4 cups (500 gr) flour

2 tablespoons dry yeast

1 teaspoon sugar

½ teaspoon malt syrup (optional)

Oil

Salt

This recipe comes from Italo and Anna Maccarini of Panificio Maccarini in San Rocco di Camogli. The focaccia may be topped with fresh rosemary, sage or very thinly sliced onions just before baking.

Sift the flour into two mounds of about ⅕ and ⅘ the amount, each in separate bowls. Dissolve the yeast, sugar and malt in about ¾ cup (1 cup UK) tepid water, form a well in the smaller mound of flour and add the dissolved mixture. Mix slowly and knead for about 5 minutes; cover with a cloth and set aside to rise in a warm spot for about 3 hours to develop into a starter. When the starter has risen and become spongy and porous, place it in the larger mound of flour, add about 1 cup warm water. Incorporate the flour and knead for about 7 minutes, adding warm water as needed, until the dough is smooth and elastic; cover with a clean towel and set aside to rise in a warm spot for 2 to 3 hours.

Generously oil a round or rectangular baking pan (the largest that will fit in your oven), preferably one with a thick bottom. Stretch the dough into the pan, pressing down firmly with your fingers to make indentations every ½ inch. Mix a pinch of salt with about 3 tablespoons water and 3 tablespoons oil. When the salt has partially dissolved, drizzle the mixture over the dough and work it into the indentations with your fingers.

Preheat the oven to 450° F./230° C. Allow the dough to sit for about ½ hour, then bake for 15 to 20 minutes, until the focaccia is golden. Serve hot or at room temperature.

Fugassa co-o formaggio

(focaccia col formaggio)

DELICATE CHEESE
FOCACCIA AS MADE IN
RECCO AND CAMOGLI

1 ½ tablespoons dry yeast

½ teaspoon sugar

½ teaspoon malt syrup (optional)

*¾ cup (1 cup UK) dry white wine or
water*

3 cups (400 gr) flour

¾ cup (1 cup UK) oil

A pinch of salt

Oil

*1 pound (500 gr) stracchino cheese
(see Note)*

This recipe comes from Italo and Anna Maccarini of Panificio Maccarini in San Rocco di Camogli.

Dissolve the yeast, sugar and malt in the wine. Pour the flour into a mound, make a well in the center and add the wine and ¾ cup (1 cup UK) oil. Incorporate the flour and knead the dough until it is smooth and elastic, about 5 minutes. Sprinkle with the salt and divide the dough into 2 equal parts. Cover the dough with cloths and set aside to rise in a warm spot for about 15 minutes. Stretch one ball of dough to the thickness of 2 sheets of paper. Stretch the second ball even thinner, until almost translucent. Set the sheets of dough aside to rest for about 10 minutes.

Preheat the oven to very hot, 500° F./260° C. Oil a large round baking pan (the largest you can fit in your oven). Place the first, thicker sheet of dough in the pan, pushing it out to the edges of the pan with your finger tips. Pinch the stracchino into rough rectangles about ½ inch long and distribute them evenly over the dough. Cover with the second, thinner sheet of dough, trim the excess dough from around the edges and pinch the sheets together. Use a fork to poke holes through the top layer of dough. Drizzle generously with olive oil, then spread the oil uniformly across the surface using the palm of your hand, pressing carefully to slightly flatten the lumps of cheese. Bake for 10 to 15 minutes, until the edges are golden brown; the focaccia should, however, remain off-white. Serve hot.

NOTE: If you cannot find stracchino cheese, try using the equivalent amount of soft, fresh mozzarella, diced and coated with a few tablespoons of yogurt to give it some tang to resemble stracchino.

\mathcal{P}andöçe

(pandolce)

CLASSIC LEAVENED
LIGURIAN CHRISTMAS
CAKE WITH CANDIED
FRUIT

\mathcal{I}n addition to the two main types of pandolce—*all'antica* or leavened—there are dozens of variations on the theme. This one comes from food writer Bruno Bini. Traditional recipes call for long periods of leavening—up to 24 hours—in part because until recently many Ligurian houses were not well heated. Pandolce is a winter cake and must rise in warm, draught-free conditions. Once upon a time it was the grandmother's job to warm the dough, swaddled in dishcloths, on her lap. Because of the trickiness of the two-stage leavening process (using a starter) no two homemade pandolce cakes are alike. In fact most Ligurians buy their pandolce from a trusted baker, whose bakery is always uniformly warm in winter. Nowadays, in a modern, well-heated home, the starter should rise for about 3 to 4 hours, and the cake dough for about 3 hours.

Mix the yeast with 3 tablespoons warm water and as much flour as it will absorb, about 4 tablespoons. Knead and let sit, covered, in a warm spot for 3 to 4 hours, to develop into a starter. Place the remaining flour on a board or other work surface, make a well in the center and add the starter, orange-flower water, Marsala, butter, sugar and salt, stirring slowly to incorporate the flour. Add the fennel seeds, pine nuts, raisins and candied fruit; knead thoroughly, adding small amounts of milk to keep the dough moist and elastic. Knead for 15 to 20 minutes. Shape the dough into a round loaf, place in a greased round baking pan, cover completely with a clean cloth and allow to rise again for 3 hours.

Preheat the oven to 425° F./220° C. Uncover the dough, score a triangle in the top and bake for about 1 hour, until it is brown and firm and a toothpick inserted in the center of the cake comes out clean. Cool to room temperature and serve.

NOTE: This recipe yields a very large loaf or two medium-sized loaves. It is easily halved.

2 tablespoons dry yeast

8 cups (1 kg) flour

2 tablespoons orange-flower water

¾ cup (1 cup UK) Marsala

½ cup (150 gr) butter, melted and cooled to room temperature

1 cup (250 gr) sugar

A pinch of salt

2 tablespoons fennel seeds

6 to 7 tablespoons pine nuts

½ cup (⅔ cup UK) raisins

1 cup (1⅓ cup UK) mixed candied fruit

Milk

Overleaf: Pandolce

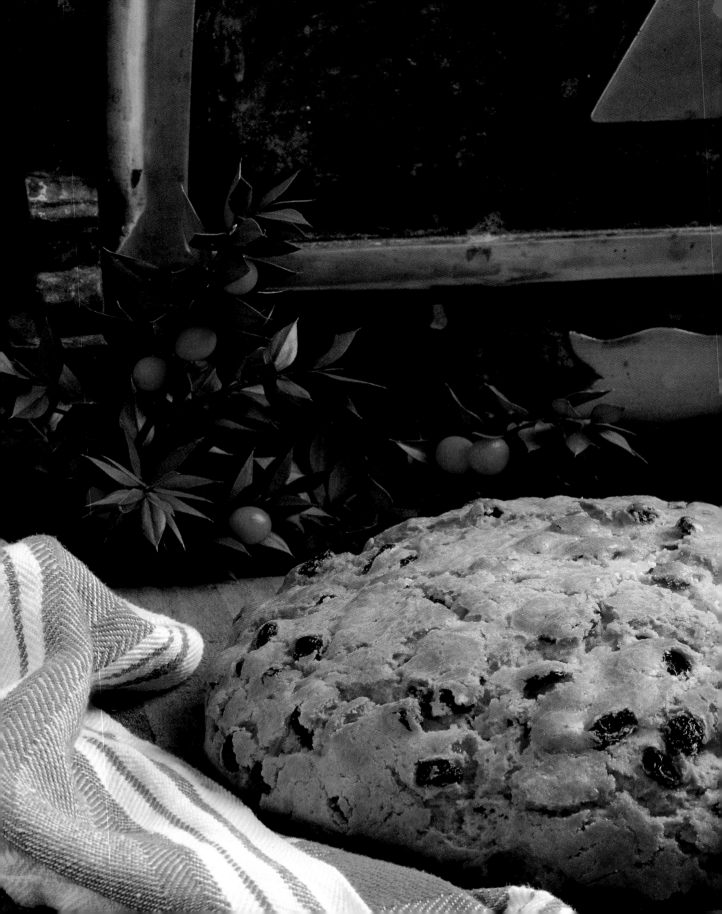

Panella

(castagnaccio)

NATURALLY SWEET
CHESTNUT FLOUR CAKE
WITH RAISINS, PINE
NUTS AND FENNEL
SEEDS

Long considered the food of the poor, chestnuts and chestnut flour are now sought-after specialty products. Most of the tens of thousands of acres of formerly cultivated chestnut woods that climb the tops of Apennine ridges have become wild forests where local hikers collect chestnuts in autumn. When combined with olive oil and baked, fresh chestnut flour has a rich, chocolately taste and is surprisingly sweet. Ligurians, who are always careful to respect the essential flavors of the ingredients they use, never add sugar to their castagnaccio.

Anna Maccarini of Panificio Maccarini makes this classic *panella*, a particular favorite in the Levante in fall and winter. "Use sparkling mineral water to make your castagnaccio and it will be lighter and tastier," she says. "The bubbles act like yeast to leaven the cake."

½ cup (100 gr) raisins

1 pound (500 gr) Italian chestnut flour

A pinch of salt

4 cups (750 ml) carbonated water

About ½ cup oil

4 tablespoons pine nuts

1½ tablespoons fennel seeds

Preheat the oven to 450° F./230° C. Soak the raisins in warm tap water for 15 minutes, drain and tamp dry. Sift the flour into a large bowl, add a pinch of salt and a small amount of carbonated water and ¼ cup (⅓ cup UK) oil, mixing slowly but thoroughly to prevent the formation of lumps. Gradually incorporate the rest of the water and add the raisins and pine nuts. Use the remaining oil to coat a large, round baking dish about 16 inches in diameter and pour in the mixture to a depth of almost ½ inch. Sprinkle with the fennel seeds and bake for 15 to 20 minutes, until firm but moist (small cracks will form on the surface). Serve hot or at room temperature.

Volume, Weight and Temperature Equivalents

These are not exact equivalents, but have been rounded up or down slightly to make measuring easier.

VOLUME EQUIVALENTS

American	Metric	Imperial
¼ t	1.25 ml	
½ t	2.5 ml	
1 t	5 ml	
½ T (1½ t)	7.5 ml	
1 T (3 t)	15 ml	
¼ cup (4 T)	60 ml	2 fl oz
⅓ cup (5 T)	75 ml	2½ fl oz
½ cup (8 T)	125 ml	4 fl oz
⅔ cup (10 T)	150 ml	5 fl oz (¼ pint)
¾ cup (12 T)	175 ml	6 fl oz
1 cup (16 T)	250 ml	8 fl oz
1¼ cups	300 ml	10 fl oz (½ pint)
1½ cups	350 ml	12 fl oz
1 pint (2 cups)	500 ml	16 fl oz
1 quart (4 cups)	1 litre	1¾ pints

WEIGHT EQUIVALENTS

Avoirdupois	Metric
¼ oz	7 g
½ oz	15 g
1 oz	30 g
2 oz	60 g
3 oz	90 g
4 oz	115 g
5 oz	150 g
6 oz	175 g
7 oz	200 g
8 oz	225 g

Avoirdupois	Metric
9 oz	250 g
10 oz	300 g
11 oz	325 g
12 oz	350 g
13 oz	375 g
14 oz	400 g
15 oz	425 g
1 lb	450 g
1 lb 2 oz	500 g
1½ lb	750 g
2 lb	900 g
2¼ lb	1 kg
3 lb	1.4 kg
4 lb	1.8 kg
4½ lb	2 kg

OVEN TEMPERATURES

Oven	°F	°C	Gas Mark
very cool	250–275	130–140	½–1
cool	300	150	2
warm	325	170	3
moderate	350	180	4
moderately hot	375	190	5
	400	200	6
hot	425	220	7
very hot	450	230	8
	475	250	9

TRAVELER'S GUIDE

\mathcal{T}he following represents only a fraction of the cultural and culinary resources that Liguria has to offer. A complete list of museums, villas, palaces, artisans, olive oil makers and specialty shops would fill an entire book and is beyond the scope of this volume.

NOTE: To dial the telephone numbers listed from outside Italy, dial the country code for Italy (39) and drop the "0" of the local area code, which is used only when dialing within the country.

19th-century nautical instruments and a portrait of a sailing ship, ship's register and Bozzo family memorabilia.

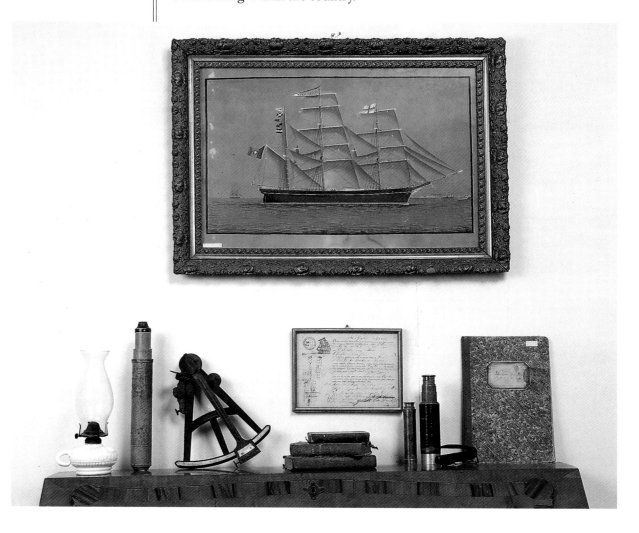

SELECT LIST OF MUSEUMS, VILLAS AND PALACES OPEN TO THE PUBLIC

Camogli: Gio Bono Ferrari Maritime Museum
41 Via G.B. Ferrari
Tel. 0185/77-15-70
Open Wed., weekends and holidays 9–noon and 3–6 p.m. (until 7 p.m. July to Sept.).

Maritime memorabilia, ship models, ex-votos, ship paintings.

Chiavari: Pinacoteca Civica di Palazzo Rocca
2 Via Costaguta
Tel. 0185/32-08-29
Open weekends 10–noon and 4–7 p.m.

17th-century patrician villa with landscaped park, picture gallery and period furniture, including early Chiavari chairs.

Chiavari: Quadreria di Palazzo Torriglia
1 Piazza Mazzini
Tel. 0185/31-02-41
Open weekdays 9–noon and 3:30–6 p.m., Sat. 9–noon.

Mannerist town house with a small collection of Genoese School paintings, some period furniture and a private "cupboard" chapel.

Genoa: Palazzo Bianco Art Gallery
11 Via Garibaldi
Tel. 010/29-18-03
Open Tue. to Sat. 9–1:15 p.m. and 3–6 p.m.

18th-century palace with large holdings of Genoese School paintings, as well as works by Rubens, Van Dyck and other Flemish painters (including Jan Matsys), Veronese and Pontormo. Hanging garden with view of Via Garibaldi; typical patrician staircases.

Genoa: Palazzo del Principe
4 Piazza del Principe
Tel. 010/25-55-09
Open by arrangement and on Sat. 10–3 p.m., Sun. 10–1 p.m.

Andrea Doria's mannerist palace, frescoed by Perin del Vaga, with loggia, period furniture and family art collection, including the portrait of Andrea Doria by Sebastiano del Piombo.

Genoa: Palazzo Reale Art Gallery
10 Via Balbi
Tel. 010/20-68-51
Open Tue., Thur. and weekends 9–1 p.m.

Sumptuous baroque palace with extraordinary stairway, hanging garden and interior furnished with period antiques. The picture gallery contains Genoese School works, plus paintings by Guido Reni, Van Dyck, Tintoretto and Il Guercino.

Genoa: Palazzo Rosso Art Gallery
18 Via Garibaldi
Tel. 010/28-24-41
Open Tue. to Sat. 9–1:15 p.m. and 3–6 p.m.

17th-century palace with fine art collection, including Genoese School painters and sculptors, plus works by Caravaggio, Veronese, Tintoretto, Titian, Dürer and Pisanello. Excellent examples of mannerist and baroque frescoes, trompe-l'oeil, stucco work and gilding; loggia and interesting architectural features, including staircases and courtyard.

Genoa: Palazzo Spinola in Pellicceria National Art Gallery
1 Piazza Pellicceria
Tel. 010/29-46-61
Open Tue. to Sat. 9–6:30 p.m., Sun. 9–1 p.m.

16th- and 17th-century patrician palace preserved as a house-museum, with period furniture, magnificent marble stairways, frescoed salons and ballrooms, a widow's walk and a 17th-century kitchen. Genoese School paintings and sculptures; works by Van Dyck, Guido Reni and Antonello da Messina.

Genoa-Pegli: Naval History Museum
7 Piazza C. Bonavino
Tel. 010/69-69-885
Open Tue. to Thur. 9–1 p.m. and Fri. and Sat. 9–7 p.m.

16th-century patrician palace in Genoa's western suburbs, housing the region's main maritime museum. Ship models, paintings, navigational instruments, antique maps and globes. Interesting also for the cycle of mannerist frescoes.

Genoa-Pegli: Villa Durazzo-Pallavicini Garden
Via Pallavicini
Tel. 010/69-81-048
Open every day but Monday, April to Sept. 9–7 p.m.; Oct. to March 10–5 p.m.

Landscaped 18th-century botanical garden and early 19th-century romantic park with statuary, pagodas, gazebos, waterfalls, kiosks—one of Italy's most striking and least-known ensembles of its kind, typical of the fanciful tastes of the period.

Imperia-Mortola Inferiore: Hanbury Garden
Villa Hanbury
Tel. 0184/61-136
Open weekdays and Sat. 10–4 p.m., Sun. 9–4 p.m., closed Wed.

Botanical garden and villa from 1867, created by English botanist Sir Thomas Hanbury. Exemplifies the lifestyle of the British colonial community of the period.

Imperia-Pontedassio: Spaghetti Historical Museum
96 Via Garibaldi
Tel. 0183/21-651
Open by arrangement.

Private museum, created by Vincenzo Agnesi, of the pasta-making dynasty, in a former pasta factory, with documents, machinery and displays. Will be of interest primarily to culinary historians and pasta fanatics.

ARTISANS AND CRAFTS SHOPS

TROMPE-L'OEIL

Decorarte
5/1 via Luca Cambiaso
Genoa
Tel. 010/51-57-90

Founded over a decade ago by four young Fine Arts Academy graduates with specialized training in wall decoration and trompe-l'oeil, Decorarte has restored a variety of palaces, villas, hotels and churches in Liguria and Provence, including the Musée Matisse in Nice. They also create custom trompe-l'oeil works for interiors, on walls or movable surfaces (canvas, wood, slate).

Burlando
27/2 B Via B. Cairoli
Sori (GE)
Tel. 0185/70-09-70

This family of trompe-l'oeil painters has been active for several generations. Luigi and Giovanni Burlando have restored and created new works for numerous buildings in Liguria, primarily on the Riviera di Levante. They specialize in exterior work: false rustication, friezes, columns, etc.

CERAMICS

Manifattura Ceramiche d'Arte S.M.
60 Via Angelo Gianelli
Genova Quinto (GE)
Tel. 010/33-13-08

Simona Marinari produces hand-painted and handmade tiles for floors, walls and surfaces, using traditional Ligurian or Spanish patterns. She also restores or designs tiles to order for architects, interior decorators and individuals.

Poterie, Ceramiche Artistiche
22R Salita del Prione
Genoa
Tel. 010/20-85-03

Founded in 1981 by ceramist Marcella Diotto, this small workshop in Genoa's *carruggi* draws on over 200 antique and contemporary designs to create tiles for every imaginable use in hand-painted Majolica and glazed or low-relief terra cotta. Restoration is a specialty. Diotto also works with architects, smiths and cabinet-makers to create contemporary furniture and installations that integrate tiles and other ceramic elements.

Studio Ernan Design
77 Corso Mazzini
Albisola Superiore (SV)
Tel. 019/48-99-16

One of the best workshops making contemporary handmade and hand-painted Albissola ceramics. Complete sets or one-of-a-kind pieces are available and custom work can be commissioned.

WOODWORK

Franco Casoni
73 Via Bighetti
Chiavari (GE)
Tel. 0185/30-14-48

Apprenticed as a boy, Casoni worked with a variety of cabinetmakers in Liguria and also received training at Chiavari's renowned local crafts school. He won the Turio-Copello crafts prize in 1989 and is president of the provincial Crafts Guild. Casoni restores Genoese antiques such as *bamboccio* chests and creates traditional and contemporary furniture, wooden sculptures and figureheads, figurines for Nativity scenes and wooden stamps for making *corzetti* pasta.

Granone & Monchieri
10R Vico del Filo
Genoa
Tel. 010/24-71-294

Near Genoa's cathedral in the heart of the *carruggi*, this workshop produces a variety of wooden kitchen utensils, including olive wood mortars and pestles, olive wood cutting boards and bowls and stamps for making *corzetti* pasta.

CHIAVARI CHAIRS

F.lli Levaggi
469 Via Parma
Chiavari
Tel. 0185/38-30-92

Ettore and Ameglio Levaggi carry on the family tradition of making ultra-light, all-wood Chiavari chairs, primarily in beech and cherry.

S.A.C. Sedie Artistiche Chiavaresi
60 Via Bancalari
Chiavari
Tel. 0185/30-55-51

After decades of apprenticeship, three Chiavari chair makers, Umberto and Giovanni Rocca and Arcangelo Strucchi, banded together to form their own company which produces the celebrated Campanino and dozens of other models of the classic Chiavari chair, as well as their own designs.

DAMASK, VELVET, MACRAMÉ AND PRINTED MEZZARI

Figli di De Martini Giuseppe
78 Via Scaletta
Lorsica (GE)
Tel. 0185/97-73-02

Lorsica's only remaining family of weavers, Ameglia De Martini and her niece and nephew produce silk, linen and cotton damasks using designs handed down the generations, as well as linen towels with macramé fringes, upholstery and fabric wall coverings.

Tessitura Artigiana Sergio Gaggioli
208/A Via Aurelia
Zoagli (GE)
Tel. 0185/25-90-57

Zoagli was once a stronghold of the Italian silk industry, but only a handful of artisans remain.

Sergio Gaggioli, his wife Lorenza, daughter Paola, son Giuseppe and daughter-in-law Luciana use several vintage looms (including a centuries-old hand-powered frame) to weave peerless velvet and damasks in silk, linen and cotton, with both antique and custom-made contemporary patterns.

Elena Venzi—Macramé Artistici
9 Via Remolari
Chiavari (GE)
Tel. 0185/30-15-57

Venzi's elaborate macramé creations can take months or years to complete and require hundreds of thousands of knots. She works for museums, churches and a variety of private clients from around the world. Venzi also gives private lessons by arrangement in the art of traditional Chiavari macramé.

Emilio Gandolfi
Pizzi al tombolo di Rapallo
1 Piazza Cavour
Rapallo (GE)
Tel. 0185/50-234

In business since 1920, this is the region's premier shop specializing in handmade lace from Rapallo, Portofino and Santa Margherita, where once upon a time 8,000 full-time lace-makers were employed. Only a few dozen remain, selling their wares through this and other shops. Every imaginable kind of lace creation is on display.

Sergio Lugano
120-2/R Via Galata
Genoa
Tel. 010/54-20-62

Genoa's top producer and biggest distributor of printed India cotton *mezzari* fabrics, which have been used in Liguria since the Middle Ages. Originally worn as a shawl or head covering, they are now commonly used as wall hangings, curtains or bedspreads and are found in nearly every Ligurian home. Lugano prints them by hand using antique Ligurian patterns, the most popular of which is the Tree of Life, and creates new designs on commission.

BOAT BUILDING

Antico Cantiere Navale, Mariano Topazio e Figlio
111 Via dei Devoto
Lavagna (GE)
Tel. 0185/31-00-41

Master boatbuilder Mariano Topazio and his son Francesco make custom handcrafted wooden *gozzi*, *leudi* and *lance*, the three most popular small boats of Liguria used for fishing, sailing and freight.

Giacomo Viacava, Maestro d'ascia
Piazza della Libertà
Portofino (GE)
Tel. 0185/26-95-40

Viacava is Portofino's last master boatbuilder able to produce all-wood *gozzi* and *leudi* using traditional methods.

SLATE

Ardesia Sculture e Oggettistica
44 Via Lombardia
Cavi di Lavagna (GE)
Tel. 0185/39-53-96

Gloria Campana, Francesca Lertora and Grazia Barreca, three young students of Francesco Dallorso and graduates of Chiavari's Art Institute, sculpt slate using traditional methods and tools, producing bas-relief sculptures and a variety of art objects.

Francesco Dallorso
136-2 Via dei Devoto
Lavagna (GE)
Tel. 0185/31-45-51

Francesco Dallorso, Liguria's foremost slate sculptor, worked as an apprentice from the age of twelve in the Bianchi & Sanguineti marble workshop of Lavagna, then went on to learn the art of fine jewelry making in Genoa. He graduated from the Fine Arts Academy of Genoa and was a professor of studio sculpture for decades before retiring recently. His bas-reliefs in slate and marble are in many homes in the region, and in the Basilica of Santo Stefano and Oratory of the Santissima Trinità, both in Lavagna.

Fratelli De Martini Ardesia S.r.l.
160 Via Provinciale, Località Bonaia
Orero (GE)
Tel. 0185/35-49-13

This medium-sized quarrying company in the Val Fontanabuona was founded in 1954 by the De Martini family, slate miners for generations. They currently produce blackboards and pool-table tops, and supply roof and floor tiles to the construction industry and slate blocks to local artisans.

METALWORK

Fratelli Ghisu
4 Via Montecarlo
Santa Margherita Ligure (GE)
Tel. 0185/28-17-52

Walter Ghisu and his brothers have made many of the pergolas, gates and exterior wrought-iron decorative elements that you admire when touring Santa Margherita, Rapallo and Portofino. They also produce typical Ligurian bedsteads.

Mario Mattoli
5 Piazza San Giacomo
Chiavari (GE)
Tel. 0185/36-01-17

Mattoli is one of perhaps a dozen top smiths in Liguria capable of making or restoring typical wrought-iron bedsteads, pergolas, gates and detailing, as well as copper pots, pans and baking dishes for restaurants and individuals, that are indistinguishable from period pieces.

COBBLESTONE DESIGNS

Armando Porta
12 Vico Sant'Antonio
Genoa
Tel. 010/24-65-743

Septuagenarian Armando Porta is the grand master of the Ligurian *risèu*—decorative, cobbled pavements made with river rocks or beach stones polished by the waves. *Risèu* has been used for centuries to embellish piazzas, the entrances of churches, gardens, paths and even gutters. Porta has spent his entire life restoring historic *risèu* and creating new cobbled areas using only stones, sand and lime—never cement. When properly made they last for hundreds of years.

SPECIALTY FOOD SHOPS AND PRODUCERS

Carasco: Azienda Agricola Noceti Roberto
1 Località Dotta - Paggi
Tel. 0185/35-01-15

An artisanal olive grower and oil producer near Sestri Levante making cold-pressed, unfiltered oils for connoisseurs, with the olive type and specific grove indicated on the label. Olive varietals are Lavagnina, Taggiasca, Razzola and Pinola. Noceti also makes Bianchetta Genovese wine and has applied the "boutique wine" approach to his oils, which are among the region's best.

Chiavari: Luchin
53 Via Bighetti
Tel. 0185/30-10-63

The third generation of the Bonino family (great-grandfather Luca Giobatta Bonino's nickname was Luchin) runs this historic osteria under the arcades of old Chiavari and makes what many believe is one of the region's best *farinatas*, baked in a wood-burning oven in huge, round copper pans. Luchin has received the mark of approval of the Accademia Italiana della Cucina and the unbendingly strict Associazione per la Tutela e la Valorizzazione della Farinata del Tigullio—an association headed by Professor David Bixio, M.D., whose goal is to promote and protect authentic *farinata*.

Chiavari: Pastificio Prato
2 Via Cittadella
Tel. 0185/30-94-24

Chiavari is a serious eating city and this is its premier fresh pasta shop. Founded in 1810, it specializes in *corzetti*, tortelloni, ravioli, *pansôuti* and all the classic Ligurian sauces, including a delicious tomato and meat sauce made in the fall with wild boar.

Frazione Sant'Agata Imperia-Oneglia: Frantoio Sant'Agata di Mela Antonio & C.
20 Via Scuola
Tel. 0183/29-34-72

With olive groves at about 1,000 feet above the coast town of Imperia, this small, family-run olive-growing and oil-making concern (not related to the huge Sant'Agata company of Genoa) uses a combination of antique and ultra-modern machinery to produce what could be the Riviera di Ponente's finest extra virgin olive oils. The special bottling Oro Taggiasco, made only from Taggiasca olives, won the coveted 1996 Ercole Olivaro award in Spoleto for the best light and fruity oil in Italy. Antonio Mela's family have been making oil in the area since 1827, though the current operation was founded in 1987.

Genoa: Bedin
54-56/R Via Dante
Tel. 010/58-09-96

This century-old restaurant (not always in the same location) in downtown Genoa serves some of the region's best chick-pea *farinata*—plain or with fresh herbs. They claim to have invented the pesto pizza, a specialty which has a small but faithful following in Genoa.

Genoa: D. Villa di Profumo M. & C.
2/R Via Portello
Tel. 010/27-70-077

Among Genoa's most handsome and longest-established (1870) chocolate and confectioner's shops, D. Villa is just off the fasionable Via Garibaldi and caters to the city's sweet-toothed *beau monde*.

Genoa: Pasticceria Tagliafico
Via Galata 31R
Tel. 010/56-57-14

Founded in 1923 and still run by the Tagliafico family, this is one of the capital's best but least publicized pastry shops, with both varieties of Genoese pandolce (*all'antica* and leavened), aniseed Lagaccio cookies, cakes, pastries and chocolates.

Genoa: Panarello
154/R Via XX Settembre
Tel. 010/56-22-38

Genoa's most famous pastry-making chain, celebrated for its classic *pandolce alla genovese*.

Genoa: Pietro Romanengo fu Stefano
74R Via Soziglia
Tel. 010/29-78-69

In the same family since 1780, this confectioner's shop in Genoa's *carruggi* produces authentic Genoese candied fruit, preserves, jams, marrons glacés, confetti and chocolates using recipes handed down the generations. The shop is a registered landmark, with a lavishly sculpted marble facade and a jewel-box interior with painted glass ceiling and wood-and-glass display cabinets with decorative moldings.

Genoa: Serafina, Artigiana Alimentari
34 Via Canneto il Curto
Tel. 010/20-37-79

This traditional, family-run delicatessen makes some of the region's most exquisite vegetables and mushrooms preserved in olive oil, dried mushrooms and pasta sauces, including arguably the best fresh pesto you can buy in Liguria.

Rapallo: Frantoio Portofino
San Maurizio di Monti
Tel. 0185/65-883

This small olive oil works on the winding road to Montallegro, high above Rapallo, produces some of the region's most delicate oils cold-pressed from hand-picked Ligurian olives, primarily of the Lavagnina variety. They also produce excellent *pasta d'olive*, a paste of fresh-crushed olives mixed with extra virgin Ligurian oil.

Rapallo: Pasta Fresca Dasso
31 Piazza Venezia
Tel. 0185/53-309

Olga Dasso makes some of the region's best fresh pasta and is celebrated for her traditional *pansôuti* (filled pasta with *preboggion* and Parmigiano), stamped round *corzetti*, pesto, *salsa di noci* (walnut and cream sauce) and all the Ligurian pasta and sauce specialties.

Recco: Panificio-Pasticceria Moltedo
2/4 Via XX Settembre
Tel. 0185/74-046

Local connoisseurs concur that Lorenzo Moltedo and his family make what is probably the best *focaccia al formaggio* in Liguria, a Recco specialty.

San Rocco di Camogli: Panificio Maccarini
46 Via San Rocco
Tel. 0185/77-06-13

Italo Maccarini descends from a dynasty of local bakers specializing in the old-fashioned mariner's sea biscuit (*la galletta del marinaio*), the staple of Camogli's seafarers for centuries. Sea biscuits are still used in dozens of Ligurian recipes. A seemingly simple hardtack, it is diabolically difficult to make properly; Maccarini's *gallette* are unquestionably Liguria's best. He also makes plain focaccia and focaccia with herbs, olive-pulp bread (a specialty of Levanto) and *focaccia al formaggio* in the style of nearby Recco. Wife Anna and daughter Valeria excel with classic Ligurian vegetable tarts and stuffed vegetables.

Sant'Olcese: Salumificio Cabella
di G.B. Pedemonte e C.
Tel. 010/70-98-09

The hill town of Sant'Olcese, a few miles inland from Genoa, is the home of celebrated Genoa salami, eaten all over the world. The original variety made here is a delicious blend of pork and veal. Cabella is one of Sant'Olcese's most authentic family-run butcher shops and salami-makers.

Sarzana: Gemmi Pasticceria
21/23 Via Mazzini
Tel. 0187/62-01-65

Sarzana is on the edge of Tuscany and within miles of Emilia and hence has a tri-regional cuisine, with ancient Etruscan and Roman overlays. This historic pastry shop on Sarzana's main street is renowned for its local dessert specialties including *spungata*, a rich pastry-shell cake stuffed with dried fruit and nuts (similar to mincemeat) which has been made in the area for several thousand years.

BIBLIOGRAPHY

Accame, Franco. *Mandilli de saea*. Valenti Editore: Genoa, 1982 and City 2 Editrice: Genoa, 1986 (3rd edition).

Accame, Franco, Virgilio Pronzati and Silvio Torre. *Il grande libro della cucina ligure*. De Ferrari Editore: Genoa, 1994.

Addison, J. *Remarks on Several Parts of Italy, &c. In the Years 1701, 1702, 1703*. F. Tonson: London, 1718 (2nd edition).

Alighieri, Dante. *La Divina Commedia*. Ulrico Hoepli: Milan, 1965.

Antica Cuciniera Genovese. ENDL-Tolozzi Editore: Genoa, no date.

Balzac, Honoré de. "Honorine," in *La Comédie Humaine*. vol. II, Gallimard: Paris, 1995.

Barletti, Alessandro N. and Gianni Medri. *Il Monte di Portofino*. Sagep Editrice: Genoa, 1972.

Barrow, R. H. *The Romans*. Penguin Books Ltd.: Harmondsworth, Middlesex, 1962.

Beny, Roloff. With text by Anthony Thwaite and Peter Porter. *Roloff Beny in Italy*. Harper & Row: New York, 1974.

Bernardo Strozzi. cata. ed. Ezia Gavazza, Giovanna Nepi Sciré and Giovanna Rotondi Terminiello, Electa: Milan, 1995.

Bertollo, Alfredo. *Amore inglese a Portofino*. Gribaudo Editore: Cavallermaggiore, 1984.

Bini, Bruno. *Codice della Cucina Ligure*. S.E.P.–Il Secolo XIX: Genoa, 1990.

Bini, Bruno. *Codice della Cucina Ligure: Torte, Ripieni, Focacce, Polpettoni, Farinata*. ed. Salvatore Marchese, Virgilio Pronzati, Carlo Romito. S.E.P.–Il Secolo XIX: Genoa, 1992.

Bini, Bruno and Paolo Lingua. *Colombo invita a tavola*. GGallery: Milan, 1992.

Braudel, Fernand. "L'Italia che mi ha incantato," in *Il Corriere della Sera*. Milan, Feb. 14, 1983.

Braudel, Fernand. *The Mediterranean and The Mediterranean World in the Age of Philip II*, vols. I and II. Harper & Row: New York, 1973.

Brino, Giovanni. *Colori di Liguria*. Sagep Editrice: Genoa, 1991.

Brosses, Charles de. *L'Italie il y a cent ans, ou Lettres écrites d'Italie à quelques amis en 1739 et 1740 par Charles de Brosses [...]*. Romain Colomb: Paris, 1836.

Brosses, Charles de. *Lettres familières sur l'Italie*. Firmin-Didot: Paris, 1931.

Burgess, Anthony and Francis Haskell. *The Age of the Grand Tour*. Crown Publishers, Inc.: New York, 1967.

Calvino, Italo. *Il sentiero dei nidi di ragno*. Giulio Einaudi Editore: Turin, 1947.

Calvino, Italo. *Ultimo viene il corvo*. Giulio Einaudi Editore: Turin, 1949.

Carden, Robert W. *The City of Genoa*. Methuen & Co.: London, 1908.

Catalogo delle Ville Genovesi. cata. ed. Emmina De Negri, Cesare Fera, Luciano Grossi Bianchi, Ennio Poleggi. Comune di Genova: Genoa, 1962.

Cocteau, Jean. *Clair obscur*. Editions du Rocher: Monaco, 1954.

Crovari, José. *Tristan da Cunha—L'Isola delle aragoste*. Silver Press: Genoa, 1990.

De Palma, M. Camilla. "La riapertura del Museo Etnografico Castello D'Albertis," in *Bollettino dei Musei Civici Genovesi*. Anno XII, N. 34-35-36, 1990. Comune di Genova: Genoa, 1990.

De Prà, Claudio and Franca Ferreri. *Liguria Nascosta*. Editore SIAG: Genoa, no date.

Dickens, Charles. *The Works of Charles Dickens*, vol. 24, *Pictures from Italy*. Peter Fenelon/Collier & Son: New York, 1900.

Dolcino, Esther and Michelangelo. *Le Ricette Liguri per tutte le occasioni.* Nuova Editrice Genovese: Genoa, 1990.

Dolcino, Michelangelo. *Tradizioni e personaggi di Liguria.* Pirella Editore: Genoa, 1973.

Doria, Giorgio. "L'opulenza ostentata nel declino di una città," in *Genova nell'Età Barocca.* cata. ed. Ezia Gavazza and Giovanna Rotondi-Terminiello. Nuova Alfa Editoriale: Genova, 1992.

Dumas, Alexandre. *Impressions de voyage. Une année à Florence.* Michel Lévy: Paris, 1851.

Dupaty, Charles. *Lettres sur l'Italie en 1785.* priv. ed.: Paris, 1789.

Ferrando, Isabella and Tiziano Mannoni. *Liguria—Portrait of a Region.* Sagep Editrice: Genoa, 1989.

Ferrari, Gio Bono. *La città dei mille bianchi velieri—Camogli.* Nuova Editrice Genovese: Genoa, 1991.

Ferrari, Gio Bono. *Racconti di Terra e di Mare.* Sagep Editrice: Genoa, 1984.

Ferro, Gaetano. *Carte nautiche dal Medioevo all'Età moderna.* Edizioni Colombo: Genoa, 1992.

Girani, Alberto. *Guida alle Cinque Terre.* Sagep Editrice: Genoa, 1989.

Grossi Bianchi, Luciano and Ennio Poleggi. *Una Città Portuale del Medioevo: Genova nei Secoli X–XVI.* Sagep Editrice: Genoa, 1979.

Grosso, Orlando. *Genoa and the Riviera of Liguria.* La Libreria dello Stato-Istituto Poligrafico dello Stato: Rome, 1953.

Guida dell'entroterra ligure. Istituto Geografico De Agostini: Novara, 1987.

Guida d'Italia del Touring Club Italiano. Liguria, T.C.I.: Milan, 1967.

Guide de Agostini, Liguria. De Agostini: Novara, 1991.

Howard, Edmund. *Breve Storia di Genova.* Sagep Editrice: Genoa, 1986.

Lamartine, Alphonse de. *Oeuvres poétiques complètes.* ed. F. Guyard. Gallimard: Paris, 1963.

Leoncini, Domenico. *Campo nei Secoli.* Comune di Campo Ligure: Campo Ligure, 1989.

La Liguria delle Casacce. cata. Provincia e Comune di Genova: Genoa, 1982.

Lingua, Paolo. *La Cucina dei Genovesi.* Franco Muzzio Editore: Padua, 1989.

Marcenaro, Giuseppe. *Viaggio in Liguria.* Sagep Editrice: Genoa, 1992.

Il Mare, Grande enciclopedia illustrata. Istituto Geografico De Agostini: Novara, 1973.

Melville, Herman. *Journal of a Visit to Europe and the Levant.* Princeton University Press: Princeton, New Jersey, 1955.

Meriana, Giovanni. *La Liguria dei Santuari.* Sagep Editrice: Genoa, 1993.

I Mezzari tra Oriente e Occidente. cata. ed. Marzia Cataldi Gallo. Sagep Editrice: Genoa, 1988.

Montale, Eugenio. *Le Occasioni.* Arnoldo Mondadori Editore: Milan, 1949.

Montesquieu, Charles L. de. *Voyages.* G. Gaunomilhon: Bordeaux, 1984.

Oro di Liguria, l'Ardesia: Storia, Lavorazione, Arte. Sagno, Centro Studi Chiavari. Edizioni Sagno: Genoa, 1988.

Pallottino, Massimo. *The Etruscans.* Penguin Books: New York, 1956.

Pastorino, Carlo. *La Mia Liguria.* ECIG: Genoa, 1987.

Pessa, Loredana and Montagni, Claudio. *L'Arte della Sedia a Chiavari.* Sagep Editrice: Genoa, 1985.

Petrarca, Francesco. *Africa.* ed. N. Festa. Sansoni: Florence, 1929.

Petrucci, Vito Elio. *Cucina & Santi.* Francesco Pirella: Genoa, 1995.

Piccinardi, Antonio. *Dizionario di Gastronomia.* Rizzoli Libri: Milan, 1993.

Profumo, Luciana Müller. *Le Pietre Parlanti.* Banca Carige: Genoa, 1992.

Quaini, Massimo. *La Conoscenza del territorio ligure fra Medio Evo ed Età Moderna*. Sagep Editrice: Genoa, 1981.

Quaini, Massimo. "La Liguria invisibile," in *La Liguria*. Giulio Einaudi Editore: Turin, 1994.

Ratto, G.B. and Giovanni. *Cuciniera Genovese*. Edizioni Pagano: Genoa, 18th edition (original ed. 1865).

Rizzi, Tina Leali. *Camogli e i suoi dintorni*. Recco, 1989.

Root, Waverley. *The Food of Italy*. Random House: New York, 1977.

Rubens—Pietro Paolo Rubens. cata. ed. Didier Bodart. De Luca Edizioni d'Arte: Padua, 1990.

Schiaffino, Pro. *The Sailing Ships of Camogli*. Sagep Editrice: Genoa, 1987.

La Scoperta della Liguria. ed. Maria Clotilde Giuliani-Balestrino, Eraldo Leardi, Massimo Quaini, Maria Pia Rota, Domenico Ruocco. Touring Club Italiano: Milan, 1991.

Seyffert, Oskar. *Dictionary of Classical Antiquities*. Meridian Books: Cleveland, 1966.

Simonetti, Farida, Guido Rosato and Giovanna Rotondi-Terminiello. *Galleria Nazionale Palazzo Spinola Genova*. Istituto Poligrafico e Zecca dello Stato, Libreria dello Stato: Rome, 1991.

Smollett, Tobias George. *Travels Through France and Italy*. ed. T. Seccombe. Oxford University Press: Oxford, 1919.

Tagliafico, Carlo and Daniela. *Liguria Intima*. Ed. Mistral: Genoa, 1986.

Twain, Mark. *The Innocents Abroad*, vol 1. Harper & Bros.: New York, 1911.

Le Ville di Genova. ed. Eugenio De Andreis. Sagep Editrice: Genoa, 1986.

GENERAL INDEX

ℱood ℐNDEX

fish, 163-66
 ingredients for, 137
 pastas and sauces, 138-53
 poultry and meat, 167-68
 vegetable dishes, 154-62
Regional cuisines:
 of Cinque Terre, 118
 cookbooks of, 112-13
 entroterra, 107-8, 113, 122, 128, 130, 132, 136
 Genoese, 101, 105, 107, 112, 136
 Saracen influence in, 120, 136
 of the sea, 108, 113, 115, 118-22
 seasonal, 124
 three zones of, 112
Ripieni, 121, **158**

Salsa di funghi, 122, **153**
Salsa di noci, **151**
Salsa di rucola, 125
Salt, 137
Sardenaira, 101
Sarza de noxe, **151**
Sauces, **138-53**
 meat, **152**
 mushroom, **153**
 walnut, **151**
Scabeccio, 120
Sea biscuits, *162*
Seafood, *see* Fish
Shellfish, 115, 118-20; *see also* Fish
Spinach, 105, 120
Spongata, 101
Stamps, *corzetti,* 141, *142*
Stoccafisso, 100, *118-19,* 121-22

Stoccafisso accomodato, 122, **163**
Stocchefisce accomodòu, **163**
Stone-cooking, 112, 118

Temperature, equivalent chart, 177
Testaroli, 101, 112
Tôcco, 132, **152**
Tôcco de funzi, **153**
Tomatoes, 127
Tomaxelle, 105
Torta alla genovese, 128
Torta cappuccina, 127
Torta di acciughe, 118, 121
Torta pasqualina, 127, 132, **156-57**
Trenette, 120, 130, **138-40,** *139*
Trippe da sbïra, 107
Trofie al pesto, 130, **138, 140**
Trofiette, 125

Veal, **168**
Vegetables, 125-27, **154-62**
 greens and herbs, 124-25
 sott'oli, 95, *96-97*
 stuffed, baked, **158**
 tarts, 127-28, **156-57**
Vitello a l'öxelletto, 105
Volume, equivalent chart, 177

Walnut sauce, **151**
Weight, equivalent chart, 177
Wine, 29, 37, 116-17

Zuppa di pesce, 120, **164-65**